W9-CTL-505

Symbolist Art

writers — Huysmans.
Mallarmé
Verlaine
Aurier

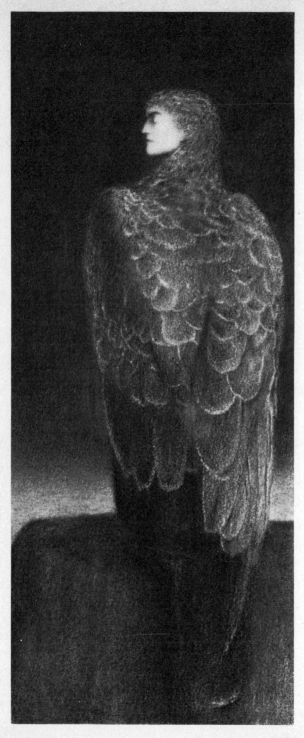

I FERNAND KHNOPFF
The Sleeping Muse
1896

Symbolist Art

Edward Lucie-Smith

Praeger Publishers

New York · Washington

For Mario Amaya

BOOKS THAT MATTER

Published in the United States of America in 1972
by Praeger Publishers, Inc.
111 Fourth Avenue, New York, N.Y. 10003

© 1972 in London, England, by Thames and Hudson Ltd

All rights reserved

No part of this publication may be reproduced, stored in a retrieval
system or transmitted in any form or by any means, electronic,
mechanical, photocopying, recording or otherwise, without the prior
permission of the Copyright owner

Library of Congress Catalog Card Number: 72-77068

Printed in Great Britain

Contents

Symbolic Art

Though this book is quite specifically about a single episode in the history of European art, the reader will, I believe, find it easier to absorb the information and the opinions which are contained in the chapters which follow if I first remind him of a few facts about the general function of symbolism in Western painting and sculpture.

This reminder would be superfluous but for the triumph of the Modernist spirit. Born of the Symbolist Movement, Modernism has nevertheless been hostile to the symbol as a means of visual communication. The rise of abstract art, in particular, has tended to focus our attention upon the work as a thing in itself, wholly identified with the art-process. Any art which can be described as symbolist must necessarily reject such an attitude. Behind the shapes and colours to be found on the picture-surface, there is always something else, another realm, another order of meaning.

It is because we have fallen out of sympathy with symbolic procedures that we often find the Old Masters difficult – more difficult, if we are honest, than some contemporary painters and sculptors who are notorious for the difficulties they present. But often the situation is different: we think we understand the work of art as it discloses itself to us, while in fact we are missing half its meaning. The medieval artist expected his contemporaries to recognize at once which saint was meant, thanks to the conventional attribute with which the figure was accompanied. As often as not, we modern pagans are simply bewildered by the very thing which was intended to enlighten us.

But rather than plunge into the complexities of medieval religious symbolism, it seems better, for my present purpose, to make a start with the Renaissance. Renaissance art manifests qualities and ideas which were to fascinate the Symbolist painters and sculptors of the nineteenth century. We find, for example, the conflict between 'open' and 'closed' systems of symbolic communication. Elements drawn from a language which every educated person was expected to be able to understand are mixed with other symbols whose meaning would reveal itself only to initiates. At the same time, we discover for

7

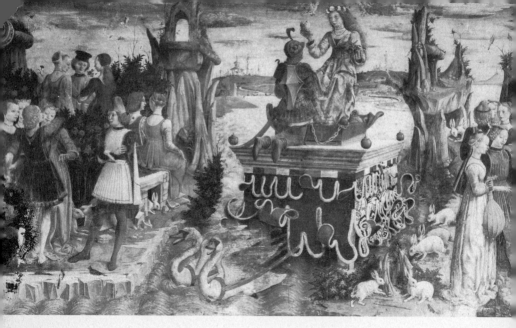

2 FRANCESCO DEL COSSA *Triumph of Venus* 1458–78

the first time, in works created by Renaissance masters such as
Giorgione, a rejection of the notion of one-for-one equivalence be-
tween the symbol used and the meaning intended. The symbol now
becomes something which resonates within the mind of the spectator,
and the work itself is more than a mere sum total of the symbols it
contains.

We can observe the progression from one kind of symbolism to
another in the work of the Italian masters who concerned themselves
with reviving and reinterpreting the imagery of pagan antiquity.
Agostino di Duccio, adorning that extraordinary monument to
Renaissance humanism, the Tempio Malatestiana at Rimini, still
thinks it enough to add one symbol to another. If his *Mercury* has an
extra significance, it is because he is provided with additional attri-
butes. Similarly, in Francesco del Cossa's allegorical frescoes in the
Palazzo Schifanoia, Ferrara, we are still, despite the festive joyousness
of the imagery, in the realm of purely 'accumulative' symbolism. In
the scene representing the Triumph of Venus, for example, we note
that Mars not only kneels before his mistress Venus, but is actually
chained to her throne, to indicate that he is her prisoner.

8

3 AGOSTINO DI DUCCIO *Mercury* after 1450

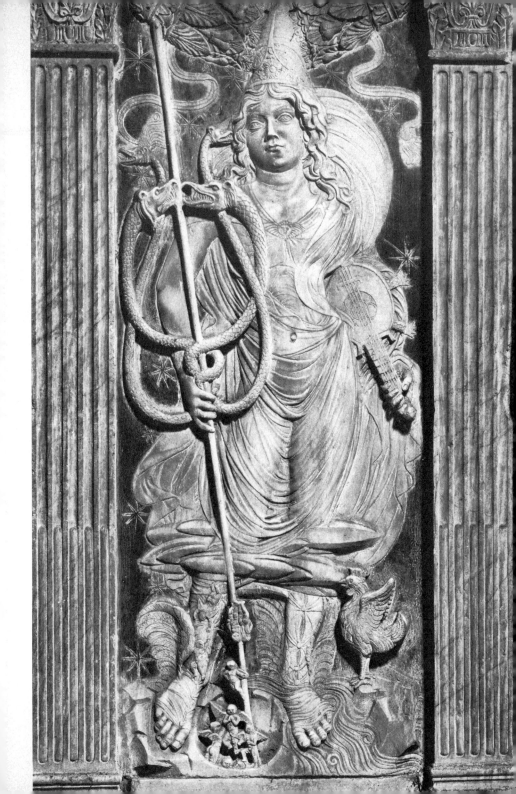

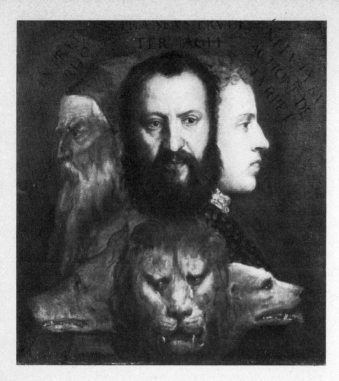

4 TITIAN *Allegory of Prudence*

5 SANDRO BOTTICELLI *Primavera (detail)* *c.* 1478

Accumulative symbolism of this sort continued to play an important role in Italian art until well into the sixteenth century. It is, for instance, the method which Titian chose to adopt when he painted the strange *Allegory of Prudence* which is now in the National Gallery in London. Three human heads are superimposed upon the heads of three beasts: facing left, a wolf; facing right, a dog; and facing directly towards us, a lion. Each visage must be related to the beast below, and the beasts must be related to each other. The wolf is the emblem of the past, of devouring time; the dog snuffs out the future; while the lion is the strength and glory of the present. Each of these three aspects must be taken into account by the prudent man, and the three of them together make up the image of Consilium, or Good Counsel, which in turn begets the higher quality of Prudence. An allusion to pagan mythology is also intended, for together the three beasts represent the triple-headed monster who was attendant upon the Egyptian god, Serapis.

But already, by the time the *Allegory of Prudence* was painted, a far more complex and subtle approach to the problems of symbolic representation had been worked out. This approach was analysed by

the late Edgar Wind in a now-celebrated art-historical study, *Pagan Mysteries of the Renaissance*. Wind perceived that an important clue to the interpretation of many of the most celebrated Renaissance pictures was to be found in the writings of the Neoplatonic philosophers, such as Plotinus, and in the interpretation placed upon these texts by Renaissance humanists. Plotinus, for example, said that the mystic philosopher 'is as one who presses onward to the inmost sanctuary, leaving behind him the statues of the outer temple'.

The point was well taken in fifteenth-century Florence. Botticelli's *Primavera*, for example, invites the spectator to extend the picture and its meaning within the recesses of his own mind, after the fashion that Plotinus seems to suggest. (The same thing is true of the apparently less complex *Birth of Venus*.) In the *Primavera*, great attention must be paid to the group of the Three Graces – to their attitudes, expressions,

5

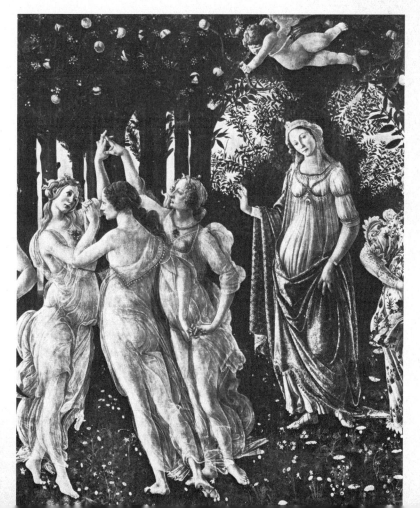

dress and ornaments, as well as to their simple presence. Renaissance philosophers interpreted the Graces as an emblem of three different aspects of love, and named them accordingly. In the *Primavera*, it is Castitas, or Chastity, whom blind Cupid threatens with his arrow. Castitas stands opposed to her wilder sister, Voluptas, or Sensual Love. Pulchritudo, or Beauty, the third of the sisters, is less vehement, but nevertheless sides with Voluptas.

Botticelli, together with Mantegna, was one of the great influences upon the Symbolist art of the late nineteenth century. In England his work was especially admired, and we find continual echoes of it in the productions of Edward Burne-Jones, Aubrey Beardsley and Charles Ricketts. It may be argued that, since the inner meaning of Botticelli's great symbolic pictures had very largely been lost until Wind rediscovered it in our own day, this was more a matter of admiration for the forms which Botticelli invented than of fascination with the content which he meant those forms to express. But the apparent obscurity of some of Botticelli's symbols only added to the allusive richness which so appealed to his nineteenth-century admirers. Much the same can be said of Mantegna, who influenced a wide spectrum of French and English Symbolists, not merely because of his taste for linear stylization, but because of his tendency to load every rift with ore. His rock-formations reappear in Moreau and Burne-Jones, while the beautiful group of Mercury and Pegasus, on the right-hand side of Mantegna's *Parnassus* (in the Louvre from 1801) is clearly the ancestor of similar groups in the work of Picasso and Redon.

What is more, Neoplatonism in a general sense was almost as important to the philosophers and aestheticians of the Symbolist Movement as it had been to the pioneers of the New Learning in Florence. In the Symbolist milieu, the philosophers in vogue were Hegel and Schopenhauer, both of whom have an important Neoplatonic component. The occult was cultivated by many Symbolists, and hermeticism was considered to be a virtue. We certainly catch an echo of Plotinus in the formulation offered by the Sâr Péladan, an important if now rather neglected popularizer of Symbolist ideas. 'The Beautiful', he declared in one of his treatises on aesthetics, 'is an interior vision where the world is clothed in supereminent qualities.'

The *Primavera* and the *Parnassus* are not, of course, the only products of the Renaissance to foreshadow the form and content of the Symbolist art of the nineteenth century. Another, which fascinated the

6 ANDREA MANTEGNA *Parnassus* (detail) c. 1490–97

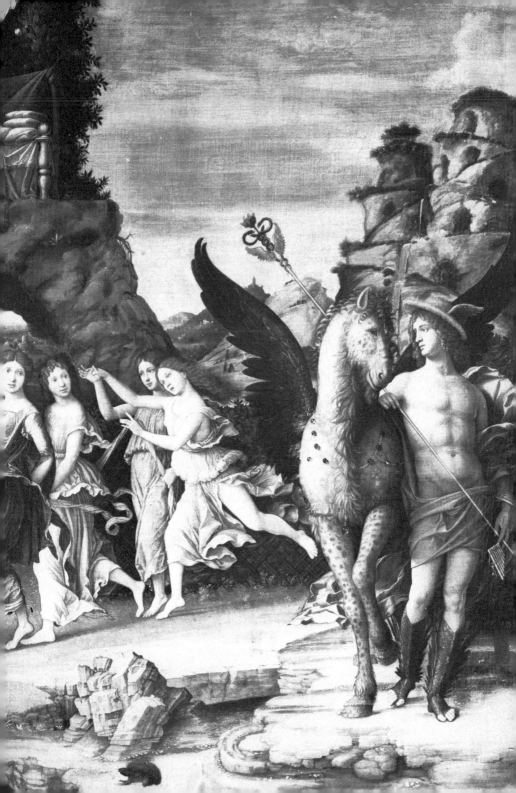

7 | Symbolists themselves, is Dürer's print, *Melancholia*. Few works of art have excited so much controversy as to their correct interpretation. The title was provided by the artist himself, and so, too, were a couple of hints as to what was meant. 'The key', he said, 'means power; the purse means wealth.' That is, *Melancholia* to some extent adheres to traditional methods of symbolization, as inherited from the Middle Ages, and precise meanings can be assigned to some at least of the many objects represented. Starting from this point, scholars have ransacked the sources available to them, and have discovered, for instance, references to the seven liberal and seven mechanical arts, as these were categorized by the scholastic thought of Dürer's own time; and also to the then axiomatic theory of the prevailing 'humours' or temperaments. Less instructed spectators have been quick to grasp something different, and perhaps more important – that the print is confessional, and speaks to us of a great artist's struggle with his own daemon. The Symbolist art of the nineteenth century also has an important confessional aspect; its use of symbolism is not impersonal.

8 | It is for this reason that perhaps the most prophetic of the legacies made by the Renaissance to the Symbolists is Giorgione's *Tempesta*, a work which is perhaps even more celebrated than the *Melancholia*, and which seems, at first sight, to be a great deal more straightforward

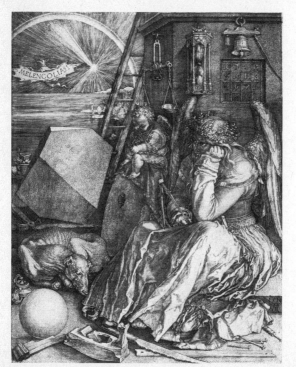

7 ALBRECHT DÜRER
Melancholia 1514

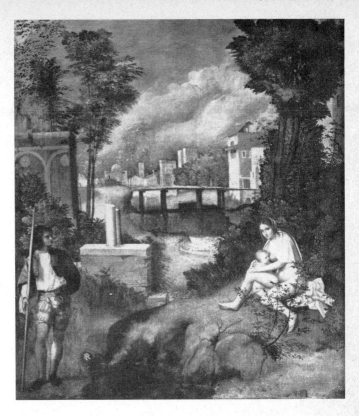

8 GIORGIONE
Tempesta

in its appeal. But in fact, as Professor Wind pointed out in an essay
devoted to the problem, Giorgione's painting is far more of a riddle
even than anything created by Botticelli. There are a number of
straightforwardly allegorical elements: the two figures, a soldier and
a gipsy girl, are both by established tradition the familiars of Fortune,
and the storm itself is an allusion to its vicissitudes. The broken columns
in the middle distance were understood in Giorgione's time as an
emblem of Fortitudo, or strength in adversity. But clearly the effect
which is made by the picture goes far beyond the scraps of information
conveyed by these details. In the *Tempesta*, art shows a mysterious
power to convey meaning without being completely specific. The
spectator completes the work for himself, with some element which
he discovers within himself. This suggestiveness and ambiguity were
the very essence of Symbolist poetry, as it was written for example by
Stéphane Mallarmé, and they were necessarily important to Symbolist
art as well.

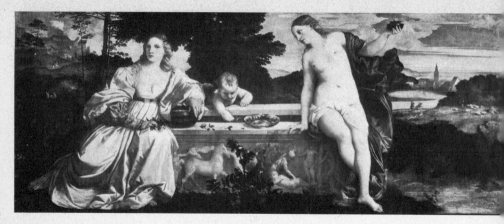

9 TITIAN *Sacred and Profane Love* c. 1515–16

If we examine the work of some of Giorgione's successors, we soon
9 discover the extent of his radicalism. Titian's *Sacred and Profane Love*,
to choose an immediately relevant example, plainly owes a good deal
to Giorgione; there is undoubtedly a magic of atmosphere in this
painting which indefinably reflects the magic of love itself. And yet,
despite the confusions which have arisen about the way in which the
artist meant his work to be interpreted, it is closely tied to a specific
allegorical programme. The chief reason why it has been considered
mysterious is that the generally accepted title – of which there is no
record before the year 1700 – misinterprets the subject-matter. It is
Celestial and Human Love that are represented; and the naked figure
is the superior, not the inferior of the two, both of them types of
chastened passion. The fountain we see is of course the Fountain of
Love, and even the reliefs with which it is ornamented have their con-
tribution to make to our understanding of what is intended; we see a
man being scourged, a woman being dragged by the hair, an un-
bridled horse being led away by the mane. The message is that carnality
must be disciplined and bridled; the horse itself is a Neoplatonic
symbol of sensuous passion.

 In Renaissance and post-Renaissance painting, it remains difficult to
separate the idea of the symbol from the idea of the allegory. The
originality of the nineteenth-century Symbolists was that they were
willing to make a distinction in theory which had to some extent long
existed in practice. The theorists of the Symbolist Movement recog-
nized that the symbol could be something which existed in its own

16

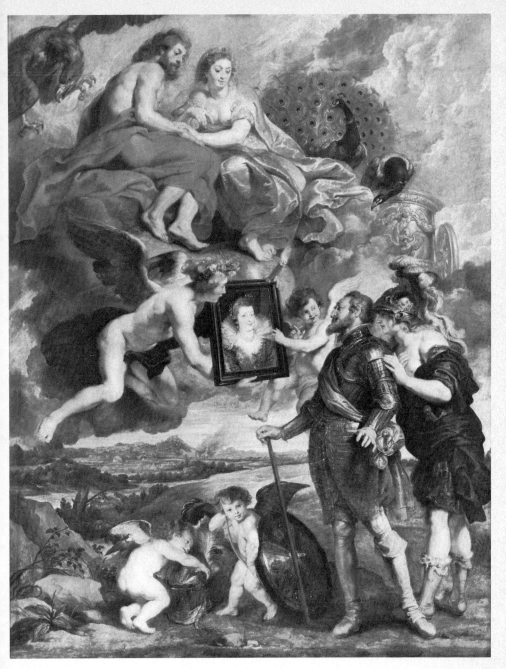

10 PETER PAUL RUBENS *Henry IV Receiving the Portrait of Marie de Médicis* 1622–25

right, diffusing a mysterious influence around itself, and affecting the whole context in which it was placed. Its operations were by no means completely predictable.

In traditional allegory, on the other hand, it was assumed that what the symbol stood for was something rationally decided in advance; symbolic objects were therefore regarded simply as units of language. A good enough demonstration of the consequences of adopting such an attitude towards symbolism – its strengths as well as its weaknesses – can be found in the *Marie de Médicis* cycle by Rubens. Here we have a flattering allegorical presentation of the main events in the Queen's life, many details of which were prescribed to the artist by his patron and her advisers. For example, one of the paintings has for its subject Henry IV receiving the portrait of Marie de Médicis. This portrait is presented to the King of France by the flying figures of Eros and Hymen. Behind him, in the guise of a semi-nude female figure, stands France personified, urging Henry to enter into this alliance. Jupiter and Juno are seated above on clouds, and look down approvingly. Meanwhile, two Cupids bear off the King's helmet and shield, as a sign of the new era of peace which the marriage will bring to his country.

A representation of this sort requires a suspension of disbelief upon the part of the spectator. It jumbles together incongruous elements, and presents us with personages and events which would be impossible in the real, perceptual world, even though the way in which they are shown to us derives ultimately from that world. An allegorical picture of this sort is a rebus; we read it element by element, symbol by symbol, and have little sense of it as a totality. Even the sensuality of Rubens's colour and brushwork cannot conceal from us the fact that *Henry IV Receiving the Portrait of Marie de Médicis* is intended to be read as much as it is to be looked at.

Related to the allegorical convention, but inferior in status (at least in the opinion of seventeenth-century theoreticians) was the *vanitas* still-life. In broad terms, the growth of still-life painting seems to represent, in the history of European culture, a more open response to the senses. The *vanitas*, however, is a still-life composed upon symbolic principles. The objects represented call the spectator's attention to his own mortality; they preach a sermon about the transient nature of the sensual world.

In some examples, the message is so adroitly concealed that we may easily miss it. Not so, however, in the example I have chosen for

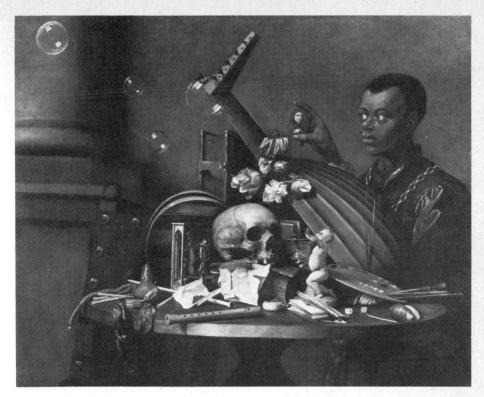

11 JACQUES DE GHEYN *Vanitas*

illustration here. This is the *vanitas* at its most opulent and elaborate. The skull – usually but not invariably present in paintings of this type – is a reminder of mortality; the bubbles reinforce the theme of transience. Among the things heaped upon the table we find objects emblematic of the five senses. Though reality as presented in a work such as this is reality of a much more continuous sort than that which we find in the paintings of the *Marie de Médicis* series, nevertheless the abstract, conceptual approach remains dominant.

This is not entirely true of certain other pictures of the same period. Claude's *Landscape with the Angel Appearing to Hagar*, for example, *12* fuses landscape-painting and history-painting through the use of a genuinely symbolic device. The figures of Hagar and her son are echoed and interpreted by the two intertwined trees – one fully grown, the other still a sapling – which stand behind them. Through these,

19

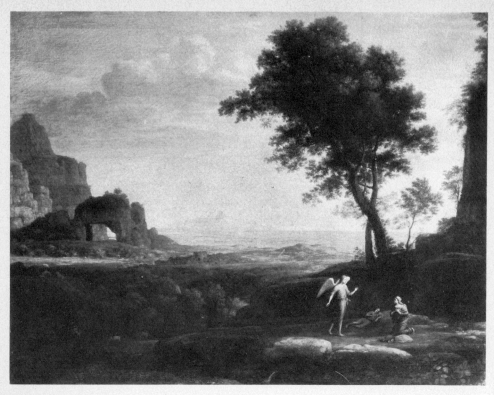

12 CLAUDE LORRAIN *Landscape with the Angel Appearing to Hagar c.* 1670

the artist is able to say something about the mother's relationship with her son. At the same time, the whole vast surrounding landscape creates a mood which in turn colours our reaction to what is being enacted by the figures.

Indeed, if we are looking for a continuous line of development in symbolic art, it is to the French landscape-painters that we should address ourselves. It has only recently been realized, for example, that 13 Watteau's celebrated *Embarkation for the Island of Cythera*, more correctly described as a *Departure from the Island of Cythera*, is a work in which symbolism plays an extremely important part. The three pairs of lovers on whom most emphasis is placed represent in fact different aspects of the same couple and the same relationship. Those on the far right are still entirely under the spell of the Goddess of Love. The woman pays no heed to the Cupid who tugs at her skirt. The next

20

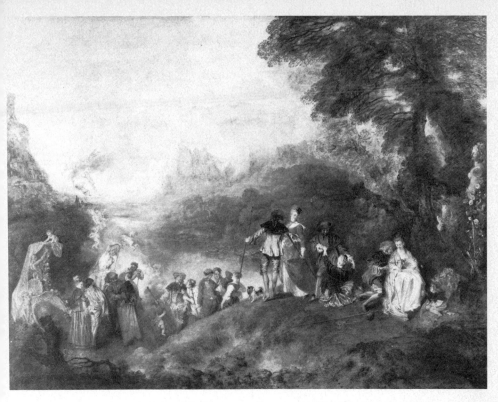

13 JEAN-ANTOINE WATTEAU *The Departure from the Island of Cythera* 1716–17

couple are already rising to their feet; and the third pair, moving off, look back regretfully. One must nevertheless admit that the smiling ambiguity which allowed a radical misinterpretation of its subject-matter is a large part of the picture's charm, and the thing which links it to Giorgione on the one hand and the Symbolist Movement on the other.

It is no accident that Watteau attracted the attention of certain artists in the Symbolist milieu, among them Aubrey Beardsley and Charles Conder. True enough, thanks to the Goncourts and others, the French eighteenth century was already fashionable in the latter part of the nineteenth. But it was also that Symbolist artists recognized in Watteau a man whose intentions were very close to their own: he had already abandoned conventional allegory in favour of a use of symbolism which was more pervasive, more powerful and more mysterious.

21

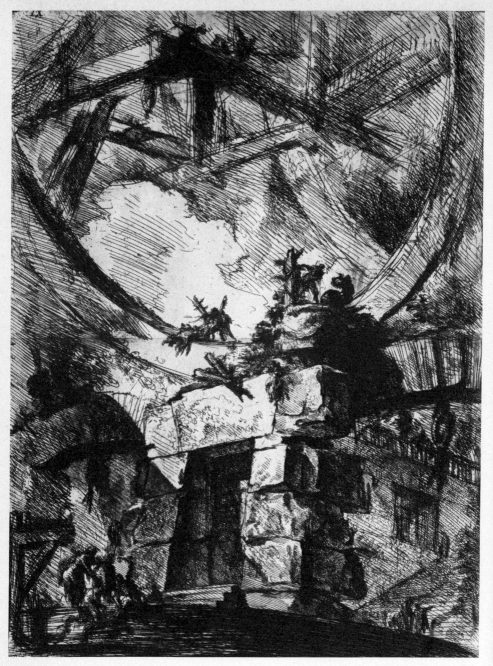

14 GIOVANNI BATTISTA PIRANESI *Prison with Colossal Wheel* 1745

Romanticism and Symbolism

Symbolism, in the narrow, historical sense of the term, must be approached only as part of a larger whole: the Romantic Movement. Romanticism represents a crisis, a convulsion in the European spirit whose effects are still being felt at the present day. In his lectures, *Some Sources of Romanticism*, Sir Isaiah Berlin speaks of 'a shift in consciousness' which 'cracked the backbone of European thought'. Essentially, the broken backbone was reason, or, rather, it was the long-standing belief in the power of human reason to govern all actions and solve all problems.

Among the Romantics, there was on the one hand a rebellion against restrictions of all kinds, and on the other hand the search for a new point of certainty, once the external frame of reference had been destroyed and the concept of immutable order abandoned. The validity and authority of the objectively perceived world having been called into doubt, subjectivity inevitably triumphed. Men now looked within themselves for guidance. There grew up the myth of the 'genius', the divinely inspired man whose unfettered imagination enabled him to transmute all his experiences and emotions into art, and who was excused, by reason of his gifts, from obedience to the normal rules; who must, indeed, refuse to submit to these in the interests of fulfilling himself.

The essence of the new doctrine, in artistic terms, was the primacy of the imagination. The Swiss critic Bodmer declared, as early as 1741, that 'Imagination outstrips all the world's magicians: it not only places the real before our eyes in a vivid image and makes distant things present, but also, with a power more potent than that of magic, it draws that which does not exist out of the state of potentiality, gives it a semblance of reality, and makes us see, feel and hear these new creations.' As the leading interpreter of Shakespeare to his own generation he was here apparently paraphrasing the 'poet's eye' speech from *A Midsummer Night's Dream*. The formulation was nevertheless controversial and radical in the context of early eighteenth-century rationalism.

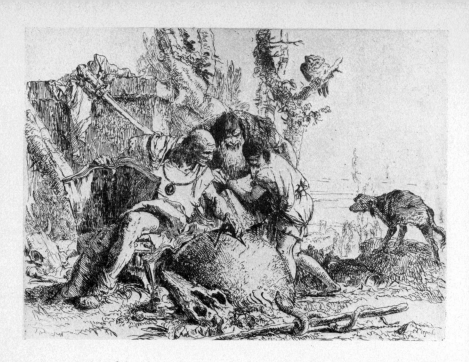

It is useful to keep Bodmer's words in mind when looking at some of the more unexpected productions of eighteenth-century artists. Notable for their strangeness are some of the prints produced by the Venetian artists G. B. Piranesi and G. B. Tiepolo. The etchings of the *Prisons* series, first published by Piranesi in 1745, might have been designed to justify Bodmer, though it is more usual to see them as forerunners of fully developed nineteenth-century Romanticism – the visual equivalent of Thomas de Quincey's *Confessions of an English Opium Eater.*

14

Historically speaking, Piranesi's *Prisons* belong to a well-established Venetian genre – that of the *capriccio*, a study of imaginary architecture (or of real architecture in an imaginary setting). A *capriccio*, as the Venetian painters and draughtsmen contemporary with Piranesi understood it, was a transposition of reality, a test of the artist's skill and inventiveness. In Venice at least, the visual arts were becoming assimilated to the more abstract and self-sufficient art of music, and artists, like the musicians of the time, were concerned to demonstrate their own virtuosity. The *capricci* of Canaletto and Guardi, in which familiar Venetian buildings and monuments appear in new settings, are exercises of this kind.

But the *capriccio* also had a purely pictorial ancestry. Ultimately, it descended from Giorgione, and from the *Tempesta* in particular. The figures who make their appearance in two series of etchings by Tiepolo, the *Capricci* and the *Scherzi di fantasia*, both of which date from the 1750s, are obviously related to the soldier and the gipsy girl who are to be found in Giorgione's masterpiece.

Tiepolo is at pains to stress the fantastic and the irrational element in his subject-matter as well as in his compositional procedures. Death holds court. A young soldier has his horoscope cast. A human skull and a leg-bone are seen burning upon a pedestal. Magicians and sorcerers make frequent appearances. In fact, what we encounter in Tiepolo's prints is a version of that shady, superstitious night-world of which we also get glimpses in the memoirs of Tiepolo's fellow countryman, Casanova. The emphasis on irrational evil is of some importance to the theme of the present book.

Tiepolo's last years were spent in Spain, working for the Spanish Court, and the work which he did there influenced the young Francisco Goya. Goya, however, remained faithful to the sunlit

15 GIOVANNI
BATTISTA TIEPOLO
*Two Magicians and
a Boy* 1755–65

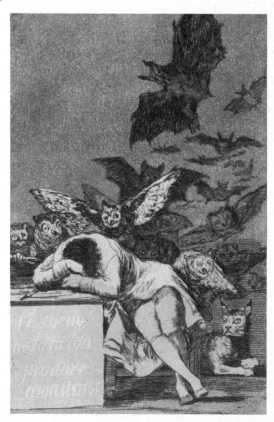

16 FRANCISCO GOYA
*The Dream of Reason
Produces Monsters*
1797–99

tradition of the Rococo until the 1790s. It was only then that he began to produce the works which posterity has chosen to regard as being typical of him. Goya, like Tiepolo, made prints as part of his general activity as an artist, and these prints, again like Tiepolo's, were used as a vehicle for personal fantasy, often of a horrific kind – at least, until the Napoleonic invasion of Spain replaced imagined horrors with real ones in Goya's mind. Indeed, he followed Venetian tradition so far as to entitle a major series of prints *Los Caprichos*. In these, as in the *Capricci* and *Scherzi di fantasia* of Tiepolo, we find imagery drawn from the lore of witchcraft, but there is also a vein of social and political commentary. The general theme is stated in No. 43, once intended as the frontispiece of the set, but later replaced by a self-portrait of the artist. The title is *The Dream of Reason Produces Monsters* – a phrase which is further explained by some contemporary manuscript notes on a trial proof: 'Fantasy abandoned by reason produces impossible monsters; united with it, she is the mother of the arts and origin of its marvels.'

16

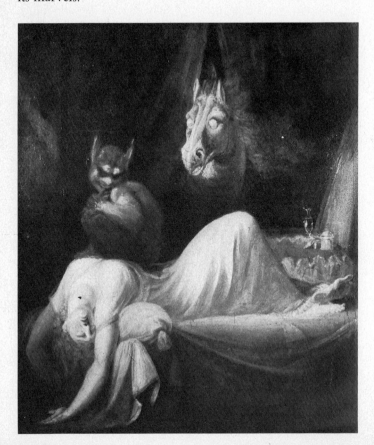

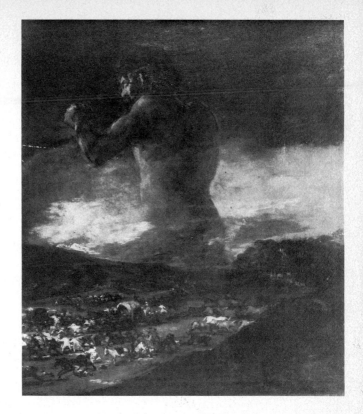

17 HENRY FUSELI *The Nightmare* c. 1782

18 FRANCISCO GOYA *Panic* 1808–12

Later, Goya was to allow his symbols a looser rein. The impressive *Panic* in the Prado is at all points a symbolic painting. The looming *18* figure which dominates the picture-space is a graphic representation of the way panic seems to swell up until it fills every cranny of the mind.

Indeed, the more closely we examine the history of Romantic art, the more salient the symbolic component becomes. Henry Fuseli's *The Nightmare* is deservedly one of the most famous monuments of early *17* Romanticism in painting. It seems the embodiment in paint of the qualities which Lavater once ascribed to the artist himself: 'His spirits are hurricane, his servants flames of fire. He goes on the wings of the wind. His laughter is the mockery of Hell, and his love a murderous lightning flash. Jupiter's eagle! Belial, who with a single kick thrusts a whole strand into the abyss.' Melodramatic as it is, *The Nightmare* has the power to haunt the mind. That ghostly horse's head, looming over the prostrate and tormented body of the sleeping woman, is more than the mere translation of a commonplace metaphor into paint.

27

For a thoroughgoing use of symbolic method, we must, however, turn to Fuseli's somewhat younger contemporary, Caspar David Friedrich. Friedrich's landscape paintings symbolize subjective ex-
20 perience. *The Cross in the Mountains*, painted in 1808, exemplifies a certain tension in Friedrich's work between the desire to represent and embody the undisturbed harmony of nature, and the contrary desire to impose upon it a human meaning.

Symbolic method is yet more in evidence in another and later work,
19 *The Wreck of the 'Hope'*, which was painted in 1821. The source for this was apparently Captain Perry's narrative of his own explorations in the Arctic; yet clearly any documentary intention was soon abandoned. The ship is hope itself, foundering in the frozen wastes of death and despair. The painting is a striking example of Friedrich's power to make a simple pictorial metaphor resonate in the mind: to make it become a symbol.

Minor figures among the French Romantic artists adopt a similar strategy on occasions. There is, for example, a striking resemblance between the painting by Friedrich which I have just been discussing
21 and one of the drawings made by Gustave Doré to illustrate that favourite Romantic text, Coleridge's *Rime of the Ancient Mariner*. There is also a kinship with some of the numerous drawings made by

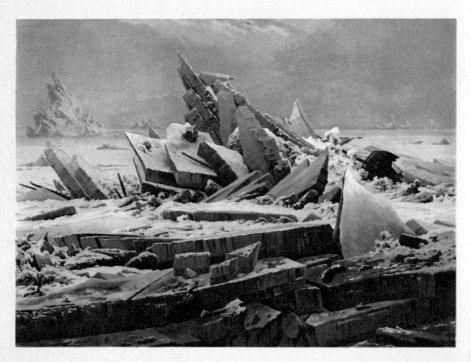

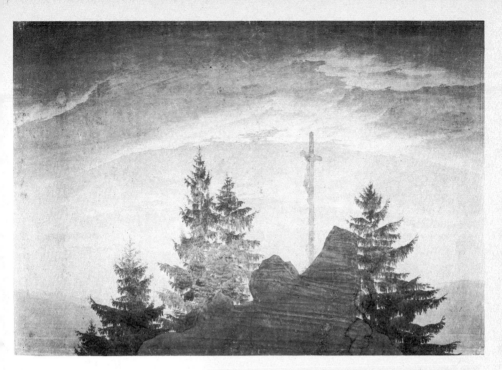

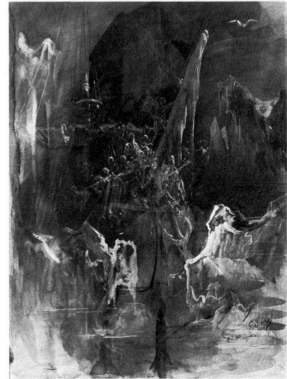

19 CASPAR DAVID FRIEDRICH
The Wreck of the 'Hope' 1821

20 CASPAR DAVID FRIEDRICH
The Cross in the Mountains
1808

21 GUSTAVE DORÉ *Ship among
Icebergs c.* 1865

23 the poet Victor Hugo. Hugo's *The Dream*, illustrated here, shows a concentration upon a single symbolic image which prefigures the drawings and lithographs of Odilon Redon.

Mostly, however, French Romantic painting has a somewhat different flavour. Its most characteristic expression is to be discovered in the immense *œuvre* of Eugène Delacroix, with its vigour, its passion, its liking for decisive extravert gestures. Yet Delacroix played an important part in the process by which the Symbolist Movement proper emerged from Romanticism. This is illustrated by

22 one of his principal masterpieces, *The Death of Sardanapalus*, exhibited at the Salon of 1827. The subject is taken from a play by Byron. The King of Assyria, last descendant of Semiramis, after hearing of the approach of an enemy whom he is unable to resist, is preparing to kill himself and all his wives, and destroy his treasure. Contemporaries such as Baudelaire – who described the artist on one occasion as a 'lake of blood, haunted by evil angels' – recognized that subjects of this kind had a special fascination for Delacroix. The languorous,

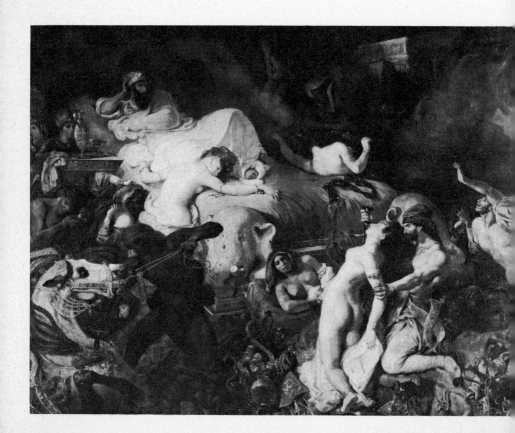

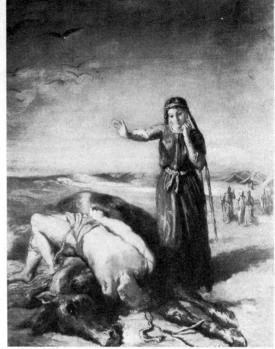

3 VICTOR HUGO *The Dream*

4 THÉODORE CHASSÉRIAU *Mazeppa* 1851

almost epicene pose of Sardanapalus, the glittering heaps of gold and jewels that surround him, the sadism with which the slave in the foreground butchers the woman whom he grasps – all of these are things that we discover again in the work of Gustave Moreau.

The link between Delacroix and the Symbolists, in a more directly personal sense, is to be discovered in the work and career of Théodore Chassériau. Chassériau was a pupil of Ingres, which should have made him in most things the opponent of Delacroix. But he soon felt the irresistible attraction of the world of the imagination which Delacroix conjured up. Like Delacroix himself, Chassériau visited Algeria, and was seduced by what he found there. He also felt the daemonic attraction of Byron's plays and poems. But there is something cool and calculated about his art: his spangled colour, in particular, is personal to himself, and can impart to his paintings a feeling of claustrophobia. And it was hard for him to abandon that reverence for line, for the bounding contour, which he had learned from Ingres. It was these qualities among others that he passed on to his pupil Gustave Moreau. Moreau revered Chassériau all his life.

24

2 EUGÈNE DELACROIX *The Death of Sardanapalus* 1827

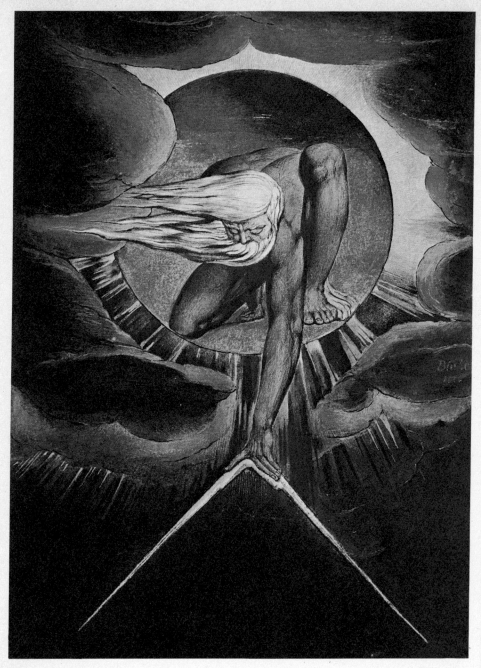

25 WILLIAM BLAKE *The Ancient of Days* 1794

Symbolist Currents in England

Commonly, art historians look upon English nineteenth-century painting as being something of a dead end. It has long been recognized that English Neo-classical artists had a widespread influence in Europe; Flaxman, in particular, was well known through his outline illustrations to Homer. Constable, a very different sort of artist, had a considerable impact on Delacroix when his work was exhibited in Paris. Turner is recognized as a genius of European stature, though the extent of his influence has been disputed; Monet, who visited London as a result of the upheavals caused by the Franco-Prussian War, seems to have known his work. The Pre-Raphaelites, on the other hand, are generally considered to be typical of the 'insularity' which afflicted English art in the second half of the century.

In fact, this view of English art and its development needs to be very considerably corrected. It is now acknowledged that the Pre-Raphaelites themselves were not an isolated phenomenon but representatives of an idealistic spirit which had existed in English art since the beginning of the century. The grandfather, if not the father, of Pre-Raphaelitism was William Blake.

Blake spent his whole life in elaborating a symbolic universe so 25
dense and complex that many aspects of it are still being elucidated by scholars. Blake believed, for example that: 'If it were not for the Poetic or Prophetic character the Philosophic & Experimental would soon be at the ratio of all things, & stand still, unable to do other than repeat the same dull round over again.' He also declared that: 'Man's perceptions are not bounded by organs of perception; he perceives more than sense (tho' ever so acute) can discover.' These visionary beliefs inform the whole of his work, whether written or drawn, and were to be echoed again and again, years later, in the work and in the writings of what we now call the Symbolist Movement.

The artistic vocabulary which Blake employed is in detail much less original than the uses he put it to. For the most part he was self-taught, and his principal influences were Raphael, Dürer and Michelangelo, as modified by the fashionable Neo-classicism of the time in which he

grew up. However, dependent as he was on the promptings of 'Inspiration and Vision', he was always willing to break the rules; and Sir Joshua Reynolds, as the great advocate of academic method, earned his detestation. The result is that we find a strange mixture of the original and the conventional in Blake's work as an artist. His whole method of drawing the figure is schematic, and is based upon the experience of art rather than upon personal observation. But these schematized, conventional figures inhabit a dream-world in which all the normal rules are abolished. They float; they plunge; immense space surrounds them. Blake's arbitrary treatment of space was in fact to be one of the most striking and durable features of his influence upon other artists.

His immediate successors were a group of young artists who dubbed themselves the 'Ancients', the most talented among them being Samuel Palmer and Edward Calvert. Though entranced by Blake, they nevertheless pursued a course somewhat different to the one which he had chosen. Their mysticism was more specifically related to nature. Nature was, for them, the imperfect reflection of a divine archetype. It was the artist's duty to discover this archetype in the scene which lay before him, and to express it with the maximum purity and intensity. There was thus a strong element of Neo-platonism in their philosophy.

27 At their best, as for example in Palmer's *The Magic Apple Tree* and
26 Edward Calvert's *A Primitive City*, they produced images where every detail combines to intensify the symbolic force of the whole. In Palmer's case, as in Calvert's, visionary inspiration endured for only

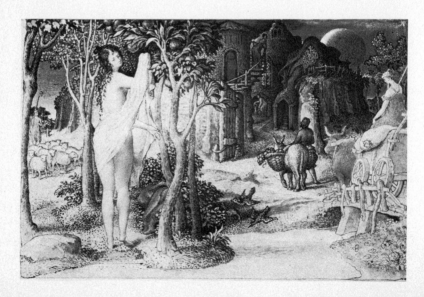

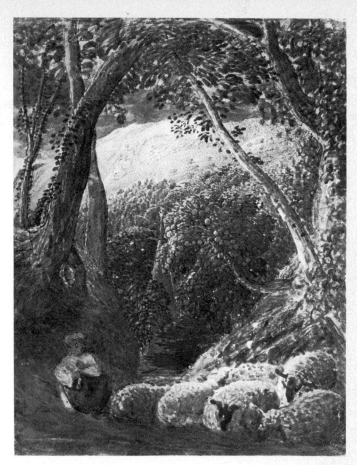

26 EDWARD CALVERT
A Primitive City
c. 1822

27 SAMUEL PALMER
The Magic Apple
Tree c. 1830

a few brief years, until the Golden Age which the artist had created in his mind was snuffed out by the materialism of the times he lived in.

At first it seemed as if no one could consistently pursue the visionary path, in the England of the Industrial Revolution, without succumbing to madness. Richard Dadd, for example, was a minor painter and draughtsman who shot his father, and was then confined in Bethlem Hospital and in Broadmoor. During the years of his confinement he produced a few works of much greater merit than he had seemed capable of before. Among them are the watercolour *The Rock and* 28
Castle of Seclusion, which, besides being an emblem of his own situation, indicates his link with Calvert; and some strange fairy-pictures, the most elaborate of which is the enigmatic *The Fairy* 29

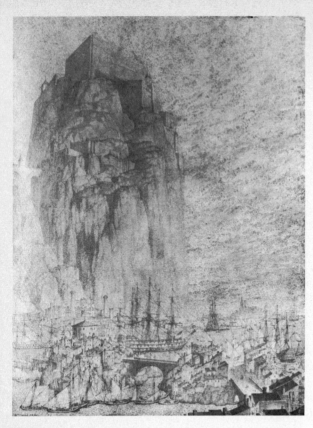

28 RICHARD DADD
*The Rock and Castle of
Seclusion* 1861

Feller's Masterstroke. Fairy-pictures were a minor Romantic genre, favoured by German artists such as Moritz von Schwind, but they did have a significance for the future, hinting as they did at the existence of another and very different universe, existing parallel with the everyday one.

The continuation of the idealistic, symbolic strain in English nineteenth-century art was, however, assured by the foundation of the Pre-Raphaelite Brotherhood. Part of Pre-Raphaelitism's inspiration came from abroad, from the German Nazarenes; but part of it was drawn from Blake, who was now, in the middle of the century, again beginning to make an impact. The principal members of the Brotherhood – Dante Gabriel Rossetti, William Holman Hunt and John Everett Millais – were in most respects very different from each other, and the movement which united them retained its cohesion for only a few years – at the most generous estimate, from 1850 to 1856.

29 RICHARD DADD *The Fairy Feller's Masterstroke* 1855–64

These early years were the years of what has since been dubbed 'hard edge' Pre-Raphaelitism, intensely seen, intensely imagined.
30 Characteristic examples are Millais's *The Return of the Dove to the Ark*
31 of 1851, and Holman Hunt's *The Scapegoat* of 1854. It is impossible to deny the label 'symbolic' to either of these pictures. Each tries to sum up an area of experience and feeling in a characteristically compressed and allusive way – in fact, the two paintings, which have little else in common other than the meticulousness of the technique employed, are both of them striking for their economy in the use of imagery.

Holman Hunt was to remain faithful to the meticulous, hard edge technique characteristic of early Pre-Raphaelitism for the rest of his long career as an artist. He never developed into what we should now recognize as a full-blown Symbolist, but remained hovering uneasily between old-fashioned religious allegory and genre painting in the

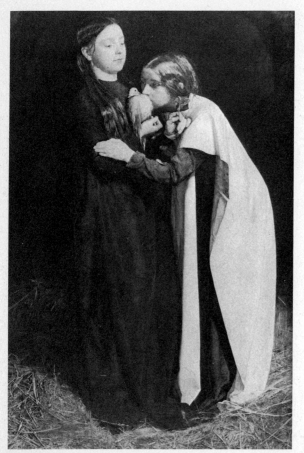

30 JOHN EVERETT MILLAIS
The Return of the Dove to the Ark 1851

31 WILLIAM HOLMAN
HUNT *The Scapegoat* 1854

32 JOHN EVERETT MILLAIS
Sir Isumbras at the Ford 1857

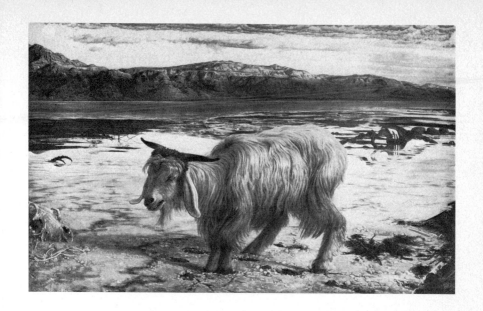

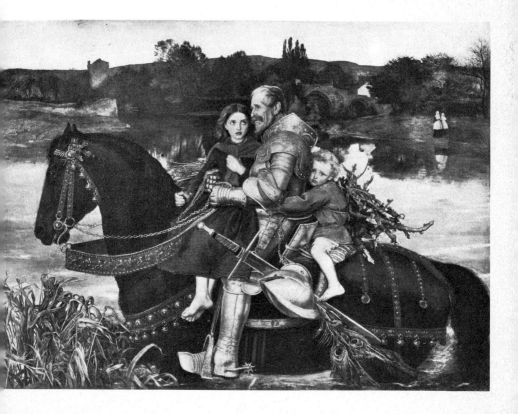

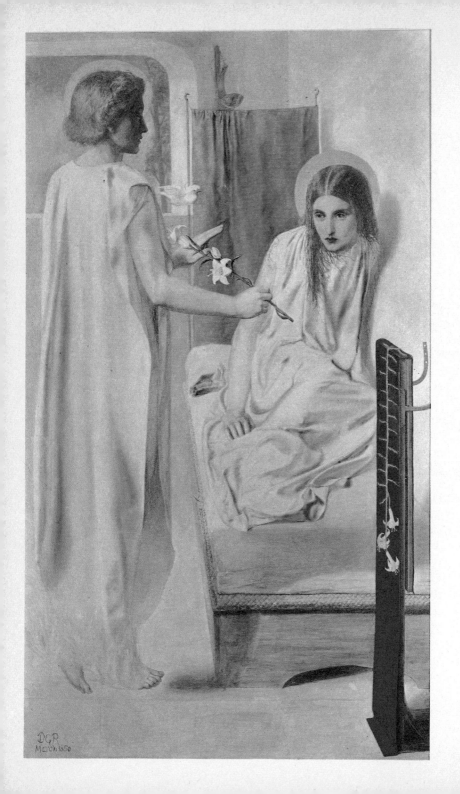

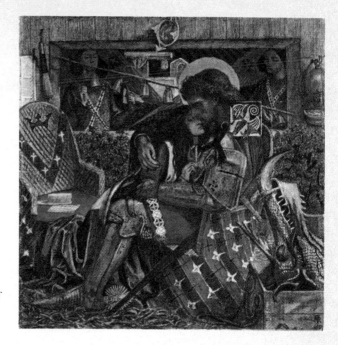

33 DANTE GABRIEL
ROSSETTI *Ecce Ancilla
Domini* 1850

34 DANTE GABRIEL
ROSSETTI *The Wedding of
St George and Princess
Sabra* 1857

classic Victorian manner. Millais, a painter of immense natural gifts, sold out to success, and plunged to the treacly depths of sentimentality.

However, just at the time when Millais was moving out of the Pre-Raphaelite orbit, he produced a small group of paintings which are of intense interest from the point of view of our present enquiry. *Sir Isumbras at the Ford* (1857) is the least successful and perhaps the most interesting of these works. It was greeted with a storm of abuse when it was exhibited at the Academy, and the abuse was directed not so much at its manifest compositional weaknesses as at the fact that it seemed to promise the spectator a narrative, and yet, when he examined it more closely, no narrative was to be found. *Sir Isumbras* is like a fragment of a dream; the context has vanished with sleep and darkness, and we are invited to supply our own.

The third major member of the Pre-Raphaelite Brotherhood, Dante Gabriel Rossetti, is the most important of the trio in our present story. English born, of Italian parents, Rossetti was a painter-poet, just as Blake had been. Indeed, it was he who pioneered a revival of interest in Blake's work, and there is no doubt that he was influenced by him. Like Blake, Rossetti suffered from very evident technical

32

41

weaknesses, though in his case these must be attributed to laziness and impatience rather than to lack of opportunity. The other-worldly air
33 of a painting such as the *Ecce Ancilla Domini* of 1850, one of Rossetti's earliest works, is due as much to the artist's incompetence in handling perspective as to any deliberate intention.

But Rossetti was at least conscious of what was lacking, and in the mid and late 1850s he concentrated his efforts upon watercolours and drawings, which were not only less intractable technically, but had a less demanding tradition – at least from the point of view of an artist who was slowly discovering his own hostility to nineteenth-century Realism.

Among the most striking of these small-scale productions is *The*
34 *Wedding of St George* of 1857. Despite its small size, this is one of the best known of all Rossetti's works, thanks partly to his fellow Pre-Raphaelite James Smetham's description of it as being 'like a golden dim dream'. The feeling of visionary stillness and unreality which it conveys is indeed very striking. Critics have not been slow to point out that this feeling springs in large part from the artist's manipulation of space. The composition seems to be made up of a large number of little boxes or compartments, and these compartments provide violent contrasts of scale.

36 The unfinished *Dantis Amor* of 1859 shows a yet bolder approach. Here, Rossetti virtually abolishes all reference to space. The figure of Dante floats upon a field which is divided diagonally, like a heraldic shield. From one of the upper corners Christ looks down from the middle of the sun's gold rays; while from a lower corner Beatrice, her head encircled by the moon, looks up. This is symbolic representation in the fullest sense of the word.

Dantis Amor is a work of exceptionally radical character, even for Rossetti. But, by the time it was painted, he had already invented the formula which, with suitable variations, was to serve him for the rest of his career as an artist. We first encounter this new manner in the
35 *Bocca Baciata* of 1859 which was, in fact, Rossetti's first full-scale attempt at oil-painting since the *Ecce Ancilla Domini* of nine years previously. From this moment on, the twin themes of women and flowers began to dominate Rossetti's work.

These paintings, and especially the later ones, have tended to receive short shrift from the historians of Pre-Raphaelitism, who have found in them evidence of Rossetti's physical and psychological decline. It

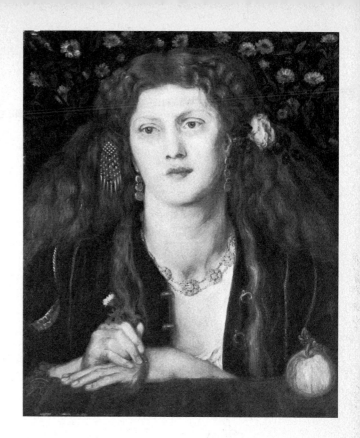

35 DANTE GABRIEL
ROSSETTI *Bocca Baciata*
1859

is, of course, true that they do not have the springtime freshness of the
work produced by the leading Pre-Raphaelites in the first half of the
1850s. But, for all that, they are interesting, and sometimes impressive.
The women whom Rossetti paints exist in a separate universe; they
have no precise location, either in space or in time. The *Astarte Syriaca* 37
of 1877, perhaps the grandest of the whole series, embodies a new
conception of woman – one which the French Symbolist poets and
painters were to render very familiar in the course of the succeeding
decade. The *femme fatale* who so much fascinated the men of the 1890s
is already embodied here with all her most characteristic attributes.
 From 1856, when the original Pre-Raphaelite Brotherhood began
to break up, Rossetti was closely associated, both personally and as an
artist, with two men whom he first met when they were both still
undergraduates at Oxford: William Morris and Edward Burne-Jones.

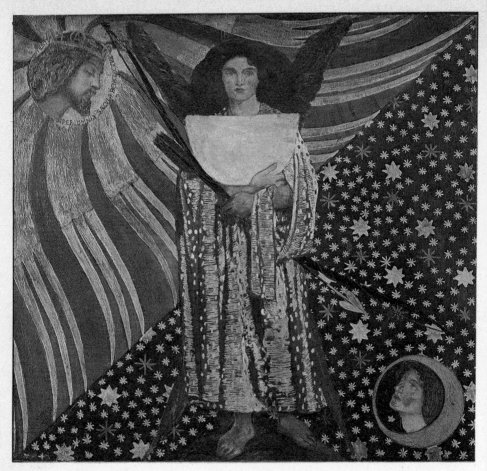

36 DANTE GABRIEL ROSSETTI *Dantis Amor* 1859

Morris was a good designer and a born organizer, but not, as it soon transpired, a born painter. To him fell the task of leading the revolt against nineteenth-century materialism in just those departments of life, such as the furnishing of middle-class homes, where its effects were most manifest. His impact on the applied arts was immense, and his work is one of the most important sources of the world-wide movement which, some decades later, was to be dubbed Art Nouveau.

Burne-Jones, on the other hand, is the outstanding painter associated with the second phase of Pre-Raphaelitism. Largely self-taught, he

44

37 DANTE GABRIEL ROSSETTI *Astarte Syriaca* 1877

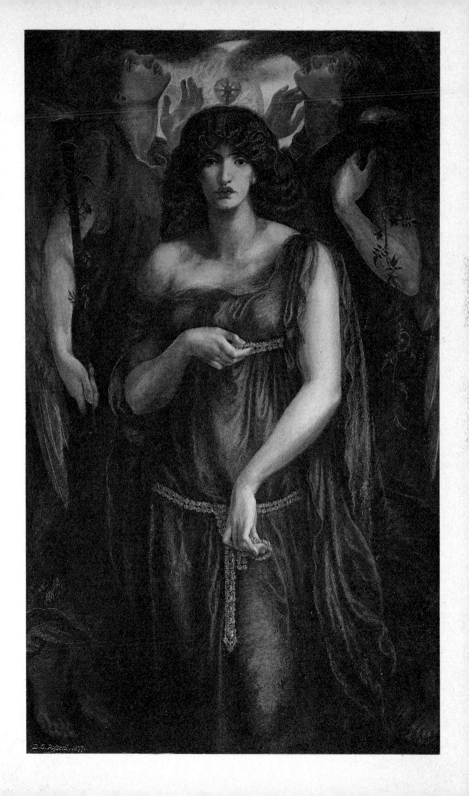

took the rather academic medievalism of the original Brotherhood and turned it into something new. In doing so, he often seemed to contradict Pre-Raphaelitism's most characteristic aims. There is, for example, a striking contrast between what Timothy Hilton has called the PRB's 'democratization of holiness' and Burne-Jones's treatment of a very wide range of mythological material, most of it not Christian. The French critic Robert de la Sizeranne well sums up the impression which Burne-Jones's work makes when he speaks of 'this impression of exquisite weariness and of elegant gaucherie, of complicated and slightly pessimistic psychology'. Burne-Jones was perhaps the first of the Victorian painters to address himself quite deliberately, and from the beginning of his career, to a restricted audience, those sensitive enough to receive the message which he wished to convey to them. Quite rightly, he became the hero of the Aesthetic Movement of the 1880s.

Burne-Jones's reputation was a plant of slow growth. It received an important impetus from the opening of the Grosvenor Gallery in 1877, which provided a place for those artists who were opposed to the Royal Academy to exhibit their work. On that occasion *Punch*, obviously aiming at Burne-Jones in particular, printed a parody of Tennyson's poem 'The Palace of Art'. One stanza ran:

The pictures – for the most part they were such
As more behold than buy –
The quaint, the queer, the mystic over-much,
The dismal and the dry.

It was only as late as 1885 that works by Burne-Jones began to fetch high prices at auction, and his fame was finally established by an invitation to exhibit at the Paris Universal Exhibition of 1889, where he was awarded a first-class medal, and by the exhibition of the *Briar Rose* series at Agnew's gallery in London in 1890.

For this reason, and also because of his very direct influence upon younger artists, both in England and abroad, it seems better to leave more detailed discussion of Burne-Jones's work to a later chapter. But it must always be remembered that, from the very beginning of the Symbolist Movement, artistic circles in Paris were well aware of Burne-Jones and what he was doing. He was one of the major creators of *fin de siècle* art.

The other English name mentioned with reverence in progressive

Parisian circles was that of George Frederick Watts. At this particular *38–40* point in time, Watts presents the art historian with a problem. Many of the great Victorian reputations in art are now being revived, but not his. Yet at the beginning of the present century Watts was not only well known in Paris; he was very celebrated in England as well. No praise was too high. It was G. K. Chesterton, for instance, who said of him that 'more than any other modern man, and much more than politicians who thundered on platforms or financiers who captured continents, [Watts] has sought in the midst of his quiet and hidden life to mirror his age'. For Chesterton, Watts's paintings were 'in a form beyond expression sad and splendid'.

Like Burne-Jones, Watts was self-taught; and, again like Burne-Jones, his reputation was of slow growth. He first exhibited at the Royal Academy in 1837, when he was only twenty, but did not become a regular exhibitor until some twenty years later. Meanwhile, he had won a first prize in the competition for the decoration of the Houses of Parliament in 1842, and another first prize in the second competition of 1846. In 1867, he was made successively an Associate and a full Member of the Royal Academy. However, he never became wholly identified with official art. He was closely connected with the Grosvenor Gallery from the moment of its foundation; and, widespread though his reputation became, he still retained the prestige of being an intellectual's artist. His great personal sympathy for the giants of Victorian literature – he painted portraits of most of them, and worshipped Tennyson in particular – evidently worked to his advantage in this.

Watts was quite clear about what he wanted to achieve as an artist. 'I paint ideas, not things,' he said. 'I paint primarily because I have something to say, and since the gift of eloquent language has been denied me, I use painting; my intention is not so much to paint pictures which shall please the eye, as to suggest great thoughts which shall speak to the imagination and to the heart and arouse all that is best and noblest in humanity.'

In his own lifetime, his admirers enthusiastically assented to the programme thus announced. One went so far as to suggest that his paintings were 'out of place in a popular exhibition', because they had 'a sacred character, and should be hung, like many of the religious works of the great masters of Italy, such as the frescoes of Fra Angelico, in some chapel of worship above the altar'.

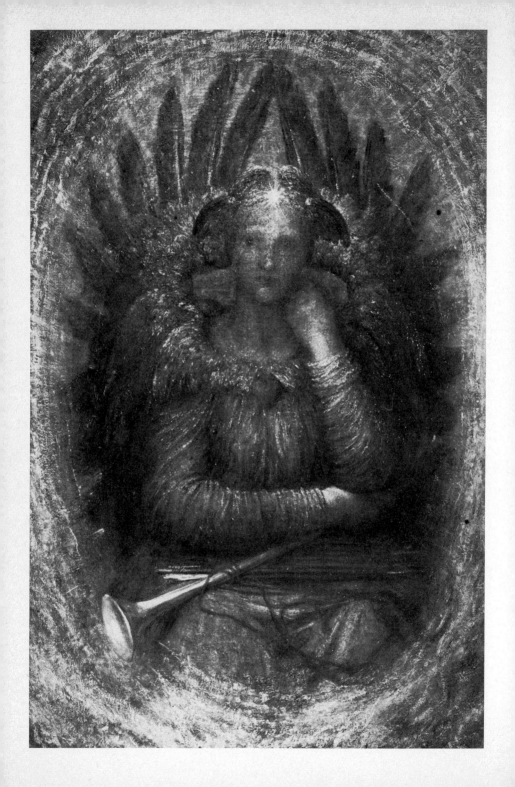

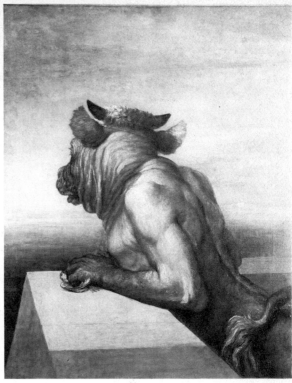

39 GEORGE FREDERICK WATTS
Love and Death 1887

40 GEORGE FREDERICK WATTS
The Minotaur c. 1877–86

It has sometimes been suggested that Watts's concentration upon the conventionally noble makes him a very different kind of artist from the true Symbolists. But, as we shall see, Symbolism took itself seriously enough. And there are many things about Watts's work which serve to link him very closely to the Symbolist Movement as it flourished upon the Continent. 'In the whole range of Watts's symbolic art,' remarks Chesterton, 'there is scarcely a single example of the ordinary and arbitrary current symbol. . . . A primeval vagueness and archaism hangs over all the canvases and cartoons, like frescoes from some prehistoric temple. There is nothing there but the eternal things, day and fire and the sea, and motherhood and the dead.' The last sentence quoted supplies an excellent list of typically Symbolist subject-matter.

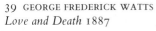

49

38 GEORGE FREDERICK WATTS *The Dweller in the Innermost* 1885–86

There is, too, Watts's use of colour, whose 'curious lustre or glitter, conveyed chiefly by a singular and individual brushwork', Chesterton much admired. Hugh MacMillan, another contemporary admirer, notes that Watts 'surrounds his ideal forms with a misty or cloudy atmosphere for the purpose of showing that they are visionary or ideal'. MacMillan goes on: 'His colours, like the colour of the veils of the ancient tabernacle, like the hues of the jewelled walls of the New Jerusalem, are invested with a parabolic significance. . . . To the commonest hues he gives a tone beyond their ordinary power.'

Turning from the fulsome tributes of Watts's contemporaries to his pictures as they have come down to us, what do we discover? It is true that it is difficult to accept their enthusiasm for his powers as a colourist. Watts was an enthusiast for Titian; but, put beside the work of the great Venetians, his paintings seem dimmed and tarnished. But there is, nevertheless, a sustained effort to put complex ideas into *40* worthy pictorial form. *The Minotaur,* for instance, is a characteristic-ally oblique tribute to the journalist W. T. Stead. Watts had been much struck by Stead's notorious 'The Maiden Tribute of Modern Babylon', which exposed the facts about London prostitution.

38, 39 More typical of Watts's work taken as a whole are compositions such as *The Dweller in the Innermost* and *Love and Death.* For all their overblown softness, they do something to support MacMillan's contention that 'Watts is essentially the seer. He thinks in pictures that come before the inward eye spontaneously and assume a definite form almost without any effort of consciousness.'

The fact that the three major Late Victorian painters whom I have just been discussing – Rossetti, Burne-Jones and Watts – did not receive the support of an English literary movement as sharply defined in its character as Symbolism was to be in France should not prevent us from recognizing their importance to any history of Symbolist art. It was they, as much as Gustave Moreau, who pioneered a new approach to painting. The work of art was placed in a new relationship to the spectator, 'giving no message at all to one, an inadequate conception to another, the full significance of the artist's own mind to a third, and telling their story to all, without any help or interpretation from the painter, as would be the case if he were dead'.

The Symbolist Movement in France

Despite a recent renewal of interest in the Symbolist and idealist art of the nineteenth century, there has been a tendency to misunderstand its development in one important respect. Strenuous efforts have been made to identify the origins of the new approach to the plastic arts which grew up in the second half of the century with the birth of the Symbolist Movement, which in its strictest definition is a literary phenomenon. The fact, however, is that the literary Symbolists, when they at last achieved an identity of their own by bringing together ideas which had existed in a state of potentiality for some years previously, also looked about for artists who seemed to echo and to justify their own announced programme in another field of creative activity. The best-known example of this is J. K. Huysmans's discovery of the work of Gustave Moreau and Odilon Redon, and the use which he made of it in his novel *A Rebours* (*Against Nature*), published in 1884. Gauguin was also to be taken up in this way, at a slightly later date, after the Café Volpini exhibition of 1889.

Huysmans is a crucial figure in another respect. One cannot discuss literary Symbolism without also discussing the notion of Decadence, which is so powerfully exemplified in *A Rebours*, and also in Huysmans's next novel, *Là-bas* (*Down There*), in which he explored the half-world of fashionable Satanism. After his conversion to orthodox Catholicism, Huysmans was to claim: 'It was through a glimpse of the supernatural of evil that I first obtained insight into the supernatural of good. The one derived from the other.' Many Symbolist writers were later to try and avoid the issue of morality altogether, on the grounds that moralism had been one of the characteristic vices of the earlier part of their century. But the movement was born in the later 1880s from a moral upheaval as well as an intellectual one.

Decadence was not a mere renewal of the Byronic obsession with the 'great, bad man', the spoilt hero who is somehow superior to his unflawed counterpart; nor was it simply a perverse revival of the early Romantic fascination with death and suffering. Decadence

41

involved a renunciation of the idea of progress, spiritual as well as material, which had sustained intellectuals ever since the eighteenth century. This idea was particularly widespread and powerful at the period when Huysmans published his two most influential books, as it formed the very centre of the prevalent mood of scientific rationalism.

88 The Satanism of *Là-bas* was, in a general sense, at the root of the Symbolist interest in the occult and the hermetic. Joséphin Péladan, the most picturesque of Symbolist propagandists, and author of *Le Vice suprême*, a novel replete with Decadent elements which was published in the same year as *A Rebours*, was just as heavily involved with the occult sciences as Huysmans himself. Indeed, there was a period when they found themselves on opposite sides in a magical conflict which both seem to have taken very seriously. Péladan, like other Symbolists, never quite achieved Huysmans's later Christian orthodoxy.

Hand in hand with this interest in the spiritually 'special', in occult knowledge communicated to only a few privileged beings, went a less rarefied intellectual (and even on occasion social) snobbery which the

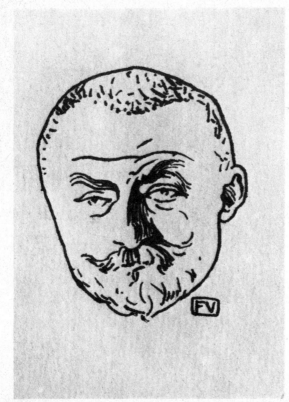

41 FÉLIX
VALLOTTON
J. K. Huysmans

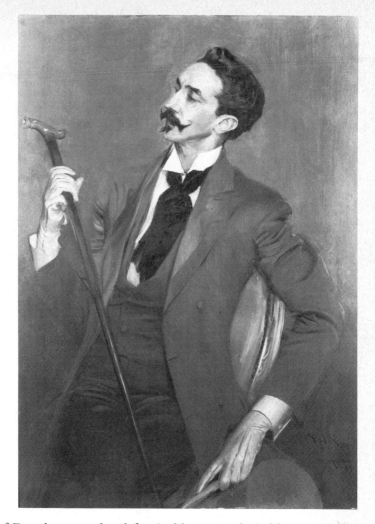

42 GIOVANNI
BOLDINI
*Count Robert de
Montesquiou* 1897

perverse notion of Decadence rendered forgivable, even admirable, in the eyes of its practitioners. The reviews, such as the celebrated *Revue blanche*, played an outstanding part in the history of the Symbolist Movement, and were always distinguished by their air of exclusiveness. The cult of the dandy, already espoused by Baudelaire, enjoyed a revival, and produced more than one exotic personage – the most exotic of all being Count Robert de Montesquiou, who, after having served Huysmans as the principal model for des Esseintes, the hero of *A Rebours*, was later to be Proust's original for the Baron de Charlus. *42*

The fact that Decadence, dandyism and snobbery can often be defined in terms of refusals, either to participate in some event or to acknowledge some individual, calls attention to the generally negative aspects of the Symbolist emotional climate. Symbolism was a way of saying 'no' to a number of things which were contemporary with itself. In particular, it was a reaction not only against moralism and rationalism but also against the crass materialism which prevailed in the 1880s; in the more narrowly literary sense it was a protest against the oppressive doctrines of Naturalism, represented by a novelist such as Zola; while from the political point of view it could be seen as a belated reaction to the crushing defeat suffered by France in the Franco-Prussian War, and the civil strife of the Commune which followed it. But, paradoxically enough, this dandified revolt against materialism, this retreat into the ivory tower – witness Mallarmé's dictum: 'Let the masses read works on morality, but for heaven's sake do not give them our poetry to spoil' – could also lead straight to Socialism. Disgust with the corrupt politics of the time eventually drove many Symbolists towards the left. The combination of Symbolism and Socialism was, however, commoner in Holland and Belgium than it was in France.

General currency was first given to the word 'Symbolism' itself not by Huysmans, or even by Péladan, but by the comparatively minor poet Jean Moréas, in a manifesto which appeared in *Le Figaro* on 18 September 1886. Conventionally reckoned, the first phase of literary Symbolism lasts from that date until 1891, when Moréas renounced the movement he had founded in favour of something more chastened and more classical which he dubbed 'Romanism'. It never caught on. Symbolism persisted until well into the 1890s.

43–45 The central figure was not Moréas, but the poet Stéphane Mallarmé. If the honour of being the first truly modern poet is in dispute between Baudelaire and Rimbaud, there can be no doubt that Mallarmé, by his poetic procedures, laid the foundations of Modernist attitudes towards the arts. His originality as a poet lay in his fascination with the mystery of language. 'To *name* an object', so he declared, 'is to suppress three-quarters of the enjoyment to be found in the poem, which consists in the pleasure of discovering things little by little: *suggestion*, that is the dream.' Since the word itself was a concrete experience to Mallarmé, the poem became a parallel universe composed of these experiences. He excludes reality because it spoils the

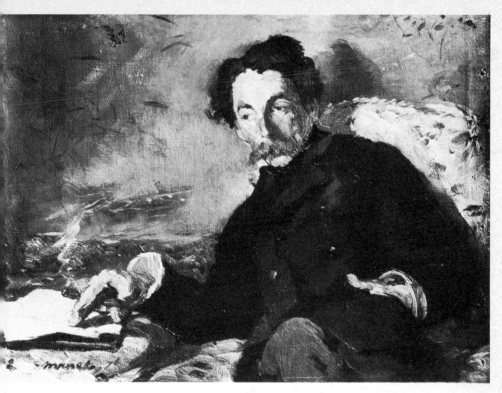

43 ÉDOUARD MANET *Stéphane Mallarmé* 1876

mystery he is at pains to create. He puts words in situations, gram-
matical and associational, which are contrary to their expected
context, and which endow them (so he hopes) with both purity and
power.

In Mallarmé's poetry we find the qualities which all true Symbolists
were later in some measure to claim as their own: deliberate
ambiguity; hermeticism; the feeling for the symbol as a catalyst
(something which, while itself remaining unchanged, generates a
reaction in the psyche); the notion that art exists alongside the real
world rather than in the midst of it; and the preference for synthesis as
opposed to analysis. Synthesis is a particularly important Symbolist
concept: it involves an effort to combine elements found in the real
world, or even borrowed from other works of art, to produce a
separate, different, and certainly self-sufficient reality.

As well as being the most powerful stylistic and theoretical influence available to younger Symbolist writers, Mallarmé also provided a personal focus for the movement, with his receptions every Tuesday at his flat in the rue de Rome. Everybody who was anybody in Symbolist circles attended them. But, as far as the visual arts were concerned, Mallarmé's sympathies were not by any means exclusively directed towards those who professed doctrines akin to those which he himself professed in literature. He was friendly with Whistler and Redon, as we shall see; and he knew Gauguin and Edvard Munch. His closest friendship with a painter was, nevertheless, undoubtedly that which he formed with Edouard Manet, one of the founders of Impressionism. Manet's portrait of Mallarmé is subtler and more intimate than the likenesses made by Munch and Gauguin, though both of these are striking examples of the 'subjective' interpretation of character.

43
44, 45

If Mallarmé had an intellectual, as well as a temperamental, link with Manet, it was probably to be found in the fact that they both subscribed to the doctrine of 'art for art's sake', though not perhaps in

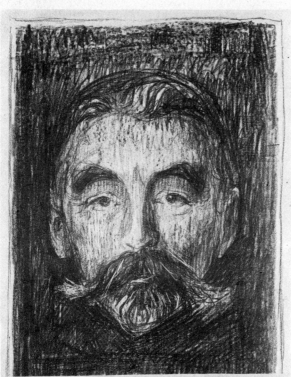

44 EDVARD MUNCH
Stéphane Mallarmé
1896

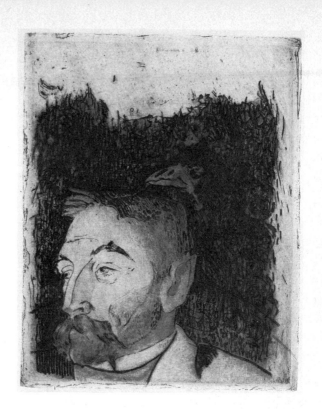

45 PAUL GAUGUIN
Stéphane Mallarmé

the rigid form in which it was inherited by later Symbolists. For
Mallarmé 'art for art's sake' meant a belief in the work of art as a
parallel universe, which did not have to provide an interpretation of,
or comment upon, the world of everyday experience. For Manet,
things were simpler. What he wanted was freedom from the tyranny
of 'subject-matter' as the Salon painters understood it. It was Whistler
who seized upon Manet's ideas and turned them into aesthetic
doctrine, but it was Manet himself who made the initial rejection of
prevalent attitudes.

Another writer of cardinal importance to literary Symbolism was
Paul Verlaine. In the 1880s, Verlaine was gradually returning to the 46
Parisian milieu, which he had deserted after the scandal of his homo-
sexual liasion with Rimbaud, and his subsequent imprisonment in
Belgium. His picturesque and sordid life-history made him highly
acceptable to the Decadents, and the effect was reinforced by his
series of essays *Les Poètes maudits* ('The Accursed Poets'), among

whom he included both Mallarmé and himself. His poetry, too, had a contribution to make, in its frequent reliance upon suggestive rather than specific conjunctions of words and phrases. Some poems, however, are specific enough, among them the famous *Art poétique*, written in 1874, during his imprisonment at Mons, and first published in 1882. It is a Symbolist manifesto more compressed, more memorable, and more effective than anything penned by Moréas:

> *Car nous voulons la Nuance encor,*
> *Pas la Couleur, rien que la nuance!*
> *Oh! la nuance seule fiance*
> *Le rêve au rêve et la flûte au cor!*

> 'For we wish for the Nuance still,
> Not Colour, only the nuance!
> Oh! only the nuance marries
> Dream to dream, and the flute to the horn!'

At the same time, it must be admitted that Verlaine seems to have found the adoration of his new generation of followers slightly comic, as well as flattering. In conversation he referred to them as 'Les Cymbalistes', a term which delighted Gauguin, who also found himself taken up with humourless enthusiasm by Symbolist intellectuals.

If men of genius, such as Mallarmé and Verlaine, supplied literary Symbolism with inspiration, the movement as such was elaborated by writers of lesser talent. Typical were men such as Gustave Kahn, the inventor of *vers libre*, and founder-editor of *La Vogue*, a review which (so he afterwards claimed) never had more than sixty-four subscribers; and Edouard Dujardin, editor of the *Revue indépendante* and co-editor of the *Revue Wagnérienne*. Dujardin was Mallarmé's most blindly enthusiastic follower, and the poet described him, with a touch of impatience, as 'the offspring of an old sea-dog and a Brittany cow'. The society-painter Jacques-Emile Blanche, who also knew Dujardin, gleefully reports in his memoirs that the one-time Symbolist ended up as 'a follower of Lenin'.

One field in which the literary intellectuals affiliated to Symbolism exercised a good deal of influence was that of art-criticism. They defended the painters and sculptors who seemed to work in accordance with their own principles, and brought them to public notice. Any artist they took up was assured of a small but vociferous claque.

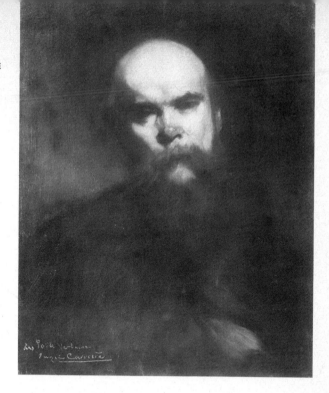

46 EUGÈNE CARRIÈRE
Paul Verlaine
c. 1896

The clearest statement of Symbolist doctrine, as applied to the plastic arts, is to be found in Albert Aurier's article on Gauguin, which appeared in the *Mercure de France* in 1891. Aurier felt that the work of art should be:

1. *Ideative*, since its sole aim should be the expression of the Idea;
2. *Symbolist*, since it must express this idea in forms;
3. *Synthetic*, since it will express those forms and signs in a way that is generally comprehensible;
4. *Subjective*, since the object will never be considered merely as an object, but as the indication of an idea perceived by the subject;
5. (in consequence) *Decorative*, since decorative painting, properly speaking, such as it was conceived by the Egyptians, very probably by the Greeks and the Primitives, is nothing other than an art at once synthetic, symbolist and ideative.

These precepts of Aurier's, though derived from Gauguin's work, and designed to create a place for Gauguin in the Symbolist pantheon, serve as a guide to all Symbolist art.

59

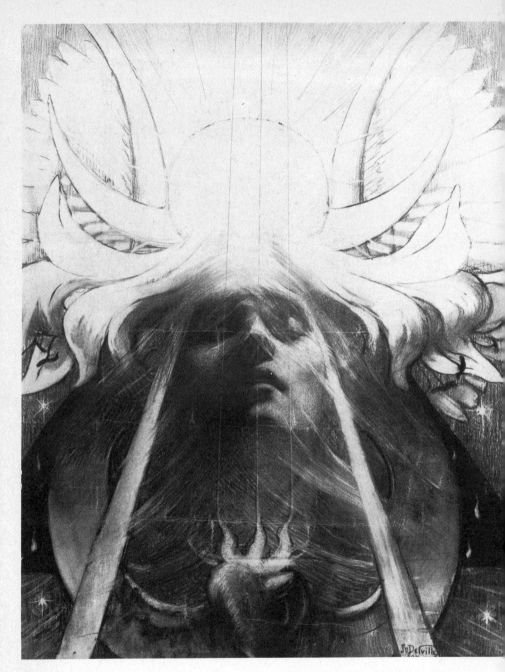

60

In a general sense, Symbolist syntheticism made it both possible and acceptable for one art to borrow ideas and concepts from another, for all arts aspired to be one art. Both literature and painting, for example, were changed and enriched by the contemporary passion for Wagner. Allusions to Wagner's operas are to be discovered again and again in Symbolist art. At the same time, there was a general tendency for any conflict between the artist and the writer to be resolved through an appeal to the values of music. I have spoken of the way in which eighteenth-century Venetian artists tended, when exploring the notion of the *capriccio*, to adopt attitudes which were close to those of the virtuoso musicians of their own period. So too, Symbolist artists often seem to aspire towards a musical method of organizing a composition, where images serve the same purpose as Wagner's *Leitmotive*. We may even go so far as to say that, while the connection between Symbolist artists and the Symbolist literary movement was usually a matter of ideas shared, or borrowed quite deliberately from literature by the plastic arts, the sympathy between Symbolist artists and contemporary musicians was deep-rooted and instinctive.

47, 48

47 JEAN DELVILLE
Parsifal 1890

48 AUBREY
BEARDSLEY
The Wagnerites
(*Tristan and Isolde*)
1894

Gustave Moreau

Gustave Moreau must be the central figure in any discussion of Symbolist art. In comparison with his contemporaries, Moreau emerges as an artist of a very special and distinctive kind. As Mario Praz points out, in *The Romantic Agony*, 'Moreau followed the example of Wagner's music, composing his pictures in the style of symphonic poems, loading them with significant accessories in which the principal theme was echoed, until the subject yielded the last drop of its symbolic sap.' We may also apply to Moreau's work a comment made by the American critic Victor Brombert on Flaubert's *Salammbô*: he remarks on the 'immobilization of life and animation of the inanimate' to be found in that work: 'As a result of this double tendency . . . the distinction between the organic and the inorganic vanishes, and *being* and *becoming* tend to merge.'

Moreau was an advocate of two linked principles – those of the Beauty of Inertia and of the Necessity of Richness. He himself remarked: 'One must only love, dream a little, and refuse to be satisfied, under pretext of simplicity, where a work of the imagination is concerned, with a simple, boring ba-bo-boo.' Like that of Burne-Jones, Moreau's rise to fame was a gradual one, and, despite the eminence of his admirers, and the vocal nature of their enthusiasm, he has always remained something of a special taste.

His earliest work shows the very pronounced influence of Delacroix; and in 1850 he met and was much influenced by Chassériau, whose taste for spangled, jewelled colour had a great influence on the formation of Moreau's style. In 1856 he followed a long-established tradition among French artists by making a visit to Italy. He remained there for four years, and was especially attracted by the Primitive painters, and by archaic vases, early mosaics and Byzantine enamels. In 1864, he made his first real impact in the official Salon with his *Oedipus*. Already his work was gaining a reputation for being eccentric and odd; one commentator said it was 'like a pastiche of Mantegna created by a German student who relaxes from his painting by reading Schopenhauer'.

49 GUSTAVE MOREAU *Mystic Flower*

He was savagely attacked by the critics for the works which he sent to the Salon of 1869, and after this tended to withdraw more and more from the rat-race of official art. He was represented in the Salon of 1872, for example, and then not until that of 1876. After 1880, he no longer exhibited.

It was, however, at the Salon of 1880 that Moreau seems to have attracted the attention of J. K. Huysmans, then a moderately well-known naturalistic novelist whom most people classified as a disciple of Zola. In his account of the exhibition, Huysmans reserved the best of his enthusiasm for Moreau's work. 'M. Gustave Moreau', he said, 'is a unique, an extraordinary artist. . . . After having been haunted by Mantegna, and by Leonardo whose princesses move through mysterious landscapes of black and blue, M. Moreau has been seized by an enthusiasm for the hieratic arts of India; and, from the two currents of Italian art and Hindu art, he has, spurred forward too by the feverish hues of Delacroix, disengaged an art which is peculiarly his own, created an art which is personal and new, whose disquieting flavour is at first disconcerting.' This was, in fact, the first trumpet-blast of Symbolist enthusiasm, and Moreau's special position in the Symbolist pantheon was to be confirmed when, four years later, Huysmans included descriptions of his work in *A Rebours*.

In the 1880s and 1890s, after his withdrawal from the Salons, Moreau also achieved, paradoxically enough, a certain degree of official recognition. He had been given the Legion of Honour in 1875; in 1883 he was given the *croix de l'officier*; in 1889 he became a Member of the Institute, and in 1892 he was made a *chef d'atelier*, a professor with a studio of his own at the Ecole des Beaux-Arts. This last appointment was something more than an empty honour. The reclusive Moreau turned out to be a teacher of genius, and among those who passed through his hands were Matisse and Rouault. (Rouault was later to be the Curator of the Musée Gustave Moreau.)

In writing about Moreau's work in *A Rebours*, Huysmans naturally selected those aspects of it to which he felt most akin by temperament, and which best suited his own artistic purposes. Des Esseintes – and by implication Huysmans himself – saw Moreau as the creator of 'disquieting and sinister allegories made more to the point by the uneasy perceptions of an altogether modern neurosis', as someone 'forever sorrowful, haunted by the symbols of superhuman perversities and superhuman loves'. What fascinated des Esseintes/Huysmans was

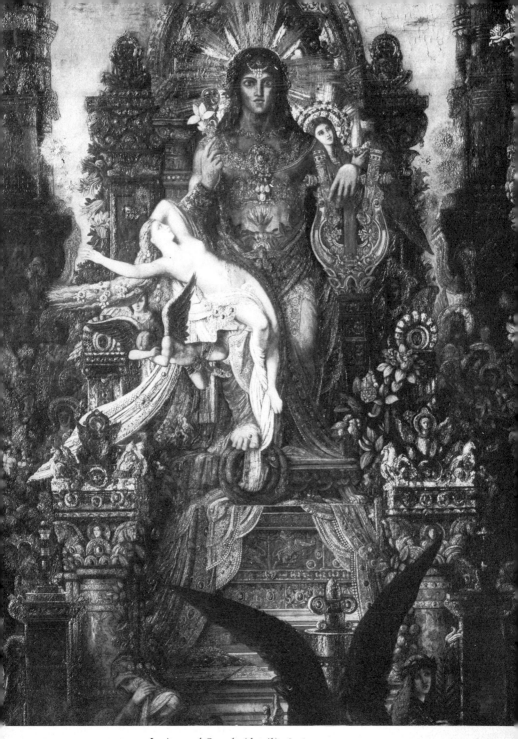

50 GUSTAVE MOREAU *Jupiter and Semele (detail)* 1896

Moreau's treatment of the Salome theme; a watercolour version of *The Apparition*, in which the severed head of the Baptist appears in a vision to the young Judaean princess, is the subject of pages of ecstatic description in *A Rebours*.

Moreau cannot altogether have appreciated this kind of attention. He always much resented the idea that he was a literary painter. In his own mind he was quite the opposite. His own notes are enlightening on this score. 'Oh noble poetry of living and impassioned silence!' he wrote. 'How admirable is that art which, under a material envelope, mirror of physical beauty, reflects also the movements of the soul, of the spirit, of the heart and the imagination, and responds to those divine necessities felt by humanity throughout the ages. It is the language of God! . . . To this eloquence, whose character, nature and power have up to now resisted definition, I have given all my care, all my efforts: the evocation of thought through line, arabesque, and the means open to the plastic arts – that has been my aim!'

Each work was based upon an elaborate programme. Of his *Jupiter and Semele*, for example, Moreau noted: 'It is an ascent towards superior spheres, a rising up of purified beings towards the Divine – terrestrial death and apotheosis in Immortality. The great Mystery completes itself, the whole of nature is impregnated with the ideal and the divine, everything is transformed.'

How far did the artist succeed in fulfilling his own programme? That he *is* literary, scarcely anyone would now doubt. He has, in fact, been seen as the direct successor of the Flaubert who created not only *Salammbô* but *La Tentation de saint Antoine*. The swarming visionary detail of the latter work seems particularly close in spirit to Moreau's paintings.

Detail, indeed, was a kind of trap to Moreau. The conception of his works gave him no difficulty; the elaboration frequently did. He was a genuinely visionary artist in that his first idea seems to have presented itself to his mind's eye complete in all its main outlines. It was when he tried to fill in these outlines, using material taken direct from nature, or even from other works of art, that he ran into trouble, as Théophile Gautier noted. Moreau's earliest sketch for a composition often comes closer to the final version than any intermediate stage.

But swarming detail was also a form of personal reticence. Odilon Redon, always shrewd in his comments on other artists, said of Moreau: 'We know nothing of his inner life. It remains veiled by an

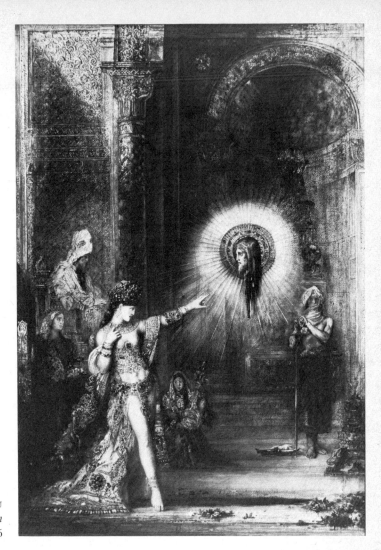

51 GUSTAVE MOREAU
The Apparition
1876

art which is essentially worldly, and the beings evoked have laid aside instinctive sincerity. Will these beings step out of the picture in order to act? No.'

At the same time we must concede his power to fire men's imaginations. Huysmans was inspired by him; the Sâr Péladan worshipped him despite the fact that Moreau was deeply suspicious of Rosicrucian hocus-pocus. Later, André Breton, pope of the Surrealist Movement,

was to haunt the Musée Gustave Moreau at a time when scarcely anybody else bothered to visit it. Looking at a work such as the *Mystic Flower*, with its tumescent forms, it is easy to understand Breton's fascination with a painter who seems to have been very much the prisoner of his own unconscious.

Particularly influential, so far as the artists of Moreau's own time were concerned, was the languid androgynous type with which he peopled his compositions. The Neoplatonic idea of the androgyne was to exercise a powerful fascination over late nineteenth-century critics and aestheticians, but it was Moreau who gave form to this idea in paint upon canvas.

But there was more to it than this. In Moreau, it is above all the male who is languid and doomed to destruction. The poets who appear often in his compositions are frail, passive creatures; in *The Suitors*, we witness the massacre of beautiful effeminates – our sympathy goes out to them, rather than to Ulysses, whose house they have invaded.

52 GUSTAVE MOREAU *Wayfaring Poet* 53 GUSTAVE MOREAU *Fairy with Griffon*

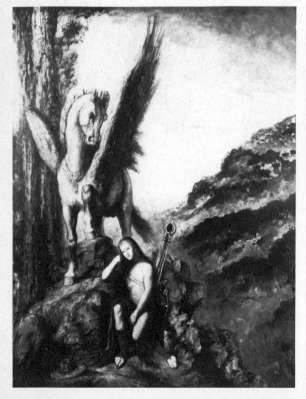

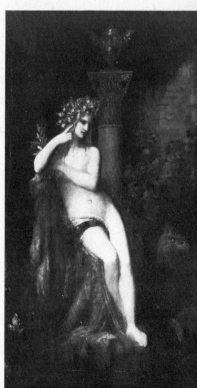

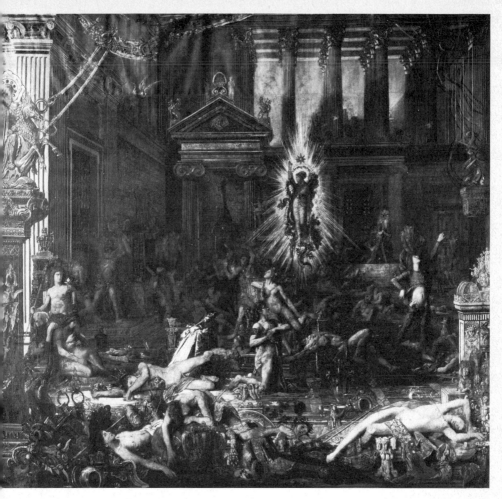

54 GUSTAVE MOREAU *The Suitors* 1852

Moreau's women, on the other hand, even if not active destroyers,
like Salome, are beings whom it would be unwise to offend. His
fairies, for instance, are never the frail, fluttering creatures of early
Romanticism, but personages who are both powerful and, for all their
beauty, sinister. They seem, like much of his other imagery, to be part
of a powerfully imaginative celebration of male fears of castration
and impotence.

53

69

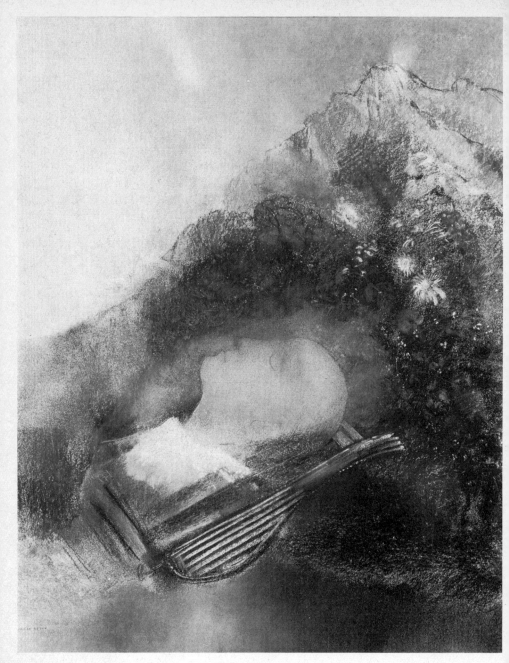

55 ODILON REDON *Orpheus c.* 1913–16

Redon and Bresdin

Besides Moreau, Huysmans's des Esseintes admitted two other contemporary artists to his house. These were Rodolphe Bresdin and Odilon Redon. Since Bresdin, who was the lesser artist, exercised an important influence upon Redon at the beginning of the latter's career, it is convenient to speak of them together.

Redon was born in Bordeaux. His father, who was also a native of that place, had made a fortune in Louisiana, and had then returned there to settle down. Redon himself seems to have been neglected by his parents, and was brought up on a family estate outside the city, under the charge of an old uncle. This estate, which was called Peyreblade, was to haunt the artist's imagination.

He early showed a talent for drawing. His first instructor was a man called Stanislas Gorin, who was in turn a pupil of the Romantic painter Isabey. Living in the Bordeaux region, Redon was quite well placed to see works by the leading contemporary masters. At the annual exhibitions of the Société des Amis des Arts he encountered paintings by Millet, Corot and Delacroix, and even early ones by Gustave Moreau. It was Delacroix whom he worshipped. Standing before his works, he felt 'tremors and fevers'.

In due course, Redon went to Paris, where he studied in the studio of the academic painter Gérôme. The conjunction of the two personalities was not a happy one. Redon was to say later, 'I was tortured by the professor.' He soon left, and it was clear that he would have to find some other means of forming himself as an artist.

Returning to Bordeaux, he encountered Bresdin, who lived and worked in the city from 1862 onwards. Bresdin, together with Moreau, was one of the very few artists to stand out against the fast-flowing tide of Naturalism in France during the 1860s and 1870s (the 1870s, in particular, were the great decade of Impressionism).

Bresdin was a solitary and somewhat eccentric individual. His physical aspect was that of a peasant; Redon describes him as 'a man of middle height, thickset and powerful, with short arms', but also with 'beautiful fine hands'. He had 'a strange nature, fantastic, childish,

71

brusque and good-humoured; suddenly withdrawing, suddenly open and jolly'. Nevertheless, Redon got on with him, as he had failed to do with Gérôme.

Bresdin was not a painter but a printmaker, with a weird, complicated, sinister imagination. Des Esseintes especially admired two compositions, which remain Bresdin's best known: *The Comedy of Death* and *The Good Samaritan*. One cannot do better than quote Huysmans's description of the former: 'In an unlikely-looking landscape, bristling with trees, coppices and clumps of vegetation, all taking on the forms of demons and phantoms, and covered with birds with the heads of rats and tails made of bean-pods, upon a terrain scattered with vertebrae, rib-bones and skulls, some willows rise, surmounted by skeletons who are waving a bouquet with their arms in the air, while Christ flees away through a dappled sky, and a hermit with his head in his hands meditates in the depths of a grotto, and an unfortunate lies dying, worn out by privations, with his feet before a pond.'

Bresdin seems to des Esseintes, and to des Esseintes's creator, 'a vague Dürer', with a brain 'clouded with opium'. But it is also possible to recognize in these plates, and in other works by the same artist, the freedom enjoyed in the nineteenth century by the graphic arts, as opposed to painting and sculpture. The caricaturists had long ago established the fact that a printmaker might take liberties with appearances which were not permitted to a painter, and, in addition to this, a kind of equivalence seems to have been established between making a print and printing a book. Visual symbols, on paper, on this sort of scale, were not so far off from being words.

Redon's decision, evidently at least in part the result of Bresdin's influence, to confine himself to black and white, and to prints and drawings, therefore opened up to him a whole range of possibilities which it would have been more difficult to explore as a painter. Redon asserted that he used lithography 'with the sole aim of producing in the spectator a sort of diffuse and dominating attraction in the dark world of the *indeterminate*'. Appropriately enough, his first lithographic album, which was published in 1879, bore the title *In Dreams*.

There has been some dispute as to whether Redon was, at this stage of his career, an illustrator. It seems rather that he should be thought of as a transposer of the images which he found in books. One book in particular seduced him: Flaubert's *Tentation de saint Antoine*, which

72

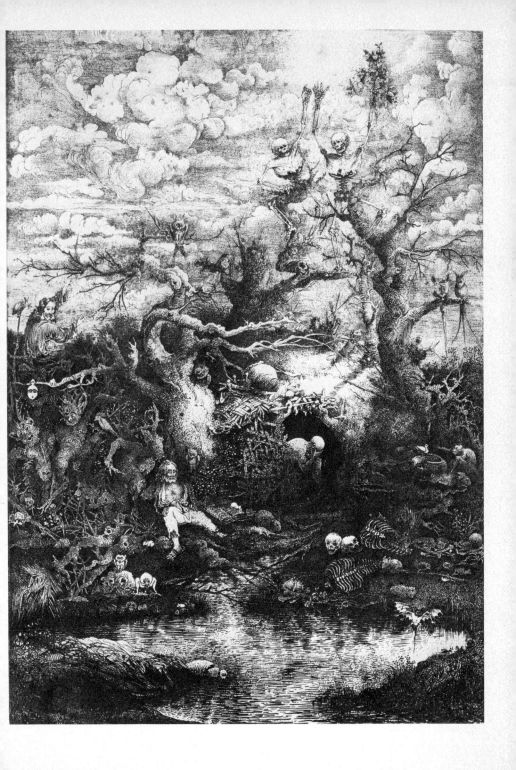

he first read in 1881. What particularly attracted him was 'the descriptive part of this work . . . the relief and colour of all these resurrections of the past'. He was to devote several lithographic albums to working out his personal relationship with what he found in Flaubert's pages.

During the 1880s, Redon's reputation slowly began to grow, but not upon anything like the scale of Moreau's. He appealed chiefly to a restricted circle of intellectuals. Huysmans was an early enthusiast; he first saw Redon's work in 1880, at the artist's first independent show at the offices of the review *La Vie moderne*. Mallarmé was introduced to Redon a little later, in 1883, and the two men became fast friends. When Redon sent Mallarmé his portfolio *Homage to Goya*, the latter wrote to him apropos of the first plate in the series: 'In my dream I saw a face of mystery. . . . I know no other design which communicates so much intellectual fear and frightful sympathy as this grandiose visage.'

Despite these distinguished admirers, it was in Belgium and Holland that Redon's reputation was established. Brussels had always had the reputation of being more liberal and experimental than Paris, and the Symbolist Movement established itself strongly there, thanks in large part to the efforts of the artists and writers connected with Les XX. Redon exhibited under the auspices of this group, and was invited to supply frontispieces for three books by the great Belgian Symbolist poet Emile Verhaeren. These were published in 1888, 1889 and 1891.

Gradually Paris began to notice Redon, too. In 1886 he exhibited with the Impressionists, and by 1889 had entered into relations with Gauguin and Gauguin's young disciple Emile Bernard. At the same time, his art began to change: Redon began to discover the possibilities of colour. In the work executed during the first half of the 1890s, he returned obsessionally to a single theme, the head with closed eyes, lost in contemplation. This was followed by a briefer period during which the figure of Christ dominated his production. After 1900, he entered into a more objective phase, and undertook some decorative commissions – a few screens, work for the Gobelins. By 1903 it could be said that at long last Redon had arrived – he was given the Legion of Honour, and in 1904 a work of his was bought by the State for the Palais du Luxembourg, while the Salon d'Automne paid him a special tribute.

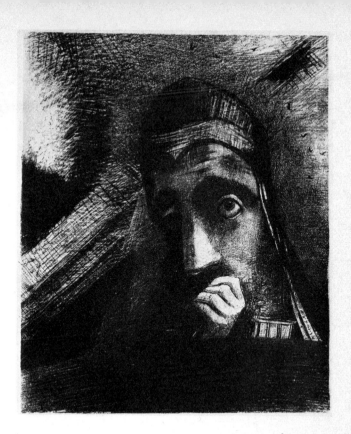

57 ODILON REDON
Homage to Goya
1885

One interesting feature of the later development of Redon's reputation was that criticism no longer associated him automatically with Moreau. His younger admirers began, instead, to link his name to that of Cézanne. Redon appears in Maurice Denis's large painting, *Homage to Cézanne*, which was painted in 1900. Meanwhile, English criticism had found another possible point of comparison. Writing about Redon in 1890, Arthur Symons referred to him as a kind of French Blake. Redon himself would probably have preferred to be likened to Turner – he was greatly impressed by Turner's work when he visited London in October 1895.

In his own estimation Redon was more genuinely ambitious than Moreau; he wanted to shake off the bonds which constricted the older artist. His advantage, which now appears very plainly, was that he had a subtler approach to the notion of 'mystery', so dear to all the Symbolists. 'The sense of mystery', he wrote, in his 'Notes to Himself',

'is a matter of being all the time amid the equivocal, in double and triple aspects, and hints of aspects (images within images), forms which are coming to birth, or which will come to birth according to the state of mind of the observer.'

Another point of difference between Redon and Moreau was their approach to the concept of nature. Both held it to be important. 'I am repelled', said Redon, 'by those who voice the word "nature", without having any trace of it in their hearts.' But he never interpreted fidelity to nature as rigidly as Moreau did: he never tried to cobble together his compositions from details observed in the external world. The collector Gustave Fayet, who was very friendly with Redon in his latter years, is the source of a revealing anecdote about Redon's methods of composition. Fayet entered the room in Redon's absence. The work in progress was *The Red Death*, a picture closely related to *The Green Death* which is illustrated here. And propped up against the

61

59 ODILON REDON
Head of a Martyr
1877

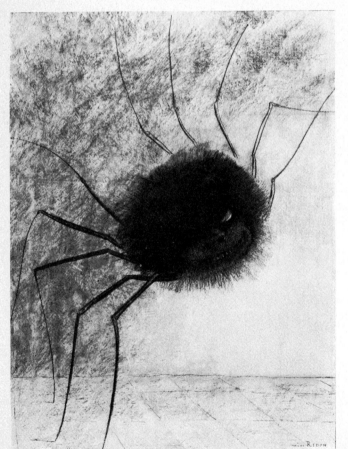

58 ODILON REDON
The Grinning Spider
1881

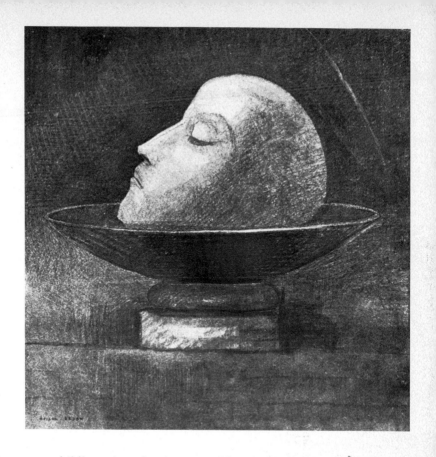

colour-box was a child's zoology book, open to show a crude illustra-
tion of a boa-constrictor. This was the source of the composition.

It would be unjust to conclude from this that Redon was naïve.
Even as far as science was concerned, the very opposite appears to
have been the case. Though a pillar of the Symbolist Movement,
Redon was clearly interested in the discoveries being made by scientific
materialism; many of the forms which appear in his compositions
seem to have been inspired by what could be seen with the aid of a
microscope. His invented creatures take on the forms of bacilli, or of
spermatozoa. Such an approach is perfectly in accord with the declara-
tion which the artist once made: 'All my originality consists . . . in
giving life in human fashion to beings which are impossible according
to the laws of possibility.' Everything was grist to his mill, including
the great Parisian zoological and botanical collections.

60 ODILON REDON *The Sun Chariot of Apollo with Four Horses c.* 1905

59

55, 60

If we look through Redon's work with this particular preoccupation in mind, we can discover most of the standard Symbolist properties – masks, snaky monsters, severed heads, *femmes fatales*, new interpretations of Classical mythology. But what matters is the very personal way in which they are interpreted. Redon claimed that he was constantly being surprised by his own art, while Maurice Denis, who admired his work greatly, declared that 'the lesson of Redon is his powerlessness to paint anything which is not representative of a state of soul, which does not express some depth of emotion, which does not translate an interior vision'. Of all the masters of Symbolist art, he is the most consistently convincing.

78

61 ODILON REDON *The Green Death c.* 1905–16

Puvis de Chavannes and Carrière

Pierre Puvis de Chavannes represents a very different aspect of Symbolism from the one illustrated in the works of Moreau and Redon. Essentially, Puvis wanted to give new life to the academic tradition; to restore to it its old seriousness and nobility of purpose. He appealed to those who wanted to follow modern ideas without losing touch with established orthodoxy. But his influence spread a good deal further than this; we find a debt to Puvis in quarters which might at first sight be unexpected. He is one of Gauguin's sources, and the Picasso of the Blue and Rose Periods also owes a good deal to him.

Puvis and Moreau were almost exact contemporaries; they were born within two years of one another, and died in the same year. In addition to this, their artistic formation was very similar. Yet they developed into artists who were different from each other in almost every respect.

As a young man, Puvis was prevented by illness from becoming an engineer or an army officer, as his father had wanted. He went to Italy to convalesce, and there his eyes were opened to art. He spent nearly a year in Florence, painting and drawing, returning to France in 1847. He then entered the studio of the painter Henri Scheffer, brother of the better-known Ary Scheffer, but soon left for Italy again. Later, he studied briefly under Delacroix, and spent three months with Couture, one of the most successful Salon painters of the time. Like Moreau, he was influenced by the short-lived Chassériau, whose mistress, the intelligent and sympathetic Princess Cantacuzène, he was later to marry.

But initially, it was Delacroix who prevailed. In 1850 Puvis showed a *Pietà* in the Salon which was almost a pastiche of the great Romantic master. He was not to make another appearance in the annual exhibition until 1859, when he sent in the Titianesque *Return from the Chase*. This was an announcement of his ambition to be a 'decorative' painter, on the scale, and very much in the manner, of the Old Masters whom he had learned to admire during his studies in Italy.

62 PIERRE PUVIS DE CHAVANNES *Meditation* 1869

To the Salon of 1861, he sent two large compositions, *Concordia* and *Bellum*, which reaffirmed the direction he had chosen. The paintings attracted a certain amount of attention, partly because of their size, but also because of their mannerisms. The simplified drawing, pale washed-out colour and frieze-like composition were individual and recognizable. Though *Concordia* was bought by the State, Puvis became a somewhat controversial figure. Despite his respect for Titian and now for Poussin, he had strayed a little outside the boundaries of the expected norm.

Nevertheless, Puvis continued to send in to the Salon, and his work continued to be hung there. In the late 1860s and in the 1870s he received a number of important official commissions, taking over the position which Delacroix himself had once occupied as the leading decorative painter in France. He began a series of decorations for the Panthéon in Paris in 1874, and laboured upon these for the succeeding four years. They brought him considerable success in the 1876 Salon.

Smaller, more personal works tended to be less well received. The 63 *Decollation of St John the Baptist*, which was exhibited in 1870, and which now seems one of the most vigorous and personal of Puvis's works, was widely attacked for what was regarded as the false naïvety of its drawing and composition.

Curiously enough, Huysmans, who exerted so great an influence upon the formation of a recognizably Symbolist taste in the visual 64 arts, was unenthusiastic about Puvis's work. Writing of *The Prodigal Son*, shown at the Salon of 1879, he said: 'One admires his efforts – one would like to applaud, then one rebels . . . it is always the same pale colouring, the same fresco-like air; it is always hard and angular; it annoys one, as always, with its pretensions to naïvety and its affected simplicity.'

Even harsher things were said by other writers. When *The Poor* 65 *Fisherman*, which now seems Puvis's masterpiece, made its appearance in the Salon of 1881, Auguste Balluffe spoke of: 'This fisherman who is neither fish, flesh, fowl nor good red herring, in the midst of a simulacrum of a painting, in an insinuation of a boat, drifting down a river which is absent. To put it bluntly, this canvas is a short-hand note of a sketch.' Paul Mantz called the same work 'a painting for Good Friday'.

Yet Puvis continued to make progress, both with the official establishment and with a new generation of young enthusiasts for his

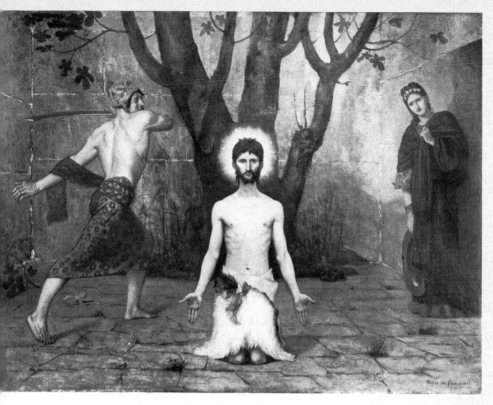

63 PIERRE PUVIS DE CHAVANNES *Decollation of St John the Baptist* 1869

work. In 1882, he was given a medal of honour at the Salon, while in 1884 a painting called *The Sacred Wood* (which was to have great influence on the Nabis) prompted the Symbolist critic and impresario Péladan to hail him as 'the greatest master of our time'.

The artist seems to have accepted official honours more complacently than he did the admiration of the Symbolists. He did his best to dis-associate himself from Péladan. When Mallarmé addressed a sonnet to him, Puvis dismissed it abruptly as 'an insanity', and said that he resented being thought of as the natural patron of such things.

Why, then, do Puvis and his work loom so large in the story of Symbolist art? In the first place, it was a matter of temperamental affinity. Puvis was melancholy by nature; he loved the half-light. On one occasion he wrote: 'I am . . . so miserable that the sun fatigues my

83

sight and troubles my soul, above all this autumn sun, which burns like one gone mad, but does not warm.' As early as 1861, we find him confessing to a friend; 'I have a weakness I scarcely dare to avow. [It] consists in preferring rather mournful aspects to all others, low skies, solitary plains, discreet in hue, where each tuft of grass plays its little tune to the indolent breath of the wind of midday. . . . I wait impatiently for the bad weather to come, and I am already negotiating with a seller of umbrellas. I assure you that bad weather has more life than good.'

Intellectually, as well as temperamentally, Puvis was attuned to Symbolist ideas, though he sometimes refused to recognize the fact. 'I wish', he said, 'to be, not Nature, but parallel to Nature.' Even a man such as Huysmans, who did not really like Puvis's work, was forced to recognize its relevance to his own way of thinking: 'Despite the revulsion which this painting arouses in me when I stand before it, I cannot prevent myself from feeling a certain attraction towards it when I am far away.'

64 PIERRE PUVIS DE CHAVANNES *The Prodigal Son c.* 1879

65 PIERRE PUVIS DE CHAVANNES *The Poor Fisherman* 1881

Today, the works by Puvis which seem to have survived the most successfully are those which bear out a remark made by the critic Castagnary: 'M. Puvis de Chavannes neither draws nor paints: he composes – that is his speciality.' When we look at the *Decollation of* 63 *St John*, for instance, what is striking about it is not the way in which it presents the subject, but the way in which the various figures are arranged within the rectangle. The single-figure compositions, such as *Hope* or *Meditation*, are particularly interesting in this respect, 62 because it is here that Puvis frees himself from the close-knit schemes of composition which he had inherited from Poussin, and, via Poussin, from Raphael. There is a deliberate awkwardness about the way in

85

which the figure is placed and posed which draws attention to its relationship to the shape which encloses it. In fact, there is in Puvis an urge towards abstraction which goes beyond the Symbolist catchphrase 'art for art's sake'.

The unnatural, chalky colouring also helps to make us aware of the abstract nature of Puvis's painting, since flesh and garment, earth and leaf, all seem made out of the same substance. In his concern for the unity of the picture-surface, Puvis is the real forerunner of Cézanne.

66 PIERRE PUVIS DE CHAVANNES *The Dream* 1883

There is another artist who, at first glance, seems linked to Puvis through a common mistrust of colour: Eugène Carrière. But the more intimately one studies the two of them, the more manifest become their differences. Carrière, though born near Paris, was brought up in Alsace, as the son of a country doctor. He therefore came from a milieu very remote from the sophisticated Parisian one in which Symbolism flourished. Nevertheless, there were artists in his immediate family. His grandfather had been a professional painter, and his great-uncle had been drawing-master at the *lycée* in Douai. At the age of nineteen, Carrière left Strasbourg for Saint-Quentin, and there, in the museum, he discovered the pastels of the great eighteenth-century portraitist Maurice Quentin de la Tour. This seems to have decided him in his vocation.

He served in the French Army in the disastrous Franco-Prussian War, and was made prisoner. Subsequently, he studied at the Ecole des Beaux-Arts. In 1877–78, he spent six months in London, where he, too, was impressed by Turner. It was not until 1879 that he appeared in the Salon, and even then he did not succeed in making much of an impression.

In fact, Carrière made the slow start typical of most of the leading Symbolist painters. His years of success began in the mid 1880s. In 1885, for example, he exhibited a painting called *The Sick Child* (a theme which was also to be treated by the great Norwegian painter Edvard Munch). This was purchased by the State, and also brought Carrière a medal. Four years later, in 1889, he was awarded a medal of honour, and decorated.

Unlike Puvis, Carrière has no inclination towards abstraction. The subject-matter of his paintings, which is usually confined within a very narrow range of possible situations, clearly meant a great deal to him. What obsessed him was family life, and particularly the relationship between mother and child. Domestic scenes had for him the force of archetypes, as he himself was well aware. He once remarked: 'I see other men within me, and find myself once more in them. What fascinates me, they value.' His approach was very much in line with certain aspects of the Symbolist aesthetic. We find him declaring: 'I do not know if reality is divided from the spirit, a gesture being a visible movement of the will. I have always thought of them as being united.'

Carrière's device of wrapping his figures in a kind of yellowish fog is symbolically intended, as Gustave Geffroy pointed out in a

87

perceptive essay; 'He feels the need to recapitulate, to make evident the essential aspect, and at the same time he reproduces this aspect in forms which are more and more ample, while enveloping these forms in a visible atmosphere which puts his canvas at a distance from the spectator, isolates it, locates it in another region from the gallery where it is exhibited.'

This 'visible atmosphere' did not please everyone, even when Carrière was at the very height of his reputation. Redon, for example, compared him to Greuze, not intending this to be altogether a compliment. In a note on Carrière's work written in 1906, Redon speaks of 'limbos . . . opaque limbos where pale, morbidly human faces float like seaweed: that is Carrière's painting. It does not have the flavour of solid reality, but remains in the muted regions of the first elaboration, which are favourable to visions, and never appears or flowers in the shining brightness of the solar prism.'

Redon's judgment of Carrière's work may have been the more acute because the two artists had certain things in common. Both of them made use of the idea of the unifying arabesque, the twisting line which binds the whole composition together, though Carrière employs it in rather sentimental fashion, to express the way in which emotion rises from the central personage in one of his family scenes, expands outwards towards others who are present, then flows back again to its source. And in 1895 Carrière broke away from his usual formula to make a series in which the form of a woman gradually arises from that of a flower or fruit. He seems to have been prompted to this experiment by a study of very much the kind of scientific material which also supplied inspiration to Redon. In a lecture entitled 'L'Homme visionnaire de la réalité', Carrière commented: 'An absolute synthesis of the world in a single creature is visible in every skeleton, which is a complete expression of true beauty.'

While Carrière the man remains a sympathetic figure – a good Socialist, an early Dreyfusard, a supporter of all the right causes – I find it harder to feel the same enthusiasm for Carrière the artist. His abundant *œuvre* is depressingly monotonous. Redon's wilful, mysterious and occasionally cruel world is infinitely more fascinating. Yet, if we omit Carrière from consideration when making a study of the Symbolists, we neglect an important aspect of the movement: he represents a revival and transformation of the cult of feeling inherited from Rousseau and the early Romantics.

88

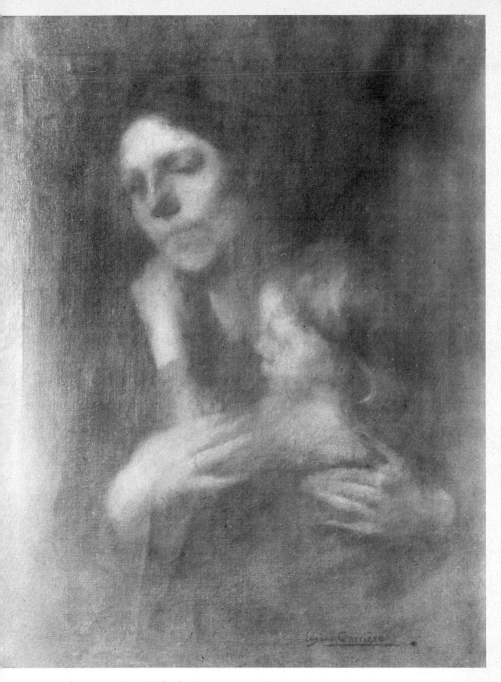

67 EUGÈNE CARRIÈRE *Motherhood*

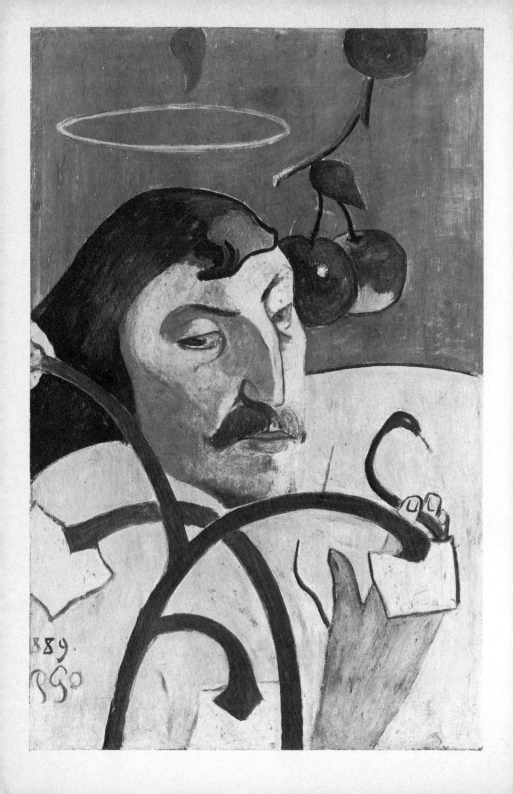

Gauguin, Pont-Aven and the Nabis

In the years 1889–90, Symbolist art found a new hero, in the person of Paul Gauguin. Characteristically, the painter, so abruptly elevated to 68 a pinnacle of intellectual if not financial esteem, scarcely knew what to make of the position which was now being accorded to him. Privately, he was a little inclined to mock his new admirers; yet at the same time he was grateful for their attention. He had had a long struggle to reach even this position.

It was in 1882 that Gauguin at last decided to become a full-time painter. He had long been a Sunday painter – a work of his had been accepted by the Salon in 1876, and he had appeared in the Impressionist exhibitions of 1880, 1881 and 1882. His sponsor among the Impressionists was Camille Pissarro, whom he spoke of as his 'professor'. Gauguin's decision to leave his job in a stock-market firm was not spontaneous, as has long been supposed. A recently discovered document proves that he was dismissed by his employers, who had been hit by the stock-market crash of the year in which he left them.

The following three years were not easy. He went to Denmark, and there he left his wife, who was a Dane (and who did not at all approve of his new mode of existence). Yet, despite his many troubles he continued to paint. He showed nineteen canvases at the eighth Impressionist Exhibition of 1886.

It was in June of that year that Gauguin first went to the village of Pont-Aven in Brittany. The charms of this remote province of France were then being discovered by numerous painters and literary men. At the pension run by Marie-Jeanne Gloanec, Gauguin found a number of other artists. Life was cheap, and he was able to live on credit. He made a friend of Charles Laval, who was later to accompany him to Panama and Martinique. And in August a nineteen-year-old art student introduced himself. His name was Emile Bernard.

Bernard was a talented and cultivated young man, who already 69 knew a number of painters, including Anquetin, Toulouse-Lautrec and Van Gogh. He was interested in all the fashionable things of the day – Symbolist poetry, Wagner's music, Schopenhauer's philosophy.

68 PAUL GAUGUIN *Self-portrait* 1889

The superiority of synthesis to analysis was already an *idée fixe* with him.

At first, Gauguin and Bernard did not get on. Bernard claimed afterwards to have been unimpressed by the work Gauguin was then doing, which he found too much influenced, not only by Pissarro, but by Puvis de Chavannes. But Bernard continued to visit Brittany. He came back in 1887, when Gauguin was away, and then again in 1888. This time, the two men found each other more sympathetic. Gauguin, after his return from Martinique, was dissatisfied with almost everything he had painted up till then, but he had not yet reached any conclusion about the direction he should be taking. Bernard, on the other hand, was about to achieve a breakthrough of his own. In July 1888, he began work on a strange picture.

70 This, the *Breton Women in a Green Pasture*, lacks both perspective and modelling. The arrangement of colour-areas, bounded within firm black lines, is the immediate point of the picture. At first sight, it looks as if the subject is merely a pretext. The element of abstraction, already latent in the work of Puvis de Chavannes, here becomes emphatic. Yet, at the same time, the work is in fact the record of something which the painter saw, or rather of something which he experienced. He has taken this experience, and translated it into the terms of art. *Breton Women in a Green Pasture* is an example of the 'synthetic' painting which Bernard had long been looking for.

Gauguin was impressed. A letter from Van Gogh reports that he exchanged one of his own canvases for it, and brought it back to Paris with him in the autumn. There Van Gogh himself was to make a watercolour copy of it. Not satisfied with expressing his admiration, Gauguin asked Bernard for the loan of some of the colours he had used, and set to work himself, to produce something in the same manner. *71* The result was the famous *Vision After the Sermon*, or *Jacob and the Angel*. This painting, besides being based upon the method of composition which Bernard had invented, actually contains a number of direct borrowings – notably the large bonneted heads which appear in the right foreground of each work.

Gauguin's painting, however, has an intensity which Bernard's lacks. The Breton women shown here are not merely compositional elements. They have just come out of church, and Jacob and the Angel appear to them as a result of the sermon they have just heard. Gauguin, by his placing of the various elements, and by his deliberately non-realistic use of colour, conjures up a visionary atmosphere which is

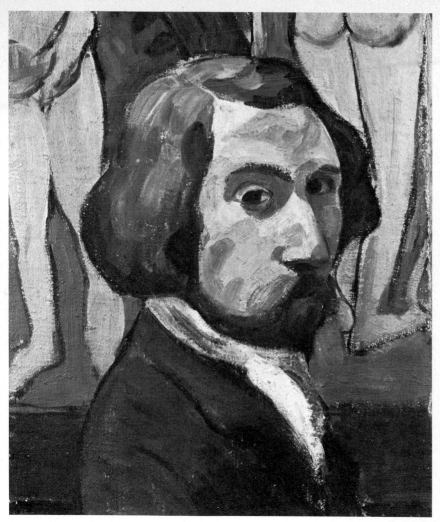

69 ÉMILE BERNARD *Self-portrait*

totally convincing. He has seized upon Bernard's discovery, and made it his own. The facility with which he absorbed and transformed Bernard's ideas was eventually to create lasting bitterness between the two artists.

The occasion of the breach seems to have been the exhibition at the Café Volpini in 1889. This was connected with the Universal

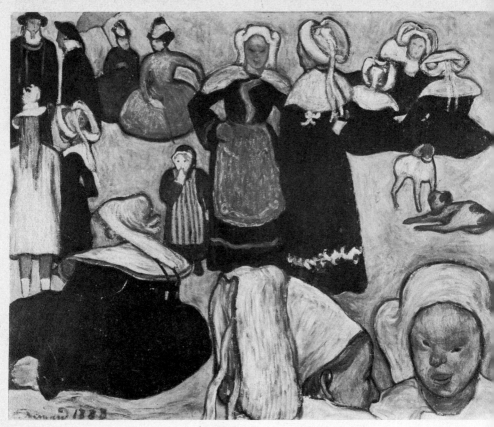

70 ÉMILE BERNARD *Breton Women in a Green Pasture* 1888

Exhibition which took place in Paris in that year. Burne-Jones was one
of the official exhibitors, and scored a great triumph with the Parisian
public. Gauguin and his friends could not hope for this kind of recog-
nition, but they did find a café within the exhibition site – in fact, it was
right beside the section devoted to the visual arts – whose proprietor
was willing to let them show their work on the walls of his establish-
ment. Nine painters were represented, most of them intimately con-
nected with Pont-Aven. The dominant personality, naturally enough,
was that of Gauguin himself.

The critics received the Café Volpini exhibition rather coolly. They
were confused by the catchpenny title which this collection of

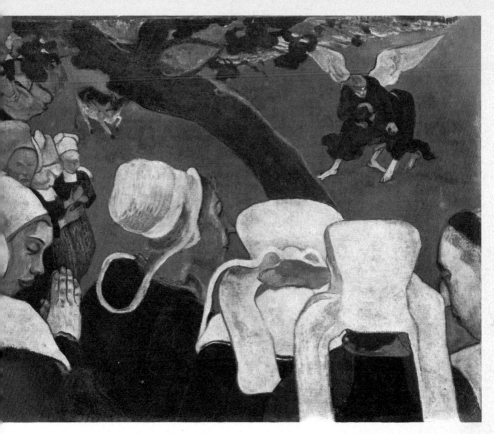

71 PAUL GAUGUIN *Vision after the Sermon (Jacob and the Angel)* 1888

relatively unknown artists had chosen for themselves: 'The Impressionist and Synthetist Group.' But at the same time they recognized the existence of one dominant personality, and were inclined to attribute all innovatory elements to him. Bernard was to spend the rest of his life fretting about the wrong which he considered Gauguin to have done him.

Gauguin's relationships with other young artists were somewhat happier. In the summer of 1888, he had had a very brief contact with a young painter called Paul Sérusier. Sérusier was of comfortably middle-class origins; he went to school at the Lycée Condorcet, which produced many leaders of the French intellectual establish-

ment; later he studied art at the Académie Julian, where he soon established himself as a dominant personality among his fellows.

In 1888, when he first visited Pont-Aven, he tended to steer clear of Gauguin and his companions. First, they had a bad reputation; second, they seemed more revolutionary than he himself dreamed of being. Contact was eventually made through Emile Bernard, just as Sérusier was preparing to return to Paris. Gauguin found something likeable about the personality of the newcomer. The day after the introduction had been effected, the two of them went together to a local beauty-spot called the Bois d'Amour. There, under Gauguin's direction and supervision, Sérusier painted a small landscape in an entirely Synthetist technique. This single lesson seems to have struck the young artist with the force of a revelation. He bore off his little picture to Paris, where it was promptly baptized *The Talisman*, and started preaching the new doctrine to a circle of friends, many of them young painters like himself.

In 1889, Gauguin and Sérusier were once more in Brittany, this time at Le Pouldu. There, on the wall of his room, Sérusier inscribed the following quotation from Wagner: 'I believe in a Last Judgment at which all those who have in this world dared to traffic in sublime and chaste art, all those who have polluted and degraded it by the baseness of their sentiments, by their vile greed for material pleasures, will be condemned to terrible punishment. On the other hand, I believe that the faithful disciples of great art will be glorified and, surrounded by a heavenly amalgam of rays, perfumes and melodious sounds, will return to lose themselves for all eternity in the bosom of the divine source of harmony.'

The content of this, as well as its authorship, are significant. Sérusier was of a systematic turn of mind. While accepting Gauguin's influence, he was at the same time eagerly absorbing everything which was intellectually fashionable in Symbolist circles – Neoplatonic philosophy, the occult, neo-Catholicism. He wanted to bring his reading into line with his experience as a painter. As Maurice Denis remarked; 'Sérusier's extremely philosophical intelligence very soon transformed Gauguin's most casual pronouncements into a scientific doctrine, which made a decisive impression upon us.'

Nor was Sérusier without influence upon Gauguin himself. He began to elaborate his own ideas about the theoretical basis of painting, and, though Symbolist enthusiasm for his work may sometimes have

72

72 PAUL SÉRUSIER *Landscape: the Bois d'Amour (The Talisman)* 1888

73 MAURICE DENIS *Landscape with Hooded Man* 1903

embarrassed him, he accepted it as his due. By the time he left for the South Seas in 1891, he had become very closely identified with the movement. The Symbolists gave a farewell banquet for him, and Mallarmé presided over it.

Nor, once he had left France, did the Symbolist influence fade. A painting such as the magical *Contes barbares* gives us precisely what the Symbolists demanded from art – mystery, ambiguity, the invitation to search for a deeper meaning underlying the surface.

Meanwhile, Sérusier had organized his friends into what amounted to a secret society. They called themselves the Nabis, *nabi* being the Hebrew word for 'prophet'. Regular meetings were held. Among the

76

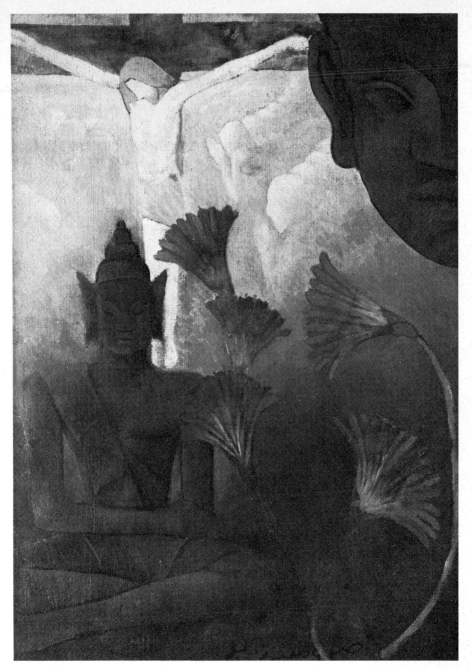

74 PAUL RANSON *Christ and Buddha c.* 1890

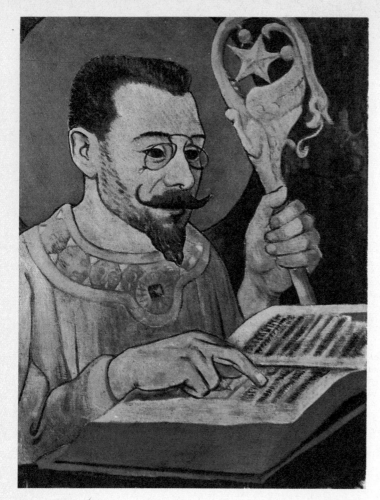

members were Maurice Denis, Paul Ranson, K.-X. Roussel, Pierre Bonnard and Edouard Vuillard. An endearing painting by Sérusier

75 himself, *Paul Ranson in Nabi Costume*, gives something of the flavour of these gatherings.

In fact, the Nabis were temperamentally very different from one another. The serious, mystical, philosophical ones were Sérusier and

73 Denis. It was they, in particular, who were drawn towards neo-

74 Catholicism, and the idea of a revival of sacred art. Paul Ranson was a less gifted painter, but had social gifts which helped to hold the group together. It was at his studio that they met every Saturday, and it was

100

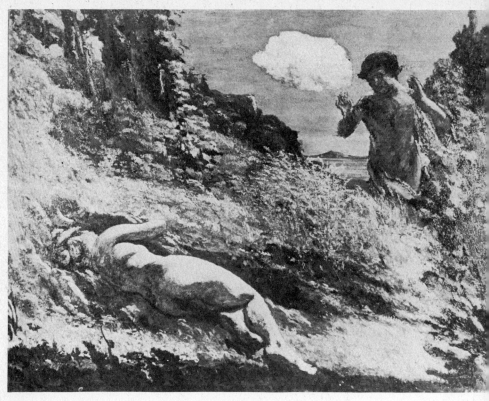

77 KER-XAVIER ROUSSEL *L'Après-midi d'un faune* 1919

he who devised the nicknames by which they were known to each other. Denis, for example, was 'Le Nabi aux belles icônes'. It is in Ranson's work that we discover the closest kinship between the style of the Nabis and Art Nouveau.

Bonnard and Vuillard, on the other hand, were not mystics. Breton peasants and Breton calvaries did not appeal to them as subject-matter for painting. What seems to have fascinated these two when they were young artists was the fashionable Symbolist milieu – the drawing-rooms where all this talk about Neoplatonism and Mallarmé and the occult took place, and the fashionable ladies who inhabited those drawing-rooms. Vuillard in particular became a kind of court-painter to Misia Sert, who was at one time married to Thadée

80

LA PARESSE

78 FÉLIX VALLOTTON *Indolence* 1896

Natanson, editor of *La Revue blanche* (one of the most important
later Symbolist reviews). Bonnard, who for several years shared a *79*
studio with Vuillard and Maurice Denis, also formed a part of the
Revue blanche circle.

Also Nabis, and duly provided with nicknames, were Vuillard's
brother-in-law, K.-X. Roussel, and the Swiss artist Félix Vallotton.
Roussel tried to find a way of adapting the art of Fragonard to the *77*
spirit of the 1890s; drawing-room paganism was his line. The mixture
always seems an uncomfortable one. Vallotton made portraits of
many of the leading Symbolist writers, and, in the period 1890–1900,
made excellent wood-engravings, thus taking up and developing a *78*
technique which had been favoured by Gauguin.

79 PIERRE BONNARD *La Revue blanche* 1894

80 ÉDOUARD VUILLARD *Misia Sert and Félix Vallotton* 1899

One sculptor was admitted to the innermost circle – the now little-
81 known Georges Lacombe. His work, too, seems to show the vivifying
impact of Gauguin's personality. Aristide Maillol, too, was connected
with the Nabis at the very beginning of his career.

Other artists, who were not Nabis, but who came under Gauguin's
spell, show occasional inclinations towards Symbolism. Two examples
will suffice. One is Claude-Emile Schuffenecker, faithful, long-
suffering Schuff, whose kindness Gauguin so much abused. Essentially
a Late Impressionist, Schuff was also, with slight incongruity, a
Theosophist. He was interested in the writings of Mme Blavatsky and
Annie Besant, and designed an appropriately mystic cover for Mme
82 Blavatsky's *Le Lotus bleu*.

81 GEORGES
LACOMBE
St Mary Magdalen
1897

82 CLAUDE-ÉMILE
SCHUFFENECKER
Le Lotus bleu

83 ARMAND SÉGUIN
Les Fleurs du mal
1892–94

The other is the short-lived Armand Séguin, who worked with Gauguin at Le Pouldu, and who was friendly with Sérusier. Séguin was forced to make a living by hack illustration, and got little chance to paint. One of his few surviving paintings, however, *Les Fleurs du* 83 *mal* in the Josefowitz collection, is as mysterious and magical as anyone could want. It makes use of Redon's technique of transposing and transforming literary experience.

The Rose+Croix

Of all aspects of Symbolist art, the most neglected until recently was that typified by the Sâr Péladan and his followers. But now, as a *88* result of recent books and exhibitions, there even seems to be a likelihood that disproportionate emphasis will be given to it. Péladan, for all his energy, never seems to have been regarded as a first-rate figure in his own time, either as a creative writer or as an aesthetician.

Yet he remains a picturesque and fascinating figure, in many respects typical of his age. He has points in common with Apollinaire, the prophet of the Cubists; but in fact the person whom he most greatly resembles is F. T. Marinetti, the declared opponent of Symbolism. Like Marinetti, Péladan seems to have been a compulsive exhibitionist, whose greatest artistic creation was his own personality. If one reads Péladan's novel *Le Vice suprême* and Marinetti's *Mafarka*, one realizes how similar is their cast of mind; and both, of course, are heavily in debt to the Flaubert of the *Tentation* and *Salammbô*.

Joséphin Péladan was born in Lyon in 1859, the son of the editor of a religious and literary periodical. His eldest brother, Dr Antonin Péladan, was responsible for leading him towards occultism. In 1872, the family moved to Nîmes. Like so many young men of the time, Péladan completed his education in Italy, and there fell in love with Italian art.

In 1882, he came to Paris, ready to set himself up as a literary man and art critic. He was not long in proclaiming his aesthetic convictions, and not much longer still in making his mark as a novelist. We find him, in his review of the Salon of 1883, putting his cards on the table. The review begins with the words: 'I believe in the Ideal, in Tradition, in Hierarchy.' In 1884, which was also the year in which *A Rebours* appeared, Péladan published his colourful novel *Le Vice suprême*, the first in a series which was to stretch to twenty volumes. Barbey d'Aurevilly, one of the founders of the Symbolist Movement in literature, contributed a preface, in which he said: 'The author of *Le Vice suprême* has within himself the three things most hated at present.

84 CARLOS SCHWABE *Poster: Salon de la Rose+Croix* 1892

He has aristocracy, Catholicism and originality.' Thanks in part to Barbey d'Aurevilly's efforts on its behalf, *Le Vice suprême* had a considerable success.

In particular, it attracted the attention of the occultist Stanislas de Guaïta. He met Péladan, and the two of them decided to revive Rosicrucianism. Christian Rosenkreuz was a fifteenth-century visionary of doubtful historicity, but the doctrines attributed to him were, in succeeding centuries, much embellished with ideas and images drawn from the Kabbala and from Freemasonry. Péladan thus became a leading figure in the busy world of French occultism. All was not cordiality; Huysmans, who had allied himself with the Abbé Boullan, a notorious black magician of the time, was deeply suspicious of Guaïta and Péladan, whom he regarded as 'magical enemies'. He was convinced that Guaïta in particular had attempted to harm him physically by means of necromancy. An important member of the Péladan/Guaïta faction was Count Antoine de la Rochefoucauld, a rich amateur painter and writer who provided the financial sinews for much Rosicrucian activity, including the first Salon de la Rose + Croix.

Eventually, Péladan and Guaïta fell out. Guaïta tended to emphasize the unorthodox elements in Rosicrucianism; Péladan to see it, in the phrase of Robert Pincus-Witten, who has been responsible for much recent research into the subject, as 'a symbolic façade disguising Catholic truths'. Péladan formed a new Rosicrucian group of his own which, for all its extravagances, was never denounced by the Roman Church as heretical – the fate which eventually overtook Guaïta's following.

During the latter part of the 1880s, Péladan was active indeed. He arrogated to himself the mysterious title of Sâr; in 1888 he went to Bayreuth, where he heard *Parsifal* for the first time (it struck him as a revelation); in 1889 he journeyed to the Holy Land where, in the words of a contemporary eulogist, René-Georges Aubrun, 'he made a discovery so astonishing that at any other era it would have shaken the Catholic world to its foundations; he rediscovered the authentic tomb of Jesus, in the Mosque of Omar'.

In 1892, Péladan was ready to launch a new Salon, in opposition to the official one, at the Durand-Ruel galleries. There is no lack of evidence as to what he approved of in the visual arts. His writings on the subject are voluminous, and he stuck to his own version of Symbolist doctrine long after Symbolism in general was out of favour.

In 1909, we still find him asserting: 'The three great divine names are: (1) Reality, the substance or the Father; (2) Beauty, life or the Son; (3) Truth, or the unification of Reality and Beauty, which is the Holy Spirit.'

Our most exact guide, however, is the set of rules which he drew up for the Salon de la Rose+Croix itself. Here are some extracts:

II. The Salon de la Rose+Croix wants to *ruin realism*, reform Latin taste and create a school of idealist art.

III. There is neither jury nor entry fee. The Order, which grows by invitation only, is too respectful of the artist to judge him on his method and imposes no other programme than that of *beauty, nobility*, lyricism.

IV. For greater clarity, here are the rejected subjects, no matter how well executed, even if perfectly:

1. History painting, prosaic and from a textbook like Delaroche;
2. Patriotic and military painting, such as by Meissonier, Neuville, Detaille;
3. All representations of contemporary, private or public life;
4. The portrait – except if it is not datable by costume and achieves style;
5. All rustic scenes;
6. All landscapes, except those composed in the manner of Poussin;
7. Seascape; sailors;
8. All humorous things;
9. Merely picturesque Orientalism;
10. All domestic animals and those relating to sport;
11. Flowers, still-life, fruits, accessories and other exercises that painters ordinarily have the effrontery to exhibit.

V. The Order favours first the Catholic ideal and Mysticism. After Legend, Myth, Allegory, the Dream, the Paraphrase of great poetry and finally all Lyricism, the Order prefers work which has a mural-like character, as being of superior essence.

VI. For greater clarification, here are the subjects which will be welcome, even if the *execution* is imperfect:

1. Catholic Dogma from Margharitone to Andrea Sacchi;
2. The interpretation of Oriental theogonies except those of the yellow races;

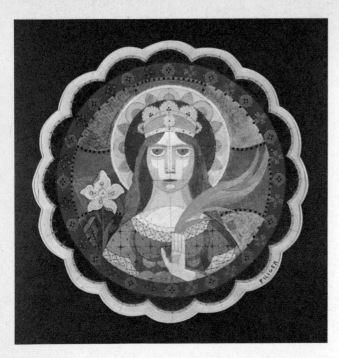

85 CHARLES FILIGER
Chromatic Notation No. 1
c. 1900

3. Allegory, be it expressive like 'Modesty and Vanity', be it decorative like a work by Puvis de Chavannes;

4. The nude made *sublime*, the nude in the style of Primaticcio, Correggio, or the expressive head in the manner of Leonardo and of Michelangelo.

VII. The same rule applies to sculpture. Ionic harmony, Gothic subtlety, and the intensity of the Renaissance are equally acceptable.

Rejected: Historical, patriotic, contemporary and picturesque sculpture, that is sculpture which only depicts the body in movement without expressing the soul. No bust will be accepted except by special permission.

VIII. The Salon de la Rose+Croix admits all forms of drawing from simple lead-pencil studies to cartoons for fresco and stained glass.

IX. Architecture: since this art was killed in 1789, only restorations or projects for fairy-tale palaces are acceptable.

What artists did Péladan discover, willing to adhere to the programme thus outlined? He did not, for example, succeed in attracting

86 ANTOINE DE LA ROCHEFOUCAULD *St Lucy c.* 1892

those whom he most admired – Gustave Moreau and Puvis de Chavannes – although some of their disciples and followers exhibited. Basically, the exhibitors can be divided into two groups, the Frenchmen and the Belgians; and among the former group further subdivisions are possible.

In the first and most important of the Salons, there were artists connected with Gauguin and Pont-Aven, and with the Nabis. Emile Bernard sent in work, and so did Vallotton. Another exhibitor who had links with Gauguin was Charles Filiger, who was perhaps the oddest figure in the whole Pont-Aven/Le Pouldu circle. He arrived at the Pension Gloanec in Pont-Aven in July 1889, was later at Le Pouldu, and finally settled at Plougastel. He remained in Brittany for the rest of his life, becoming increasingly reclusive.

Filiger was a mystic above all. His compositions are nearly always on a small scale, painted in gouache, with firm outlines. The draughtsmanship usually has something naïve and primitive about it. Especially interesting are what the artist labelled his *Chromatic Notations*. These are circular or polygonal compositions, with the whole area divided into facets, which in turn are used to build up the stylized head of the Madonna or of a saint. They seem to have been created just after 1900.

In life, Filiger was an *artiste maudit* of a fairly traditional sort – a heavy drinker, subject to paranoid delusions in which he believed that he was pursued across the Breton countryside by his enemies, and finally a suicide. At the same time he wrote long mystico-philosophical letters to his friends in Paris. Among his warmest admirers were Alfred Jarry, the author of *Ubu roi*, and Count Antoine de la Rochefoucauld, who got to know his work, in 1892, as a result of the first Salon de la Rose + Croix, and became his steadiest patron. There is, in fact, a strong family likeness between La Rochefoucauld's own work and Filiger's. Both show a certain amount of influence from the Pointillists – a tendency of which Péladan violently disapproved, and which seems to have led to the breach between the Sâr and his patron.

There was another Pointillist-influenced artist, however, who escaped the ban. Alphonse Osbert exhibited in all the six Rose + Croix exhibitions. His main artistic influences were from Puvis de Chavannes (who was a close enough friend to act as best man when Osbert married in 1894), and Georges Seurat, with whom Osbert was on intimate terms from student days onward. *The Vision*, reproduced here, shows St Genevieve, patron saint of Paris – a subject very familiar to

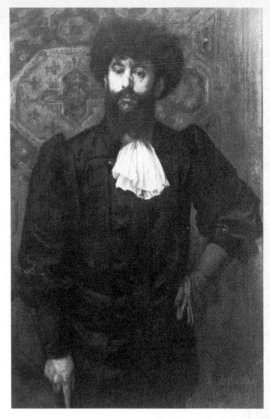

87 ALPHONSE OSBERT
The Vision 1892

88 MARCELLIN DESBOUTIN
Sâr Péladan 1891

Puvis, but showing strong traces of Seurat's late style. It was exhibited in the second Salon de la Rose + Croix.

Perhaps more characteristic of the stylistic orientation of most of the French exhibitors were men such as Armand Point, Alexandre Séon, Edgard Maxence and Marcellin Desboutin. Point was a *89* medievalizing painter, very accomplished technically, whose style mingled the influence of Moreau with that of the Pre-Raphaelites. Maxence was actually Moreau's pupil, but in him, too, we sometimes find a Pre-Raphaelite influence – an example is *The Soul of the Forest*, *92* now in the museum at Nantes. Séon, who made frontispieces for *90* Péladan's novels, and also made a portrait of him, combines influences

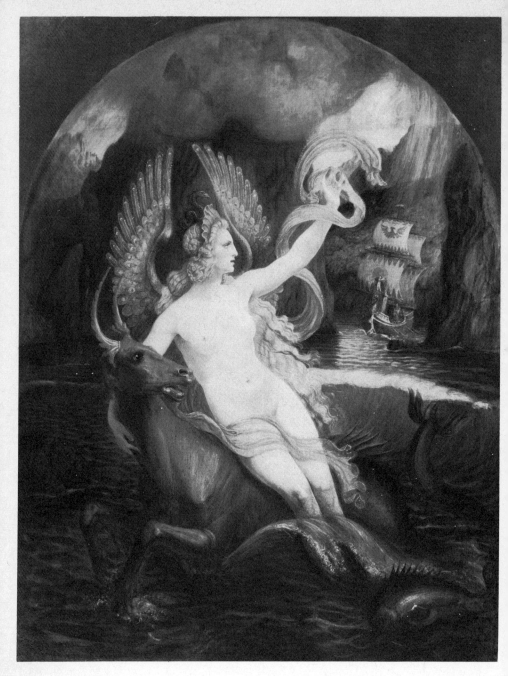

89 ARMAND POINT
The Siren 1897

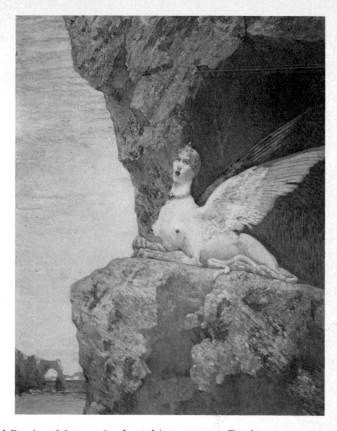

90 ALEXANDRE SÉON
The Chimaera's Despair
c. 1892

from both Moreau and Puvis – Moreau in the subject-matter, Puvis in the colouring. A statement of his, written in 1892, makes it plain that he was deeply committed to the Symbolist aesthetic: 'We must embody a symbol *through lines* in an amplified model of the archetype,' he says; 'we must homogenize that symbol *by means of colours* with the character of a living creature, or better still with its substratum.'

Marcellin Desboutin deserves notice chiefly as the author of the portrait of Péladan which appeared in the second Salon de la Rose+ 88 Croix in 1893. The Sâr's biographer Aubrun praises this in extravagant terms which, we may be reasonably sure, reflect the views of the magus himself. 'We must go back to the splendours of the Venetian Renaissance', says Aubrun, 'before we encounter a similar aristocracy of modelling and execution; this work is not merely the masterpiece of contemporary iconography; without doubt, it must be compared to the grandest of Titians.' The painting does not live up to the

description; it has the tarnished, overworked, academic air of Watts's less successful portraits.

Good artists were certainly to be discovered among the exhibitors at the Salons de la Rose+Croix: the sculptor Bourdelle showed at the first two Salons; the young Rouault was well represented at the last in the series. And, if one cannot claim that artists such as Point and Osbert are of comparable importance, certainly they have been unjustly neglected; and so, too, has a man such as Edmond Aman-Jean, who varied his competent but rather tame studies of women and

91 flowers with paintings such as the *St Julian the Hospitaller* which is illustrated here. But there was no real consistency of achievement.

92 EDGARD
MAXENCE *The
Soul of the
Forest*

91 EDMOND
AMAN-JEAN
*St Julian the
Hospitaller*
1882

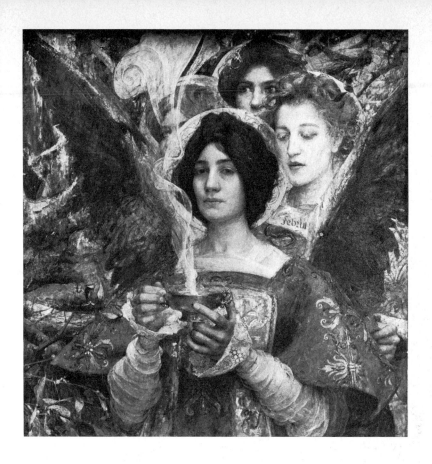

If the Salons did play an important role, it was in drawing attention to the work of a number of Symbolist painters who were not of French nationality. These included the Swiss Ferdinand Hodler and *140* the Dutchman Jan Toorop, both of whom will be dealt with in more *153* detail later in these pages. But the most important contingent came from Belgium. Many of them also belonged to the avant-garde Belgian group, Les XX, and in fact formed a dissident faction within it. Jean Delville was the leader of this schism, which broke out in 1892, the very year of the first Salon de la Rose+Croix, in which he exhibited, as he did in three subsequent exhibitions.

Delville's work often seems to be an extravagant, almost a paro- distic development of Moreau's. The severed head in *Orpheus* (the *94* model was the artist's wife) is combined with the poet's lyre, and the

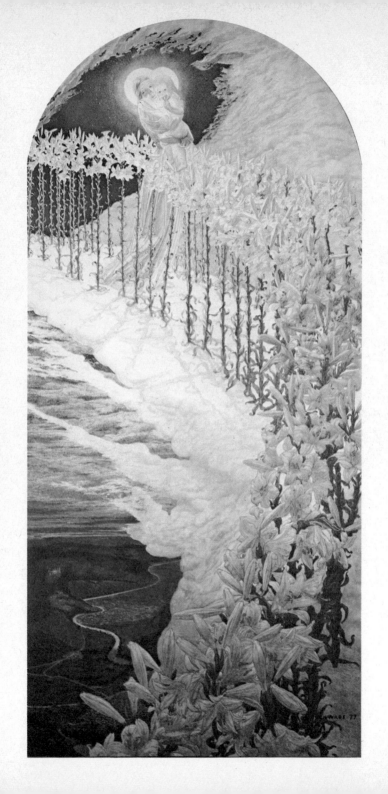

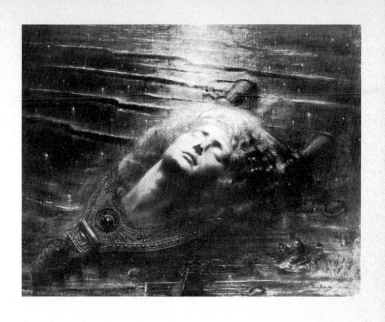

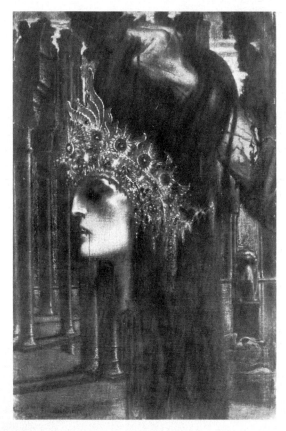

93 (*opposite page*)
CARLOS SCHWABE
The Virgin with Lilacs
1897

94 JEAN DELVILLE
Orpheus 1893

95 JEAN DELVILLE
The End of a Reign
1893

121

95 trophy is set amid waves and seashells; while in another painting, entitled *The End of a Reign*, an executioner's hand grasps the head, severed but still crowned, of a Byzantine empress, while the background suggests a building such as a mosque.

Also related to Moreau, but in a more personal way, with elements of the Pre-Raphaelites and of Alma-Tadema, are the paintings and drawings of Fernand Khnopff.

96, 97 Khnopff is the most important of the Belgian Symbolists (apart from the very different James Ensor), and his rediscovery constitutes the great achievement of the present enthusiasm for Symbolist art. Brought up in Bruges, and later in Brussels, he was influenced when young by his reading of Flaubert, Baudelaire and the Parnassian poet Leconte de Lisle. As he came of a legal family, he first of all studied law, but later turned to painting under the guidance of Xavier Mellery, an exhibitor in the Salons de la Rose + Croix and member of Les XX. In 1879 he went to Paris, to complete his studies in art, and there became infected with an enthusiasm for Moreau. He did not stay there long; in 1880 he returned to Belgium, and in 1883 he scored his first public success with a painting entitled *Listening to Schumann*. It made him seem, according to his biographer Dumont-Wilden, 'both attractive and suspect' in the eyes of the Belgian public.

Péladan greatly admired Khnopff's work, hailing him as 'the equal of Gustave Moreau, of Burne-Jones, of Chavannes and of Rops'. The admiration was returned, Khnopff made frontispieces for Péladan's novels, and drew on *Le Vice suprême* for subject-matter. Khnopff was a dandy – in his habitation as much as in his pictures. His house in Brussels reminded his privileged visitors of des Esseintes and *A Rebours*. He had the dedicated pessimism which seems to be one characteristic of the true dandy; his themes, indeed, may be summed up for the most part in four words – pride, isolation, cruelty and disdain. He also had the dandy's fanatical interest in precision. However strange his compositions, they are never accidental. Every effect is calculated, every detail precisely and deliberately placed.

1, 99 The element of perversity in Khnopff's work is very marked – and has one strange characteristic of its own, in that the feminine types he used in his compositions all seem to be based upon his sister, whose beauty obsessed him. Dumont-Wilden gives an eloquent description of the kind of emotion Khnopff tries to convey, speaking of 'these feminine physiognomies, at the same time energetic and languid,

122

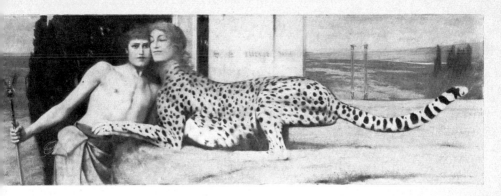

96 FERNAND KHNOPFF *The Caresses of the Sphinx* 1896

where the desire for what is impossible and the anguished thirst of
unslakeable passions assert themselves; singular and heroic souls,
whose chosen heroine must always be Elizabeth of Austria'.

In the circumstances, it hardly seems surprising that Khnopff's
reputation has now again recovered to the point where enthusiasts
compare him to Beardsley, if not as an artist then at least as a culture-
hero.

97 FERNAND KHNOPFF *I Lock the Door upon Myself* 1891

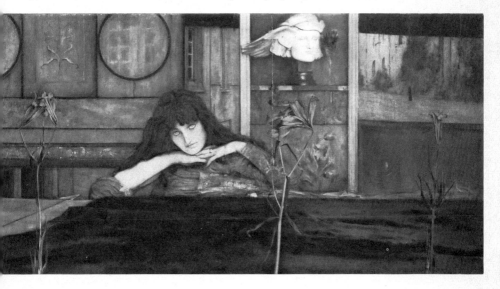

Other leading Belgian Symbolists, all of whom showed work at the
100 Salons de la Rose + Croix, were Xavier Mellery (who taught Khnopff),
Emile Fabry (one of Delville's principal allies when he quarrelled with
98 Les XX), and the sculptor Georges Minne. There was also Carlos
84 Schwabe, who supplied the poster for the first in the series of exhibitions, but never appeared at them again. This poster has now acquired
a certain celebrity, as a forerunner of fully developed Art Nouveau
and an obvious influence on Alphonse Mucha. But Schwabe also
worked in a different, a more Pre-Raphaelite style. His large water-
93 colour, *The Virgin with Lilacs*, is an example. The composition, with
its tall narrow format and compression of space, with a linking curve
to join the foreground to the background, comes very close to Burne-
Jones, though in detail it is more naturalistic. In its combination of
the eccentric and the academic, it seems typical of many of the artists
who exhibited at Péladan's Salons.

The Salons de la Rose + Croix were symptomatic rather than
epoch-making. They summed up the mood of the time, but they did
not accomplish any kind of revolution in the visual arts. The artists
connected with them were enormously fashionable at the time, but
most of them sank into an oblivion from which they have only
recently been rescued.

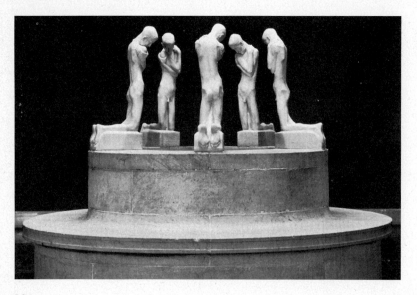

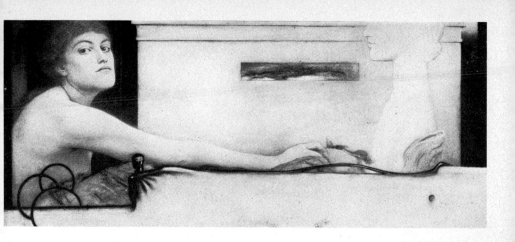

99 FERNAND KHNOPFF
The Offering 1891

98 GEORGES MINNE
*Fountain with Kneeling
Youths* 1898–1906

100 XAVIER MELLERY
Autumn

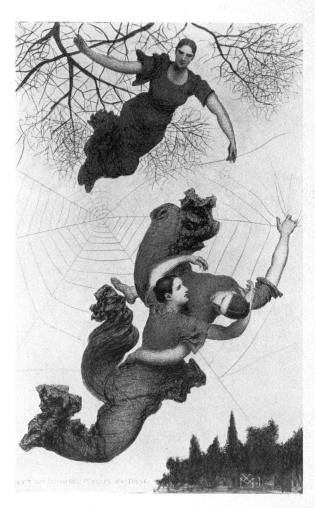

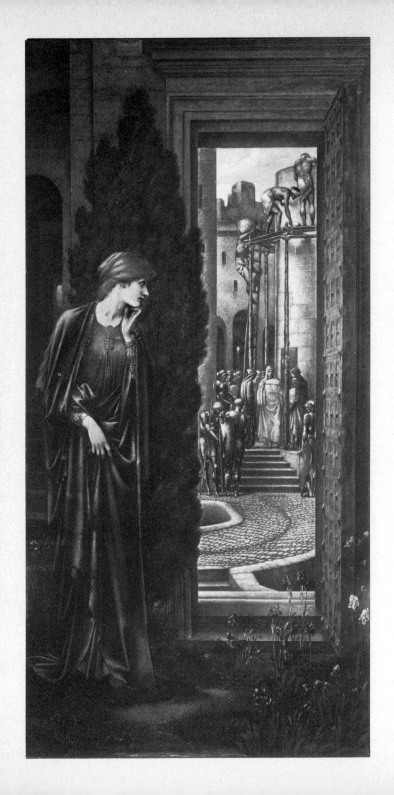

The English 1890s

Something has already been said about Burne-Jones's historical position in the development of English art during the second half of the nineteenth century. It is now time to try and say something about his achievements as a painter. At the moment, these are still underrated. Burne-Jones took the rather pedantic medievalism of the early Pre-Raphaelites, and turned it into an idiom which was altogether his own. His work is very visibly in debt to the great masters of the Italian Renaissance: he loved Mantegna, Leonardo, Botticelli, Signorelli, Michelangelo. But he was able to use his borrowings as part of a very personal language. Seldom as intense as the young Millais or the young Holman Hunt, he was far more inventive formally. And he was also exceedingly industrious. Though certain characteristics are constant, especially in the work which he did from the 1870s onwards, he allowed himself enough elbow-room for discovery.

He experimented, for example, with the format of his pictures. Sometimes he used a long horizontal, evidently suggested by Italian *cassone* panels. *Love and the Pilgrim* in the Tate Gallery is an example *104* of this, and we see how Burne-Jones has exaggerated the effect already created by the shape of the picture itself, in the mannered drawing of the figures, who are deliberately compressed within a very shallow space, and whose angular gestures enable them to occupy as much of the available surface-area as possible.

More often, however, Burne-Jones chose a format which was exaggeratedly tall and narrow. *The Annunciation* is a striking example, *102* because the subject is usually – and logically – presented in a composition longer than it is tall, so as to give the two principal figures room to breathe and to move. The angel perched in the top left-hand corner of Burne-Jones's composition has a dream-like illogicallity which we discover throughout his work. Lady Burne-Jones, in her rather bland biography of her husband, does in fact mention that he 'suffered many things in dreams'.

Burne-Jones used these tall shapes of his in two different ways – either the perspective is exaggeratedly deep, as, for instance, in

101 EDWARD BURNE-JONES *Danaë: The Tower of Brass* 1887–88

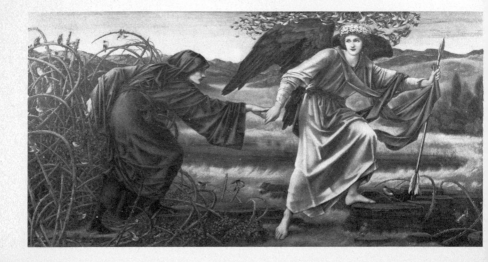

Danaë: The Tower of Brass, where the little figures in the background *101*
(borrowed from Signorelli) make an extreme contrast with the huge
foreground figure of Danaë; or else space is unnaturally compressed,
as in *The Golden Stairs*. This latter picture serves to call attention to *103*
Burne-Jones's affinity with Blake. The figures are not solidly placed;
they have no weight, just as the stairs themselves develop into a kind
of arabesque laid on the surface. One might even be reminded of
Blake's *Whirlwind of Lovers*, which works, though more violently and
assertively, on much the same principle.

In other respects, however, Burne-Jones is very much of his own
time. As the French Symbolists recognized immediately, when his
work was shown in Paris in 1889, he had certain instinctive preferences
which were the same as theirs. For example, he shared their love of the
androgyne. In the *Pygmalion* series, which are not the most successful *105*
pictures Burne-Jones ever painted, but which are certainly among the
most revealing from a psychological point of view, the goddess, when
she bends from her pedestal to embrace the sculptor who has created
her, seems to embrace a being who is in many respects more essentially
feminine than she is herself.

102 EDWARD BURNE-JONES
The Annunciation 1879

103 EDWARD BURNE-JONES
The Golden Stairs 1880

104 EDWARD BURNE-JONES
Love and the Pilgrim 1896–97

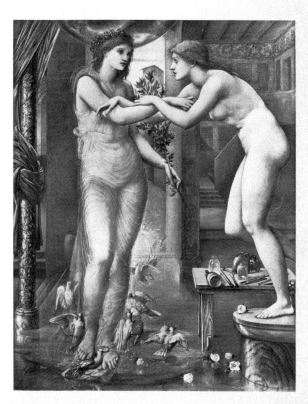

105 EDWARD BURNE-JONES
Pygmalion: The Godhead Fires
1878

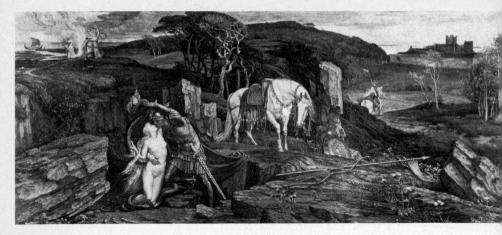

106 WALTER CRANE *The Laidly Worm* 1881

Like that of most prolific artists, Burne-Jones's work needs to be looked at selectively. One can readily admire the poetry of *The Sleeping Knights* in Liverpool, where the figures seem the very incarnation of *fin de siècle* languor, though the picture was painted as early as 1871. And there is enormous inventiveness in the circular watercolours which he made over a period of years for the 'Flower Book' which he presented to his wife. Each design in the 'Flower Book' is a fantasy on the popular name, rather than the actual appearance, of a flower. 'I want the name', said Burne-Jones, 'and the picture to be one soul together, and indissoluble, as if they could not exist apart.' The result in many cases lives up to his hope. Despite, or perhaps because of, their limited scale, the designs show his powers of invention at their strongest.

Burne-Jones's influence was exceedingly powerful. It was felt by the successful Academicians of the Late Victorian Age, such as Lord Leighton and Sir Frederick Poynter. The later followers of the Pre-Raphaelites mostly derive from Burne-Jones in particular, though they are seldom as mannered as he is. Walter Crane, for example, whose talents as a painter are again emerging from obscurity, owes a great deal to him.

130

107 EDWARD BURNE-JONES
*The Flower Book: Grave
of the Sea*

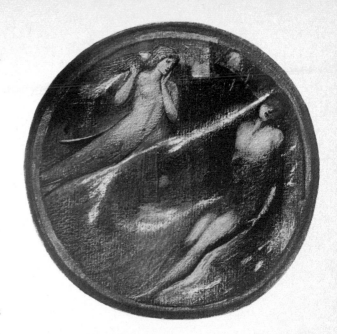

108 EDWARD BURNE-JONES
The Sleeping Knights 1871

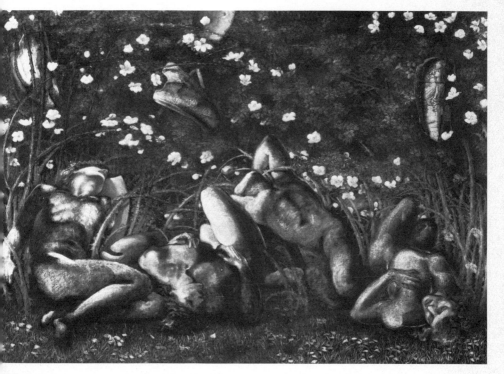

The most celebrated example of Burne-Jones's power over younger men is, however, the impact which he had upon Aubrey Beardsley, the tragically short-lived draughtsman and illustrator who still remains for most people the embodiment of the English 1890s. Burne-Jones was, inevitably, the man whom Beardsley approached with his early efforts in 1891, and the older artist had the perception and the good sense to encourage him. In 1892, Beardsley received his first important commission as a book-illustrator. The book was an edition of *Le Morte d'Arthur*, and what the publisher expected, and what to some extent he got, was a democratization of the work done at William Morris's Kelmscott Press, for which Burne-Jones himself had provided woodcut illustrations.

It is interesting to compare an early Burne-Jones, the *Merlin and Nimue* in the Victoria and Albert Museum, with Beardsley's version of the subject. The debts are obvious, and so are the differences. Beardsley seems to have been especially fascinated by what was perverse in Burne-Jones's work; what was latent in the older man, he chose to make obvious. At the same time, he seized on Burne-Jones's compositional wilfulness, his compression of space and asymmetrical balance of forms (preferences reinforced in Beardsley's

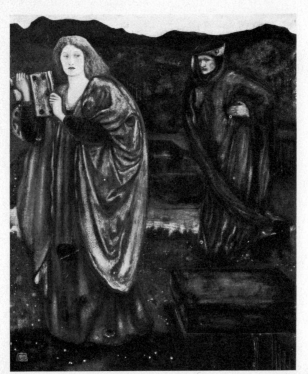

109 EDWARD
BURNE-JONES
Merlin and Nimue
1861

110 AUBREY
BEARDSLEY
Merlin and Nimue
1893–94

case by a study of Japanese prints). He seems to have understood, too, that the conventions used to render the draperies in many of Burne-Jones's late pictures could be of great service to him as a graphic designer. Burne-Jones's draperies tend to be strongly linear, and made of no particular substance; they often have a life which is independent of the life of the figures themselves. Working in black and white, Beardsley was able to develop these characteristics still further. Linear arabesque, balanced against areas of stark black, became his mode of expression for most of his career.

In 1891, Beardsley was introduced to Oscar Wilde at Burne-Jones's house. In 1894, Wilde's play *Salome* (first written in French and now provided with an English translation by Lord Alfred Douglas) was published with Beardsley's illustrations. These illustrations made an immense effect. Beardsley was one of the founders of the Art Nouveau style in Europe, and his influence was all-pervasive there in the decorative arts.

133

111 CHARLES RICKETTS *In the Thebaid* 1894

Keenly aware of the intellectual climate of his time, Beardsley tackled most of the favourite Symbolist themes: the medieval dream-world of Arthurian legend; the *femme fatale* (Moreau's influence can be detected in Beardsley's version of Salome and Messalina); and, of course, the operas of Wagner. His innate dandyism, more pronounced in him perhaps than in any other Symbolist artist, led him towards depictions of contemporary life; and he also became increasingly interested in the eighteenth century, an interest which culminates in his dazzling illustrations to Alexander Pope's *Rape of the Lock*.

134

112 AUBREY BEARDSLEY *Salome c.* 1894

It has sometimes been assumed that Beardsley was completely *sui generis*. This was not the case. A number of other artists, illustrators in particular, can be set beside him. One of these was the painter and draughtsman Charles Ricketts, whose illustrations are by far the most 'Symbolist' part of his production as an artist. Ricketts's illustrations to Oscar Wilde's poem *The Sphynx* actually seem to have been 111 finished some time before the Beardsley designs for *Salome*, though they were published slightly later. There is no doubt about their inventiveness, nor about their essentially Symbolist character.

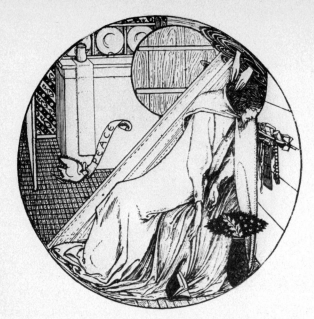

113 THOMAS
STURGE MOORE
*Vision of James I of
Scotland*

Ricketts was, in fact, one of the channels through which the influence of continental Symbolism found its way to England, and refertilized a tradition which was in its essentials Pre-Raphaelite. His lithograph *The Great Worm*, published in the first issue of his luxurious private magazine *The Dial* (1889), is a straightforward pastiche of Moreau.

He was also a much closer associate of Wilde's than Beardsley was ever to be, and a more steadfast friend when the great scandal broke. In addition to illustrating *The Sphynx*, Ricketts earlier made designs for *The Picture of Dorian Gray*, *A House of Pomegranates*, and *Intentions*.

Associated with Ricketts were his lifelong friend and companion, Charles Shannon, and the poet and wood-engraver Thomas Sturge Moore. No one would pretend that Sturge Moore counts as anything but a very minor artist, but some of the designs he made for *The Dial* are delightful – and historically fascinating because of their high degree of abstraction.

Abstraction also characterizes the work done by artists who belonged to the Glasgow School, one of the great fountain-heads of Art Nouveau. The Glasgow School was the circle which clustered round the architect Charles Rennie Mackintosh, and most of the creative effort of the group went into design, rather than fine art.

113

Nevertheless, the drawings made by the two Macdonald sisters, *114, 115* Margaret, who married Mackintosh, and Frances, who married the designer Herbert MacNair, show the Late Symbolist tendency towards abstraction very well developed, a fact which is perhaps explained in this case by the influence of the Dutch painter Jan *153* Toorop. Toorop's work was known to them because it was published in the influential London magazine *The Studio*.

114 MARGARET MACDONALD MACKINTOSH *Kysterion's Garden c.* 1906

115 FRANCES MACNAIR MACDONALD *The Moonlit Garden c.* 1895–97

116 CHARLES CONDER
A Toccata of Galuppi's
1900

117 AUBREY BEARDSLEY
The Rheingold (Third
Tableau) c. 1896

118 ARTHUR RACKHAM
The Rhinemaidens
Teasing Alberich 1910

Book-illustration, even more than painting, came to be completely dominated by Symbolist conceptions. Partly art and partly craft, illustration rapidly assimilated itself to the much more broadly based Art Nouveau movement in architecture and decoration. The work of illustrators such as Edmund Dulac and Arthur Rackham is that thoroughly paradoxical thing, a popularization of ideas which are essentially esoteric. Rackham's illustration to Wagner's *Rheingold*, *118* published in 1910, makes a fascinating comparison with Beardsley's *117* Wagner designs published less than twenty years earlier. The inspiration is recognizably similar; but, for all his skill, Rackham, unlike Beardsley, cannot resist the sentimental.

This account of the direct descendants of Burne-Jones by no means completes the story of Symbolist art in Britain. A number of minor *116* artists are difficult to classify. There is, among them, Charles Conder, of whom Jacques Emile Blanche said that his style was 'purely English'. If so, it was despite the fact that a large part of his career was spent in France. Conder was a friend of Lautrec and Bonnard, but he was also in contact with leading Symbolists and Rosicrucians through Blanche

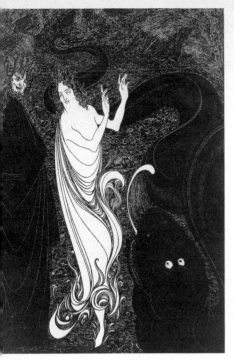
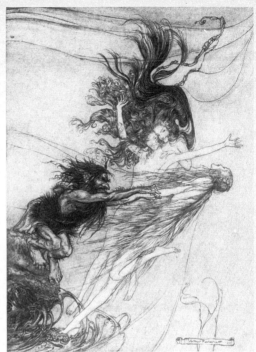

himself, and also through the circle which centred upon *La Revue indépendante*. He, like Ricketts and innumerable others, was a great admirer of the work of Puvis de Chavannes.

His great independent discovery, however, seems to have been the fact that Watteau would translate very satisfactorily into Symbolist terms. The French eighteenth century was already fashionable, thanks to the Goncourts, on the one hand, and the rather more baneful influence of the Empress Eugénie, on the other. The Goncourts made eighteenth-century art intellectually respectable, while Eugénie revived eighteenth-century styles of decoration (with paintings to match) in the drawing-rooms of the fashionable world. Watteau's pictures had long since become eagerly sought after by collectors such as the Marquess of Hertford and his successors, but no one had discovered a way of giving contemporary relevance to the *fête galante*. Conder seems to have sensed, almost instinctively, that it was – or could become – the Arthurian dream-world in different clothes, and he acted on his discovery. He passed his enthusiasm on to Beardsley; they were friends in Dieppe, or, rather, friendly enemies.

Conder's work has certain affinities with that of Whistler, and he and Whistler are certainly linked through their close involvement with contemporary French art and French artists. Whistler was an American, who owed his artistic formation to France. He was not in any strict sense of the term a Symbolist; yet, despite his apparent isolation, no assessment of the Symbolist and idealist current in late nineteenth-century art would be complete without some mention of him.

One person who sensed Whistler's importance at the time was Huysmans. In *Certains*, he rather shrewdly compares Whistler to Verlaine: 'At certain moments he evokes, like [Verlaine], subtle suggestions, and at others lulls like an incantation whose occult spell vanishes.'

The thing which marks Whistler off from the true Symbolists was the fact that he deliberately avoided the metaphysical dimension. If we compare the *Symphony in White, No. 2* of 1864 to the kind of work that Rossetti was doing at the same time, we are immediately struck by the resemblance; Whistler's personal and artistic relationship with Rossetti was especially close when the picture was painted. But we notice, too, how matter-of-fact Whistler is. The girl is thoughtful, one might almost say dreamy, but there is no sense of yearning for the *au-delà*, such as we would inevitably find in a work by Rossetti.

Whistler's real contribution to Symbolist art was an intellectual one. In his libel action against Ruskin, in 1878, he had asserted the artist's right to be freed from the old moral criteria. His own picture *The Falling Rocket*, which Ruskin had characterized as 'a pot of paint flung in the public's face', he himself described simply as 'an artistic arrangement', thus anticipating the doctrine of Maurice Denis and his fellow Nabis. Having won his action, to the extent of a symbolic farthing's damages, Whistler returned to the attack in his *Ten O'Clock Lecture* of 1885, scornfully noting that: 'Beauty is confounded with virtue, and before a work of Art it is asked "What good shall it do?".' It comes as no surprise to discover that it was Mallarmé who translated the *Ten O'Clock* into French.

In addition to being the most telling advocate of 'art for art's sake' – a doctrine which formed part of the Symbolist credo, though few of them adhered to it as consistently as Whistler himself – he was responsible for a number of ideas and innovations which became part of the repertoire of Symbolist painting. Whistler's passion for

119 JAMES
ABBOTT MCNEILL
WHISTLER *The
Little White
Girl: Symphony
in White No. 2*
1864

japonaiserie became widespread; his early and consistent use of musical titles 'nocturnes', 'symphonies' and 'arrangements', helped to confirm the impression that the visual arts ought to aspire towards the condition of music; and his decorative ideas – such as the use of a peacock-feather pattern in the room which he painted for his patron F. R. Leyland – were extensively plagiarized. The peacocks and peacock-patterns in Beardsley's *Salome* are taken over from Whistler, not from Moréau or Burne-Jones.

 There is some current disposition to underrate Whistler, and to write him off as an essentially isolated artist. To do this is to distort the history of the art of his time, in which he was, and remained an influential, even central, figure.

112

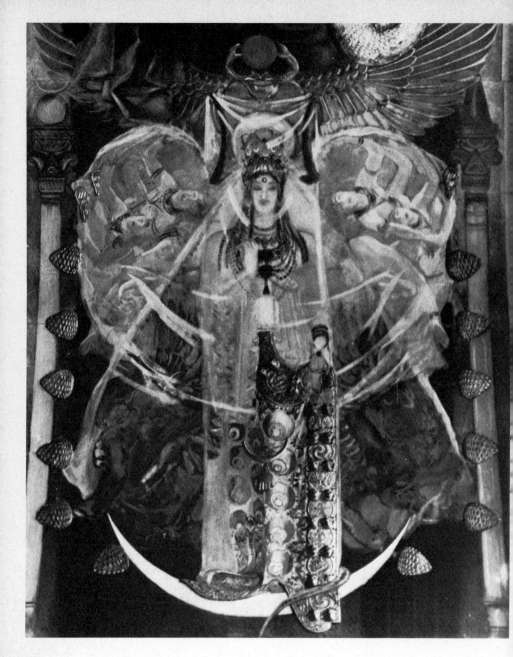

120 JOHN SINGER SARGENT *Astarte c.* 1892

The Symbolist International

The standard, French-centred account of the development of modern art, which describes how Impressionism begat Post-Impressionism, which in turn begat Fauvism, which in turn begat Cubism, distorts the truth, as most students of the subject have now come to realize. One of the most serious of its distortions relates to the progress of the Symbolist movement in painting and sculpture.

Towards the end of the nineteenth century, and during the first decade of the twentieth, Symbolist art was internationally dominant. In this it resembled Mannerism at the end of the sixteenth century and at the beginning of the seventeenth. Indeed, the two styles, Symbolism and Mannerism, had a good deal in common. Both of them were the characteristic product of a relatively unified culture, which transcended national boundaries, and which was directed by an élite determined to emphasize the distance which lay between itself and the mob. Both put forward the proposition that the arts were a closed, special world, a world with its own rules and its own language.

In achieving acceptance as *the* progressive art of the day, and not merely as one of the competing modes of progressive art, Symbolist painting and sculpture had one advantage. Since Symbolists attached more importance to philosophical attitudes than to techniques of expression, Symbolist art was often able to maintain its links with the retrograde world of the official salons and academies, which still controlled the way in which honours and official patronage were distributed. The painters and sculptors attached to Symbolism did not achieve their full share of these rewards; but they received some share, as we have already seen from the life-histories of artists such as Gustave Moreau and Puvis de Chavannes. And this undoubtedly helped them to maintain their position.

There were, of course, countries in which Symbolist painting did not make much progress. The United States is a case in point, perhaps because it was all too easy to identify the ultra-refinement of Symbolism with those aspects of European culture to which Americans found themselves most instinctively hostile. Oscar Wilde enjoyed immense

success on his American lecture tour, but native American art has comparatively few Symbolists to show. Some of these are provincial Pre-Raphaelites, such as Elihu Vedder. Others are artists who deviated into Symbolism in order to suit an occasion. The most famous example of such a deviation is the decorations made by John Singer Sargent for the Boston Public Library. The subject, which Sargent seems to have settled upon for himself, after considering and rejecting much more conventional alternatives such as 'The quest and achievement of the Holy Grail', was nothing less than the evolution of religion. His biographer the Hon. Evan Charteris says that to Sargent this 'was a subject which could be viewed with detachment; he approached it without bias or preference'. It seems that he saw the commission chiefly as a means of proving that he was more than a flashy portrait-painter, and turned to the Symbolist idiom as being, in the 1890s, the right one for the job. The pagan Near Eastern deities who form the least traditional part of the scheme are also that portion where Symbolist influence is most strongly apparent.

A more original kind of American Symbolism is to be discovered in the work of Arthur B. Davies. These mythological scenes, remote descendants of the landscapes of Giorgione, do their rather pale best to convey feelings of mystery and ambiguity. A stronger painter, but a more eclectic one, is Maurice Prendergast, influenced by the Nabis, and also by Seurat.

121

120

123

122

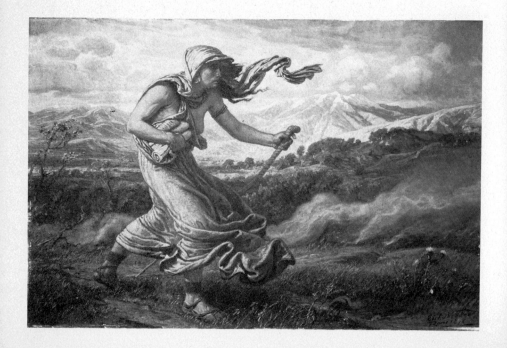

122 MAURICE PRENDERGAST
The Picnic 1915

121 ELIHU VEDDER *The Cumaean Sibyl* 1876

123 ARTHUR BOWER DAVIES
Full-orbed Moon

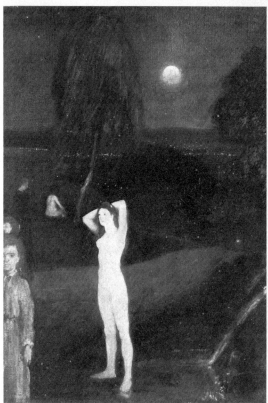

124 VICTOR BORISSOV-MUSSATOV *The Sleep of the Gods* 1903

Symbolism had a much more important impact in another vast country, influenced by Europe, but not entirely of it: pre-revolutionary Russia. Perhaps the earliest true Symbolist in Russian painting was 125 Mikhail Vrubel, an isolated figure who was followed by the even 124 more isolated Victor Borissov-Mussatov, who went to Paris in 1895 and worked in Gustave Moreau's studio, later coming under the influence of Puvis de Chavannes. Borissov-Mussatov died prematurely in 1905, but his influence continued, thanks to Diaghilev's admiration for him. His landscapes, with their figures in 1830 costume, and their muted colouring, have a resemblance to some of Conder's work. Certainly they betray much the same nostalgia for the past.

The World of Art group in St Petersburg, which centred upon the personalities of Diaghilev and Alexandre Benois, was the first really well-organized cohort of Russian Symbolists. Benois gives a lively account of its origins, achievements and eventual decline in his two volumes of memoirs. Like the Nabi group in Paris, the World of Art had its roots in a band of young men who were school-friends. To this nucleus, other recruits were added, among them Bakst and Diaghilev, who was originally regarded as a naïve country cousin and something of a joke. Diaghilev organized his first exhibitions in 1897, and the first number of *Mir Iskusstva* ('World of Art'), a new and luxurious magazine, was published in October 1898.

Diaghilev's artistic sympathies, at the time when his taste began to
65, 130 mature, lay with Puvis de Chavannes and with Arnold Böcklin (who

146

is discussed later in this chapter). Later, he was interested in the Nabis. Benois was a Symbolist of the nostalgic kind, obsessed with the *128* glories of the Russian eighteenth century, of Peter I and Catherine II, but enough a man of his time to worship Wagner. His first designs for the stage were made for a production of *Götterdämmerung* in 1903.

As matters turned out, the St Petersburg Symbolists of the World of Art circle were to make their international reputations as designers for the stage, rather than as easel-painters. Diaghilev took the Ballets Russes to Paris for the first time in 1909. Included in this initial programme were the 'Polovstian Dances' from *Prince Igor*, in a décor *127* designed by Nikolay Roerich, and *Cléopâtre*, starring the society

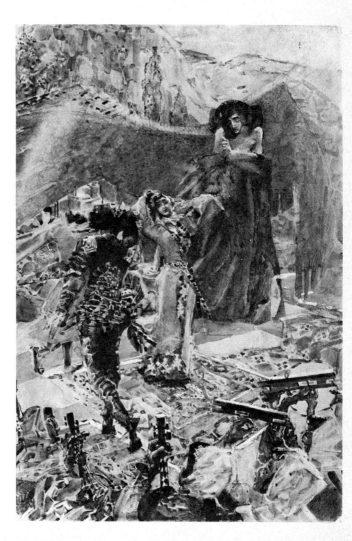

125 MIKHAIL VRUBEL
The Dance of Tamara
1890

beauty Ida Rubinstein, with décor by Leon Bakst. It was these that best answered the expectations of the Parisian public. Roerich had wide archaeological knowledge, and his sets for *Prince Igor* reflected this. But they were by no means mere exercises in pedantry; they had a primeval grandeur which suited the dancing, and this grandeur was evoked by Symbolist means. Bakst's work, and particularly his sets and costumes for *Schéhérazade*, first presented in the 1910 season, actually helped to prolong the life of the Symbolist style beyond what might have seemed its natural term.

Bakst's vision of life in the harem derived, ultimately, from the Salome theme as treated by Gustave Moreau, with some contributory influence from Aubrey Beardsley, whose work was well known in Russia from the mid 1890s onward. What Bakst added was Russian energy, and the Russian feeling for exotic colour. *Schéhérazade* took the Parisian audience by storm, and had a profound effect on fashionable clothes and fashionable styles of interior decoration.

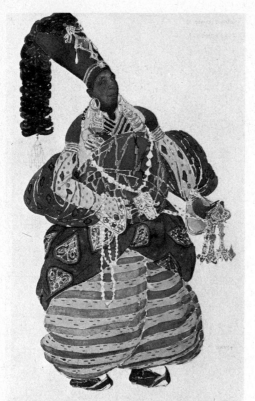

127 NIKOLAY ROERICH
Set for 'Prince Igor' 1909

128 ALEXANDRE BENOIS
Le Pavillon d'Armide
1907

126 LEON BAKST
Schéhérezade: The Grand Eunuch 1910

The most important developments in Symbolist art outside France and England were to be found in central Europe. A key figure is the Swiss-born Arnold Böcklin, who occupies, in relation to his own tradition, a position somewhat akin to that of Gustave Moreau in France. Böcklin began his career as a Romantic landscape-painter with many affinities to Caspar David Friedrich, though in fact his early work is less openly Symbolic than Friedrich's. But Böcklin was also very much in thrall to the Classical dream which played so significant a part in the German culture of the nineteenth century. In 1850, he made his first journey to Italy, staying there till 1852, and returning in 1853 to stay until 1857. Italy, his native city of Basle, Zürich, and the Bavarian capital of Munich were to attract him in turn during the remainder of his life. By the end of the 1850s, he was painting a new kind of picture, at least in German art. Best described as 'mood-paintings', they are sometimes pure landscapes, sometimes landscapes with figures, and sometimes mythological compositions. The most celebrated is *The Island of the Dead*, the first version of which dates from as late as 1880.

130

129 ARNOLD BÖCKLIN *Battle of the Centaurs* 1873

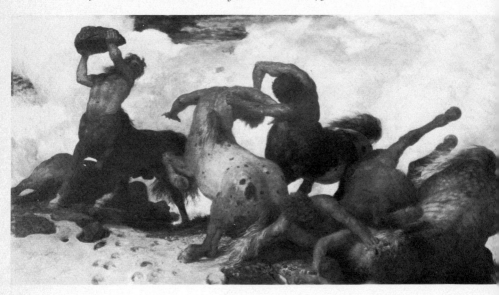

130 ARNOLD BÖCKLIN *The Island of the Dead* 1880

The Island of the Dead is a 'synthetic' picture, in a fully Symbolist sense. It does not depict nature as it actually exists, but brings together various impressions received by the mind of the artist, to create a new and different world, governed by his own subjective mood. In this case, the mood is one of withdrawal, of rejection of reality. It is interesting to note that the title by which the work is now known was coined by a dealer. Böcklin himself was less specific; he characterized it simply as 'a picture for dreaming over'.

Other paintings do seem to have a rather more definite programme. This is particularly true of some of the mythological pictures. The *Battle of the Centaurs*, painted in 1873, tackles a favourite theme of the artists of the time. Böcklin here symbolizes the blind, brute force of nature. *Calm Sea*, of 1887, is again a representation of half-human creatures – this time a mermaid and a triton. It is the mermaid who is shown as dominant; siren-like, she reposes on her rock, and gazes out

129

131

131 ARNOLD BÖCKLIN
Calm Sea 1887

at the spectator, while her male partner sinks impotently away into the depths.

From the technical point of view, Böcklin remains firmly within the academic tradition – but this is an observation which can also be made of Moreau. It is themes which are important.

Böcklin fathered a dynasty of artists. Max Klinger worked under Böcklin, and undoubtedly owed much to the experience, though his own essential talent was for something a great deal more fantastic, and related to Goya (whose prints he greatly admired). Klinger, in turn, exercised an influence not only over Otto Greiner, whose principal series of prints was dedicated to him, but also over Alfred Kubin, who recorded the impact made by Klinger's work in his autobiography: 'I looked and quivered with delight. Here a new art was thrown open to me, which offered free play for the imaginative expression of every conceivable world of feeling.'

Another artist who belongs to this particular ambiance is Franz von Stuck, a founder-member of the Munich Secession in 1892, and

132

136
133

132 MAX KLINGER *The Rape* 1878–80

133 ALFRED KUBIN
One-eyed Monster
1899

134 FRANZ VON
STUCK *Fighting
Fauns* 1889

135 FRANZ VON
STUCK *The Kiss of
the Sphinx c.* 1895

154

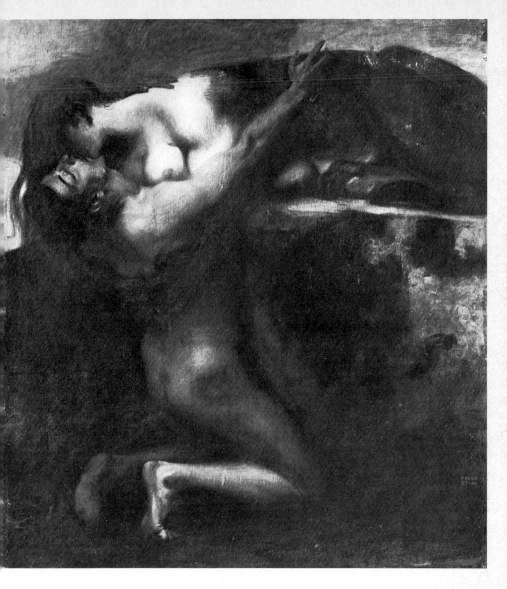

for many years an important figure in the art world of that city. Stuck's
work, from the *Fighting Fauns* of 1889 onwards, is an important *134*
contribution to the development of Symbolist art in Germany.
Fighting Fauns, a relatively early picture, is of course closely related to
Böcklin's *Battle of the Centaurs*, and seems to express much the same *129*

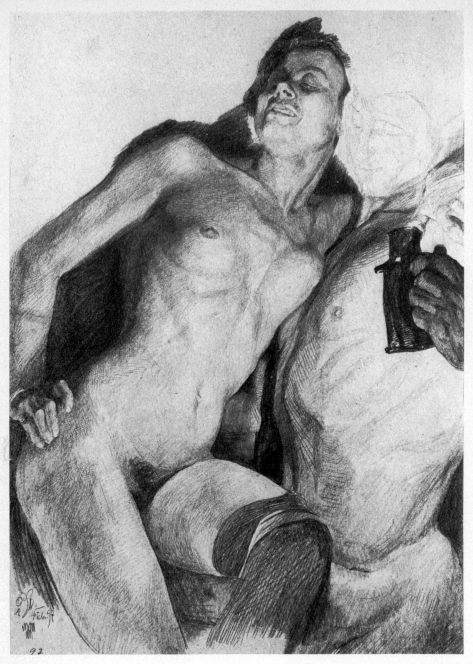

136 OTTO GREINER *The Devil Showing Woman to the People* 1897

137 ALBERT WELTI *The King's Daughters* 1901

attitude towards the forces of nature: an admiring recognition of their essential amorality. Later work by Stuck, such as *The Kiss of the Sphinx*, develops a quality which is latent in Böcklin – the sense of evil. We encounter a very similar mood in Klinger, Greiner and Kubin, and in the work of an important Belgian draughtsman and printmaker, Félicien Rops.

 But, in connection with the work of Franz von Stuck, it is perhaps worth emphasizing the tenaciousness of the Symbolist tradition in Munich itself. Munich was, at this period, almost universally considered to be the artistic capital of Germany, and it attracted numerous artists from elsewhere. One, of precisely the same generation as Stuck, was the Swiss painter Albert Welti. He, like Klinger, studied under Böcklin, and, after living in Paris and Vienna, returned in 1889 to settle in Munich. His work has a somewhat different flavour from that of the group whom I have just discussed – more cautious, closer to the English Pre-Raphaelites. Nevertheless, it too can be classified as Symbolist.

135

137

A younger painter who came to settle in Munich was the Russian, Vassily Kandinsky. Although he was only three years younger than Stuck and four years younger than Welti, Kandinsky belonged to an entirely different generation from the artistic point of view. Kandinsky took up painting only at the age of thirty, and soon after, in 1896, he arrived in Munich. He studied under Stuck, but his own strength of personality soon brought him to a position of leadership among the members of the Munich avant-garde. He became Chairman of the Phalanx Association, which had its own art school. In 1906, he made contact with Willibrord Verkade, a Dutchman who had been in close touch with Gauguin both in Paris and at Pont-Aven, and who had subsequently taken monastic vows at the German Abbey of Beuron, celebrated for its school of religious painting. Verkade was then on leave from his monastery, and studying painting in Munich.

In 1909, Kandinsky, together with his mistress Gabriele Münter and his fellow Russian Alexey Yavlensky, formed a new body, the Neue Künstlervereinigung. An early adherent of this group was Alfred Kubin. Kubin's descriptions of abstract colour visions in his novel *Die andere Seite* ('The Other Side'), which was published in the same year,

138 MIKALOJUS
ČIURLIONIS
*Sonata of the
Stars* 1908

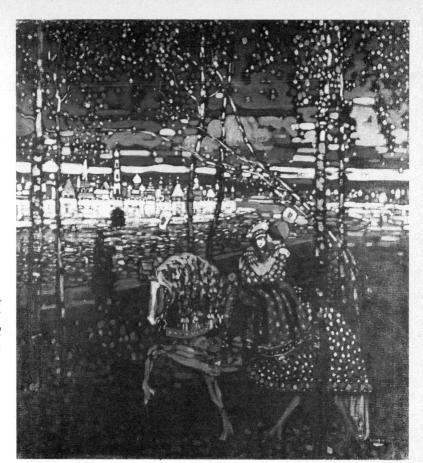

139 VASSILY
KANDINSKY
Couple Riding
c. 1905

seem to have influenced Kandinsky, who was now moving towards abstraction. Two years later, towards the end of 1911, the Neue Künstlervereinigung split, and Kandinsky and Franz Marc resigned to form the Blaue Reiter.

It is usual to categorize Kandinsky's painting in his later figurative period as being 'Fauve', and there are indeed important Fauve influences to be found in his work from about 1906 onwards, as well as ideas borrowed from the Divisionists and Pont-Aven. But the subject-matter – often scenes from medieval legend – confirms his connection with Symbolism.

Nor was the connection broken when he took the decisive step into a totally abstract art in 1910/11. Werner Haftmann, in his classic

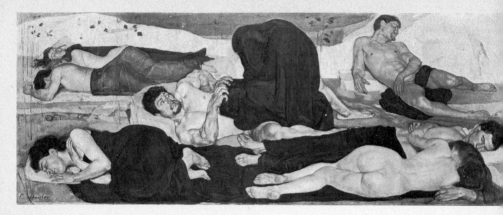

140 FERDINAND HODLER *The Night* 1890

history, *Painting in the Twentieth Century*, has pointed out the link between Kandinsky's work and that of the strange Lithuanian artist
138 M.K. Čiurlionis. Čiurlionis's aim was to find a pictorial equivalent for music – he had begun life as a musical prodigy, then had abruptly

141 FERDINAND HODLER *Adoration* 1894

142 FRANZ MARC *The Bewitched Mill* 1913

turned to painting about the year 1905. He seems to have been influenced in his researches both by Redon's prints and by the writings of the Rosicrucians. Kandinsky, too, was pursuing a synaesthetic vision, and, as his little book *On the Spiritual in Art* serves to prove, was inclined to see the artist as a kind of mystic. In this text, Kandinsky expresses the greatest respect for the ideas of Mme Blavatsky.

142 Franz Marc, the other leading figure in the Blaue Reiter, is equally open to the Symbolist influence which seems to have persisted in Munich right up to the outbreak of the First World War. The difference between Marc's pictures and those of the Expressionists of north Germany, such as Max Pechstein or Erich Heckel, lies in the spiritual, other-worldly quality of his art.

Böcklin and Welti were by no means the only Symbolist painters that Switzerland produced. Next to Böcklin himself, perhaps the most important of them was Ferdinand Hodler. Hodler drew much of his inspiration from Swiss history, Swiss landscape, and the Swiss artists of the sixteenth century. His bold, simplified style was especially suited to large-scale murals, and he carried out many important commissions of this kind in which there is scarcely a trace of anything which could be called Symbolism.

On the other hand, he felt the influence of Puvis de Chavannes (who praised Hodler's work when it was shown in the Paris Universal Exhibition of 1889), and his nature mysticism led him to produce
141 compositions of single figures in landscapes which come remarkably close to Puvis's essays in the same genre. It was perhaps this resemblance to Puvis which led to Hodler's being invited to show at the first of the Salons de la Rose+Croix in 1892. He explained the artistic attitude which informed this category of his work in an article published in *Liberté de Fribourg* in 1897. 'The mission of the artist . . .' says Hodler, 'is to give expression to beauty, the external element of nature: to extract from nature essential beauty.'

His *œuvre* also contains a small handful of allegorical compositions in a recognizably Symbolist style. The best known of these are the
140 *Night* of 1890, and the *Day* of 1900.

In Italy, too, a certain amount of Symbolist art was produced, though it never achieved the dominant position which one might be tempted to deduce from Futurist denunciations of Symbolism. The most intense and most committed of the Italian Symbolist painters
143 was Giovanni Segantini. He, like his Swiss contemporaries, was

162

143 GIOVANNI SEGANTINI *The Punishment of Lust* 1897

attracted by the wild and hostile scenery of the Alps, and drew mystical nourishment from them. He lived at Savignio in Switzerland from 1886 to 1894, then moved to the Engadine. His work shows not merely Symbolist tendencies in a general sense, but strong affinities with Jugendstil, the Art Nouveau of central Europe. He was in contact with Gustav Klimt, and in 1896 the Secessionist group in Munich honoured him with an exhibition.

Gaetano Previati, who was one of the exhibitors at the first Salon de la Rose + Croix, produced the occasional conventionally Symbolist picture, such as *The Night Defeats The Day* in the Museo Civico, Trieste; but his most interesting ventures into Symbolist territory were with paintings which explore a nostalgia for the world of the *145* seventeenth and eighteenth centuries, rather similar to the mood which is to be found in the work of Benois or Conder. *116, 128*

Other Italian painters and draughtsmen of the period work in a range of styles. A handful are influenced by Symbolism in one way or another. One example is G. A. Sartorio, a rhetorical, exuberant academic artist whose contact with Symbolism was through Gabriele d'Annunzio, with whom he collaborated on the periodical *Il Convito*. Another, totally different, is the self-taught Romolo Romani, whose *147* strange allegorical drawings have an affinity with those of Filiger.

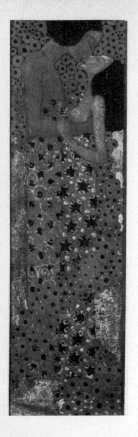

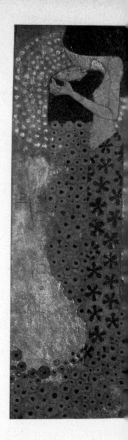
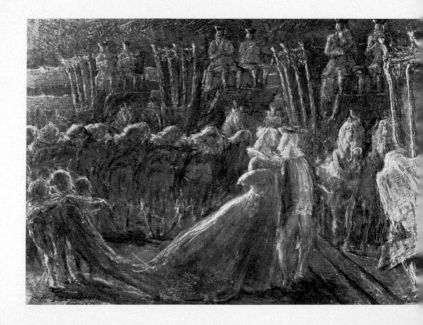

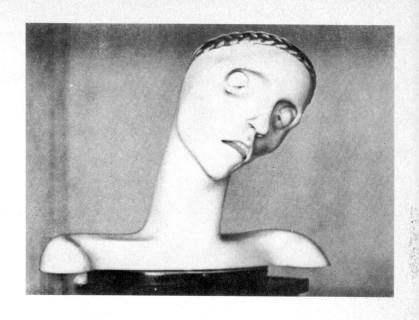

144 VITTORIO ZECCHIN
Salome Triptych 1909–12

145 GAETANO PREVIATI
The Sun King 1890–93

146 ADOLFO WILDT
A Rosary 1915

147 ROMOLO ROMANI
Lust 1904–05

144 Different again is the work of the Venetian painter Vittorio Zecchin, who took his inspiration from the Secessionists in Munich and Vienna, and who was particularly strongly influenced by Klimt.

146 There was also an Italian Symbolist sculptor, to whom increasing attention is now being paid. His name was Adolfo Wildt. Macabre, perverse, wilfully mannered, Wildt sometimes handles stone in a way that will remind Englishmen of Eric Gill. But the essential flavour is very different. Wildt is the exponent of a death-obsessed Catholicism which seems more Spanish than Italian. Curiously enough, his work becomes more, rather than less, Symbolist after 1910, despite the rising tide of Futurist opposition to Symbolist ideas.

149 The Futurists, in spite of Marinetti's shrill slogan, 'Murder the Moonlight!', did in fact retain closer links to Symbolism than any of them would have cared to admit. This was especially true of Boccioni, perhaps the most gifted of the Futurist painters, whose attempts to render emotional states have a clearly Symbolist parentage. And we find Symbolism still very much present in the early metaphysical painting of Giorgio de Chirico. His empty piazzas are 'mood-pictures' in line of descent from Böcklin's *The Island of the Dead*.

148 FRANK KUPKA *The Soul of the Lotus* 1898

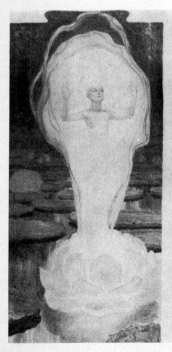

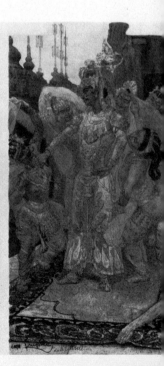

149 UMBERTO BOCCIONI *Those Who Stay* 1911

Symbolism had a particular hold upon the imaginations of various
central European artists who expatriated themselves to Paris. Alphonse
Mucha became the great exponent of the Art Nouveau poster; and
the more important Frank Kupka, later to be a pioneer of abstract *148*
painting, began his career under the influence of Odilon Redon and
Alfred Kubin. Constantin Brancusi, who arrived in Paris almost a
decade later than Kupka, having travelled there (mostly on foot) via
Munich, shows strongly Symbolist tendencies in his early work, such
as the figure *Prayer* which dates from 1907; and it is not too much to *150*
say that Symbolism remained latent in his work throughout the rest
of his career.

Lastly, we must look beyond Paris again, to Holland, and examine
the work of a small but important group of Symbolist artists there.
The two most important of them are Jan Toorop and Johan Thorn
Prikker. Toorop was born in Java, and was of partly Javanese ancestry.
He left the East Indies at an early age to settle in Holland. In 1882, he

167

went to study art in Brussels, on a scholarship from the Academy of Fine Arts, and there he came into contact with the artists of Les XX. He himself became a member of this group in 1885. He also visited London, and was in contact with Pre-Raphaelite circles there.

During the 1880s and early 1890s, Toorop was subject to a wide range of influences – that of Ensor on the one hand, that of Redon and Rops on the other. Literary influences were also important to him. He was associated with the Dutch avant-garde group of writers known as the Tachtigers, and he met Verlaine and the Sâr Péladan when they visited Holland in November 1892. The Sâr seems to have interested Toorop in Rosicrucian doctrines.

Nevertheless, the beginning of Toorop's fully Symbolist period precedes this visit by about three years, and precedes, indeed, the Symbolist manifesto issued in 1890 by the Dutch writer Willem Kloos. This phase of Toorop's work was extremely intense, but of short duration; it was past its climax by 1894, and after 1905, when he was converted to Catholicism, Toorop virtually ceased to be a Symbolist at all.

150 CONSTANTIN BRANCUSI *The Prayer* 1907

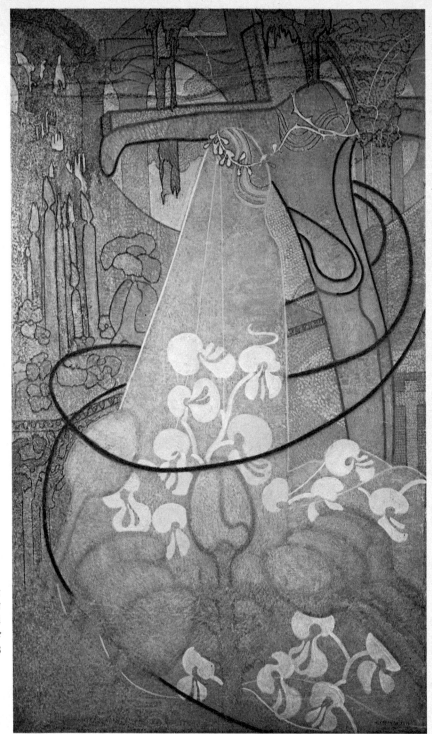

151 JOHAN
THORN
PRIKKER
The Bride
1892–93

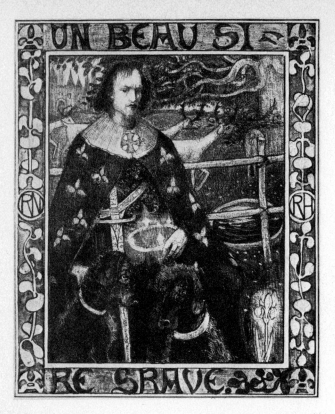

152 ROLAND HOLST
Un beau sire grave

The brief period of Toorop's commitment to Symbolism is important because during that time he pushed the characteristic devices of Symbolist art to extremes. In the 1890s his work shows a gradual surrender of logical space-construction, a development perhaps influenced by the art of the East Indies, and especially by batik designs on fabric. The picture-surface is organized by means of undulating lines, which wander and interweave in complex patterns, but which never penetrate in depth.

Toorop's thinking was a curious mixture of traditionalism and experimentalism. *The Three Brides* of 1893, which is probably the best known, as well as one of the most elaborate, of his Symbolist compositions, is really a restatement of the theme of the Three Graces which we find in Botticelli, but in a key very much characteristic of its own period. The Innocent Bride is here placed between the sensual and blood-thirsty Hellish Bride, and the Nun Bride who inhabits a higher spiritual sphere. Toorop had a hatred of anarchy and barbarism,

154

5

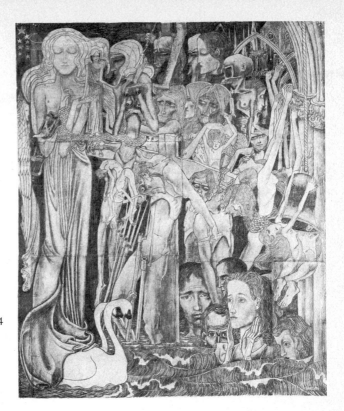

153 JAN TOOROP
Faith in Decline 1894

of anything which threatened the established hegemony of Church
and State, and these feelings must have played a considerable part in
leading him towards the Roman Catholic Church.

He was not, however, immune to the enthusiasms of his time. He,
too, was a Wagnerite. In his drawing *Faith in Decline*, for example, 153
the swans are evidently suggested by *Lohengrin*.

Johan Thorn Prikker's commitment to Symbolism was as brief as
Toorop's. He began as an Impressionist, and moved towards Sym-
bolism about 1892, with a series of drawings illustrating the life and
passion of Christ. In 1893, he was invited to exhibit with Les XX in
Brussels. Here he came into contact with Verhaeren, and also with
Henri van de Velde. We can guess something of his temperament and
ideas from the fact that (unlike Toorop) he disapproved of the
flamboyant Péladan, but (like Toorop) he was impressed by Verlaine.
Yet it was Thorn Prikker who produced work even more extreme
than Toorop's. The most famous example is his painting *The Bride*, 151

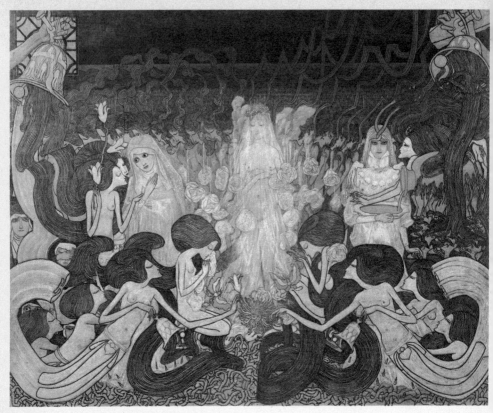

154 JAN TOOROP *The Three Brides* 1893

which is almost abstract – the bride herself is reduced to a transparent veil, which is menaced by skull–like snapdragons and phallic tulips.

Two other Dutch Symbolists also deserve mention. One was R. N. Roland Holst, whose early work was influenced by Van Gogh, but who went through a brief Symbolist period in the years 1891–95. He, like Toorop and Thorn Prikker, was in contact with Les XX in Brussels, and he seems to have experienced a brief enthusiasm for Péladan's ideas. But he was also interested in the work of Beardsley, of Whistler, and (in particular) of Rossetti, about whose work he *152* published an essay. The lithograph *Un beau sire grave* shows Rossetti's influence, but is probably intended as an illustration to Péladan's *Le Vice suprême*.

Rops and Ensor

Having discussed the general pattern of development in Symbolist art, it is now time to examine specific cases. In Belgium, for example, there is the striking polarity between James Ensor and Félicien Rops. Rops is an intermittently Symbolist artist with a firm place in any history of Symbolism. The much greater Ensor fits in less easily. Though a Belgian and a member of Les XX, he offers a pattern of development very different from that of the other Belgian Symbolists.

It is Rops who enables us to understand the degree and nature of this difference, because he enjoyed an almost unique *réclame* among the literary supporters of Symbolism, not only in Belgium but elsewhere. Péladan admired him enormously, and so did J. K. Huysmans, who devotes some eloquent paragraphs to him in *Certains*:

'Adopting the old concept of the Middle Ages, where man floats between Good and Evil, struggles between God and the Devil, between Purity, whose essence is divine, and Lust which is the Demon himself, M. Félicien Rops, with the soul of an inverted Primitive, has accomplished the task of Memling in reverse: he has penetrated Satanism, and summarized it in admirable prints which are, as inventions, as symbols, as examples of incisive and vigorous art, truly unique.'

Time has been hard on Rops's work: he now seems to represent everything that is most fundamentally opportunistic and tedious about the Symbolist movement. At the same time, we must do him the justice of admitting that he had established himself as an artist long before Symbolism became a force. The Goncourts were among the first to praise him, noting in 1868 that 'Rops is truly eloquent in depicting the cruel aspect of contemporary woman, her steely glance, and her malevolence towards man, not hidden, not disguised, but evident in the whole of her person.' After 1874, when he settled in Paris, Rops enjoyed a considerable reputation as an illustrator, especially of rather dubious erotic texts, and we find in his work a reflection of most of the boulevard fashions of the time – a facility in making vulgar versions of eighteenth-century art, and an equal but

155 FÉLICIEN ROPS *The Monsters*

more praiseworthy skill in the depiction of contemporary low-life.

What drew Rops towards the Decadents, and the Decadents, in turn, towards him, was his hostility towards women – in fact, the very aspect which the Goncourts picked upon in his work. This hostility drew Rops towards Satanism, just as Huysmans was drawn towards it, one suspects, for similar reasons. When Huysmans praises him for having 'celebrated the spirituality of Lust, which is to say Satanism; and painted, in pages which could not be more perfect, the supernatural aspect of perversity, the other world of Evil', we get the idea that these are words which Huysmans would very much have liked to see applied to himself.

155 Rops's best-known performances, in this particular vein, are the etchings known as *Les Sataniques*. Deliberately blasphemous, these are less a monument to evil than one to vulgarity. Their saving grace, from the art-historian's point of view, is that in some respects they anticipate the devices of metamorphic Surrealism. Even so, it is difficult to regard them as in any way marking an important step forward in the development of European art, for the metamorphoses

which Rops here presents had long been the stock-in-trade of cari-
caturists. Rops's innovation lay chiefly in asking the spectator to take
them seriously.

While James Ensor has nothing in common, temperamentally, with
Rops, the two artists share a fondness for certain properties – masks and
skeletons in particular. But whereas Rops uses these images with strict
conventionality, Ensor makes them deeply personal, and imbues them
with extraordinary life.

Art criticism has never quite known what to make of Ensor's work,
and the difficulties have been increased by the fact that he made a
brilliant beginning, followed by a long decline. Born in Ostend in
1860, of half-English, half-Belgian parentage, he studied at the
Brussels Academy in 1877–79, then returned to his native town, where
he remained for the rest of his life. In 1883, he joined Les XX, and,
during the early part of his career, they provided him with the only
opportunity he could find to exhibit his work. Even so, he ran into
trouble with his colleagues. He was several times asked to withdraw
his work from the society's exhibitions, and there was even at one
time a move to expel him from its ranks. During the same period he
seems to have been treated with little sympathy by his exceedingly
bourgeois family.

Yet his family did contribute something important to his art. They
were shop-keepers, and sold souvenirs, curiosities, exotic objects and
toys. At carnival-time, they also sold masks. These objects had an
important effect on Ensor's imagination – an effect which was not the
less decisive because it was connected with his feelings about his
relatives as individuals.

Ensor's first mask painting dates from as early as 1879, but the theme
had its greatest importance for him from the mid 1880s onwards. This
was also the time at which there was a decisive change in his palette.
From being rather dark, his paintings now, under the influence of
French Impressionism, became flooded with light.

Ensor's colour has a pearly, iridescent sheen which is a long way
from being naturalistic. We see it at its best in some of the still-lifes –
for instance, in *The Ray* of 1892. This painting reminds one of Redon's
pastels. Occasionally in Redon, as for example in the celebrated pastel
The Conch Shell, the artist's description of a natural object seems to
cloak a sexual metaphor. One gets much the same impression from
Ensor's *The Ray* – not merely from its colouring, but from the fish

156 JAMES ENSOR
The Ray 1892

157 JAMES ENSOR
*The Vengeance of
Hop Frog c.* 1910

158 JAMES ENSOR *Self-portrait with Masks* 1899

itself which, the longer one looks at it, tends to take on a curiously human and threatening presence.

The symbolism of the mask pictures is much more obvious. The beautiful *Self-portrait with Masks*, which dates from 1899, offers an introduction to the way in which Ensor's work should be read. The painter himself appears in the centre of the composition, wearing a jaunty carnival hat adorned with a feather. This portrait is a paraphrase of a well-known self-portrait by Rubens. The whole of the rest of the picture-surface is crowded with masks. All but one or two of these seem to ignore the unmasked man among them. The two or three who do seem to look at him stare with mindless malignancy.

It is not hard to work out the intended meaning. Rubens was the greatest of Flemish painters, and the one who enjoyed the greatest degree of worldly success. Ensor presents himself as a poor parody of Rubens's greatness, a carnival-king of painters. Around him crowd the representatives of ordinary bourgeois society. With these, the mask has become the face; the disguise for spiritual ugliness is itself more hideous than reality could ever be. The crowded airlessness of the composition seems to express Ensor's own feeling of claustrophobia. It is to be found in many of his compositions.

Two other mask pictures can be taken in conjunction with the *Self-portrait*. One is the *Old Woman with Masks*. This is said to have started life as a commissioned portrait – almost the only commission of its kind given to Ensor at this period. The sitter rejected the painting as too ugly, whereupon Ensor took it back, emphasized the ugliness still further, and added the masks. Here, I think, we are intended to see the living face and the masks as equivalents. The suggestion is that the old woman is in the process of turning into the hollow mask she already resembles. Yet there is also a feeling of compassion. Ensor is not blind to the pathos of age, or to the still keener pathos of our hopeless attempts to resist it.

The third mask picture is the most ambitious Ensor ever painted, *The Entry of Christ into Brussels*, which dates from 1889. This was the painting which nearly led to his expulsion from Les XX; he was saved by one vote – his own. The implication of the picture is, of course, that if Christ returned to earth, the Belgians would undoubtedly treat him in the same way as did the Jews of Jerusalem. The political banner – LONG LIVE SOCIALISM! – adds a fierce touch of political irony. *The Entry of Christ into Brussels* illustrates a facet of Ensor's art

159 JAMES ENSOR
Old Woman with Masks
1889

Space claustrophobia feeling of alienation

which has often been commented upon: its spatial discontinuity, which in this case gives a feeling of the uncontrollable movement of a vast crowd. The crowd itself is one of Ensor's characteristic images – one of his ways of projecting his feeling of alienation.

During this early period, Ensor's art sometimes becomes altogether hallucinatory and visionary – as for instance in *The Vengeance of Hop Frog*, intended as an illustration to the story by Edgar Allan Poe. Often, however, the intention seems to be satirical, as in the *Skeletons Quarrelling over a Hanged Man*, which is most easily read as a comment on what society does to the artist.

157 early period

After 1900, Ensor's work shows a distinct slackening of creative force. There is a certain irony to be found in the fact that this was just the time at which he began to achieve recognition. In 1898 there was a small exhibition of his work in Paris, which attracted no attention; but in 1899 *La Plume* issued a special Ensor number, in 1903 he was

160 JAMES ENSOR *The Cathedral* 1886

made a *chevalier* of the Order of Leopold, and in 1908 Verhaeren published a monograph devoted to his work. Ensor lived on. Finally, in 1930, he was made a Baron.

It has been said that the work which Ensor was producing during his most intense and original period should be regarded as the reflection of a psychosis. Dominant are images of panic, such as the swarming crowd which appears in his etching *The Cathedral*, and images of alienation – masks, skeletons and phantoms. All these images serve to suggest that the artist is moving through a world which lacks some dimension of reality, and in which all other individuals appear as ghosts.

180

161 JAMES ENSOR *The Entry of Christ into Brussels* 1889

There is certainly some substance in this view. But we must also consider the degree to which Ensor managed to control his own fantasies, and to turn them into art. He, above all the other artists discussed in the pages of this book, supplies the proof that Symbolist art was not merely something tacked on to the literary movement which was dubbed Symbolism. One of the least literary of Symbolist painters, he is also one of the most powerful. Though his means of expression have little in common with those adopted by the Belgian painters who exhibited at the Salons de la Rose + Croix, he deserves the Symbolist label at least as much as they do.

181

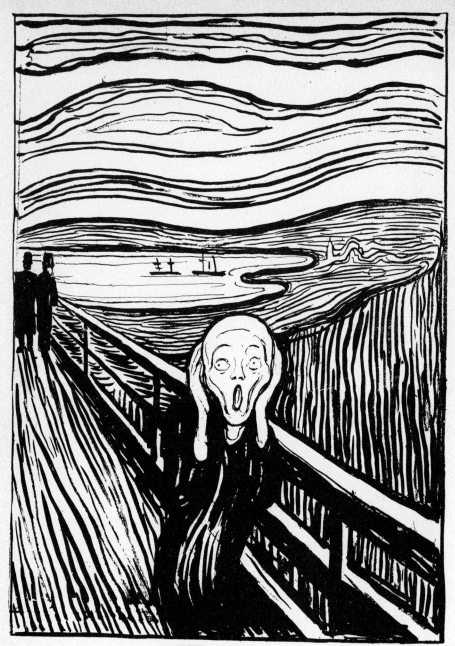

162 EDVARD MUNCH *The Cry* 1895

Edvard Munch

The European contemporary who had the greatest kinship with Ensor was undoubtedly the Norwegian painter Edvard Munch. Like Ensor, Munch has the gift of infusing a picture with some dominant emotion. Subject-matter and symbol are intertwined, and are not to be distinguished from one another.

Munch began his training in 1881, at the Royal School of Design in Christiania (now Oslo). The dominant influence in Norwegian painting at this time was Realism: painters were concerned with the life of the poor, the more so because Norway was still largely a peasant country, less prosperous than its neighbours. In 1883, he attended the 'open-air academy' run by Frits Thaulow, the Danish artist who was Gauguin's brother-in-law. By 1884, he was in contact with the Bohème movement in Christiania, a lively group of artists and writers whose activities centered upon a paper which, significantly enough, was called *The Impressionist*. Their attitudes can easily be deduced from the joking list of 'Nine Bohemian Commandments' which the periodical once printed. It runs as follows:

1. Thou shalt write thine own life.
2. Thou shalt sever all family bonds.
3. One cannot treat one's parents badly enough.
4. Thou shalt never soak thy neighbour for less than five kroner.
5. Thou shalt hate and despise all peasants, such as Bjørnsterne Bjørnson.
6. Thou shalt never wear celluloid cuffs.
7. Never fail to create a scandal in the Christiania Theatre.
8. Thou shalt never regret.
9. Thou shalt take thine own life.

The first of these regulations, at least, Munch did not take as a joke. It sums up in a phrase what he was to do all his life long.

He was too big, both as an individual and an artist, to be confined for long to the small world of Christiania. In 1885, he made a brief visit to Paris on a scholarship provided by Thaulow. He stayed only three

weeks, and the painter whose work impressed him most was Manet. Yet it is not without significance that 1885 was the year in which he began *The Sick Child* and *Puberty*, which are the earliest of his Symbolist compositions.

In 1889, he returned to Paris for a more prolonged visit, entering Léon Bonnat's Academy. He was to travel back and forth between France and Norway until 1892, which was the year in which the Verein Berliner Künstler invited him to show under their auspices in Berlin. The show created a considerable scandal, and was shut down after a week. The upshot of the scandal was the foundation of the Berlin Secession, under the leadership of Max Liebermann, and a considerable increase in Munch's reputation as a painter.

Between 1893 and 1908, he spent most of his time in Germany. These were very important years for him – perhaps the most important of his entire career. It was during this period that his *Frieze of Life* was conceived, and partly executed. The *Frieze of Life* was a notion very typical of the Symbolist movement. What Munch planned to do was to make a symbolic presentation of his life experience, embodied in various archetypes. Among the chosen subjects were *The Dance of Life*, *The Cry*, *The Vampire*, *Madonna*, *Death and the Maiden*. Some of these, as it happened, had obsessed other Symbolists, among them men, such as Gustave Moreau, who were fundamentally very different from Munch. But Munch was able to give a personal colouring to all of them. This is not surprising, when we reflect on his belief that individual personality was the mainspring of the impulse towards art. He was later to say: 'My art has given my life a meaning. I was seeking the light through it. It has been a stick to lean on which I needed.'

His approach to the idea of the artist and his mission was to some extent influenced by his literary contacts. He was on terms of friendship with Strindberg; he was commissioned to paint a portrait of Nietzsche; and he was closely linked to the most important Symbolist circles in Paris. In 1895, for example, *La Revue blanche* published his lithograph of *The Cry*; while in 1896 and 1897 he exhibited at the Salon des Indépendants, and in 1896 at Bing's gallery, L'Art Nouveau. This was also the year in which he met Mallarmé.

Much of Munch's art, during these crucial years, is connected with feelings about womanhood, or, rather, with feelings about the transmutations of the female principle. In *The Sick Child*, of 1896, we see the young, immature girl's encounter with death – a theme later to

184

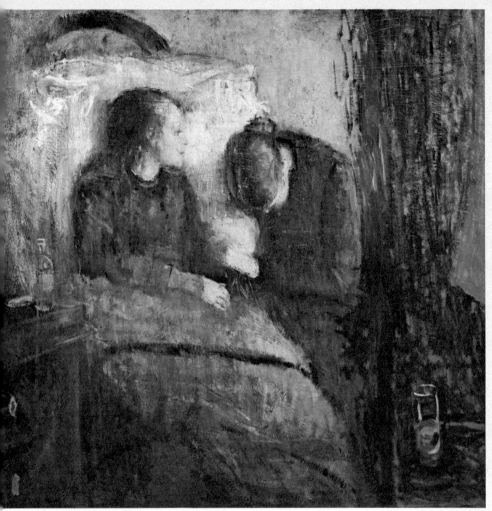

163 EDVARD MUNCH *The Sick Child* 1896

be taken up, in more traditional though less naturalistic form, with
Death and the Maiden. In *Puberty*, the subject is the girl's discovery that
she is no longer a child, but a woman; while *The Three Stages of*
Woman tries to show the female in all her important aspects.

Munch was very much a product of his own time. He was, for
example, fascinated by subjects which we have now come to regard as

PUBERTY

168

Salome typical of *1890's* —

male terror female sexuality

connection Self —

devoid of Self-consciousness

figu[re]

being especially typical of the 1890s. His *Salome* is a sister of Moreau's, and Beardsley's and Gustav Klimt's. And the obsession with the idea of the *femme fatale* reappears in other compositions such as *The Vampire*, which is a powerful evocation of the male terror of female sexuality.

Like Redon, Munch was interested by the imagery of science. In several prints entitled *Madonna*, further evocations of dominant female sexuality, the image is presented within a framework of spermatic particles and embryos. In *Man and Woman Meeting in Space*, the figures actually borrow their shape from the spermatic particles around them.

However, there is something which makes him different from, and greater than, most of the artists who were his contemporaries. This is his contempt for the notion of stylishness. Few artists speak to us so directly about the self, but even fewer are so devoid of self-consciousness. In 1889, Munch declared: 'No longer shall I paint interiors, and people reading, and women knitting. I shall paint living people, who breathe and feel and suffer and love – I shall paint a number of

165 EDVARD MUNCH *Vampire* 1896–1902

pictures of this kind. People will understand the sacredness of it, and will take off their hats as though they were in church!'

One of the striking things about Munch is the way in which every element in a given composition contributes to the purpose, helps to create the emotion which the artist wants to convey. *The Cry* is the most famous example, in which not only the figure, but the landscape surrounding the figure, cries out. In the course of this account, we have met other artists who display similar tendencies: Eugène Carrière comes immediately to mind. Yet Carrière seems always to sacrifice something to the unity which he is so determined to achieve; by imposing a rigorous unity on his compositions, he also distances them from us. The opposite is true of Munch. Of all the artists discussed in this book, he is probably the one who touches our nerves most directly.

It may be argued that the 'raw emotion' of Munch's work in fact makes him at least as much an Expressionist as a Symbolist. It is certainly true that his work had a greater influence upon the Expres-

187

164 EDVARD MUNCH *The Voice* 1893

166 EDVARD MUNCH *Madonna* 1895–1902

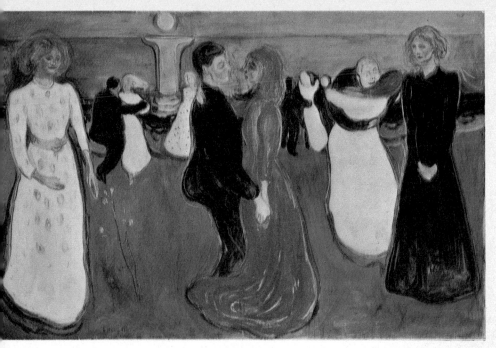

167 EDVARD MUNCH *Dance of Life* 1899–1900

sionist artists whom he met in northern Germany. Yet his aims always remained different from theirs, in that he was never content with emotion alone, but wanted to convey the resonances of feeling, as well as its initial upsurge. With Munch, we get not only the bell-stroke, but its reverberation. This is particularly true of the compositions suffused with the light of a northern evening, such as *Summer's Night* and *The Voice*, which are also evocations of the jealousy of the forsaken woman. It is also significant that the emotions which Munch chooses to evoke, during this, the most crucial period of his career, are in themselves ambiguous and complex. Desire, jealousy, melancholy – these are the feelings he goes back to again and again.

No artist could work under the pressures which Munch imposed on himself without eventually paying a price. He suffered from a number of illnesses during the 1890s, and eventually, in 1908, had a serious nervous breakdown. This marked a watershed in Munch's life.

During 1909, while he was still recovering at the clinic to which he had been sent, he entered the competition for a series of murals for the

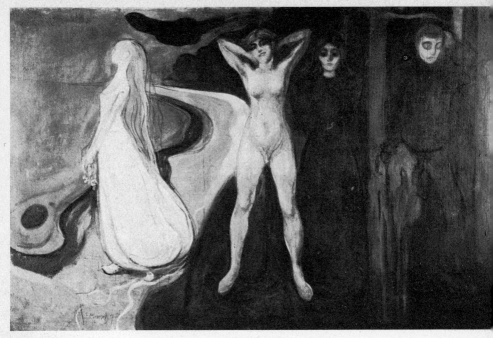

168 EDVARD MUNCH *Three Stages of Woman* 1894

great hall of Oslo University. He settled permanently again in Norway
in 1910. In 1911, it was announced that he had won the commission.
It is true that signs of recognition had not been lacking, even before
this date. His work had already entered the National Gallery in Oslo,
admittedly amid some controversy. And the earliest monograph on
his work was published in 1894. But now, very definitely, he was no
longer a lone wolf, a man crying out against life and its injustices.

One does not find the rapid decline of artistic talent in Munch's
work after 1908 that one finds in Ensor's after 1900. He remained a
great painter, although his period of greatest international importance
was over. If we want to understand how Symbolism led towards
Modernism, then it is to Munch's work in the 1890s that we must look.
During that decade, in particular, he had every claim to be called the
most advanced artist of his time. Long before it was enunciated else-
where, he embodied the doctrine that the modern artist puts himself
personally at risk in his art – that in giving life to his creations, he
necessarily risks his own.

190

169 EDVARD MUNCH *Self-portrait* c. 1893

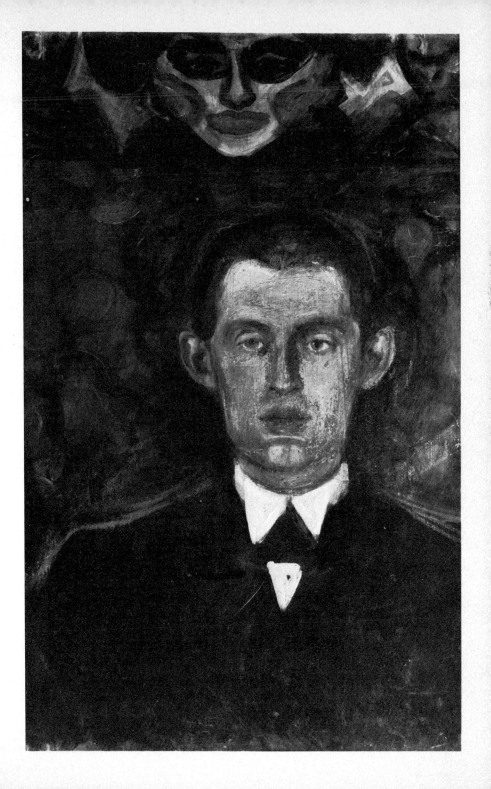

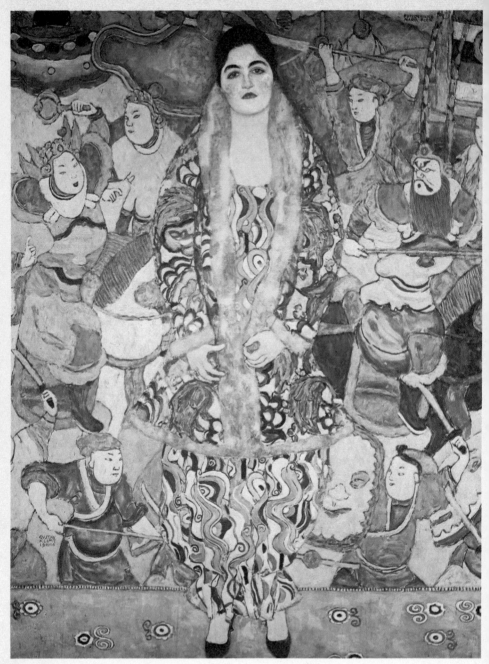

170 GUSTAV KLIMT *Frederica Maria Beer* 1916

Klimt and the Vienna Secession

If Munch represents one important aspect of later Symbolist painting, Gustav Klimt represents quite another. Symbolism can be regarded with equal justice either as the precursor of Modernism, or as the last flowering of the European civilization which was to be destroyed by the First World War. It is this second aspect that seems dominant in Klimt's work, not least because he was very much a product of the Austro-Hungarian Empire which was itself to founder in the cataclysm. Klimt was an avant-garde artist, in terms of his own time; but it is in the terms of his own time that we are constrained to judge him.

He was born in 1862, and had already established his artistic reputation by 1883. But it was only in 1891 that he began to move towards an idiom that we should now recognize as Symbolist. About this date, his work began to show a strong feeling for two-dimensional patterning. His real identification with the world of international Symbolism came with the formation of the Vienna Secession in April 1897, with Klimt as its first President. The early years of the Secession's history were dominated by Klimt's artistic personality, and these were also the years in which he himself made an international reputation.

One of the best ways of reaching an understanding of the Secession, and what it was about, is to look at the subjects of some of its early exhibitions. The eighth exhibition, for example, which took place in 1900, introduced Vienna to the work of Charles Rennie Mackintosh and the Glasgow School; the fourteenth exhibition of 1902 had as its centrepiece an ambitious sculpture of Beethoven by Max Klinger, and Klimt himself designed a frieze to surround this; the fifteenth exhibition, in the same year, introduced French Impressionist and Post-Impressionist art to Vienna; and the seventeenth exhibition was devoted to Klimt himself. British art and artists were also well represented in these early shows. Among those who showed – in addition to the members of the Glasgow group – were Walter Crane, Charles Shannon, Aubrey Beardsley, and Whistler.

In 1905 Klimt and the group who surrounded him quarrelled with the other members of the Secession, and left the organization. Never-

theless in the course of eight years they had created a new image for Symbolist art – almost the last fruits of the whole Symbolist harvest. It has been said that Symbolism, in its Viennese form, was almost grotesque in its degree of eclecticism. Certainly there are an enormous number of attributable influences to be discovered in the work of Klimt and his followers. One of the most important was that of Munich Jugendstil, but to this could be added that of Glasgow Art Nouveau, of Late Pre-Raphaelitism, as exemplified by Crane, Beardsley and Burne-Jones, and even of the more extreme works of Jan Toorop.

These influences were fused to make a characteristic and coherent style – at least, as far as Klimt's own work was concerned. His work, especially in the period from 1891 to 1910, tends to tread a tightrope. There is a constant tension between what is representational and what *170, 171* is abstract. In a given composition, certain areas (the faces) will be illusionistic, others (such as the garments) will be flat patterns. Naturally, this leads to a breaking up of the continuity of spatial representation. Although, as Johannes Dubai points out, precursors of Klimt's method of pictorial construction can be found in the Pre-Raphaelites, and also in some works by Gustave Moreau, he carries his experiments a great deal further than they do. Beardsley is perhaps the only artist who is prepared to take matters quite as far; however, Beardsley is not a painter but an illustrator. He can think of the design as something written on a surface, whose essential flatness must be preserved in order to balance the type which appears either on the same page or on a facing page.

Dubai also remarks that 'more than any other of his contemporaries, Klimt treated the painting as a material object as well as a vehicle of representation and carrier of symbolic meaning'. In fact, the breaking *174* up of spatial continuity which we notice in Klimt comes about precisely because the object-quality of the painting is so much emphasized.

The Vienna Secession, in any case, was heavily committed to bringing about a reform of the applied arts, and much of its most important work was done in this field. In this, it resembled Symbolist movements elsewhere. The English Pre-Raphaelites were, from the 1860s onwards, committed to a reform of the crafts; and it was also a field of activity which deeply interested Klimt's Dutch and Belgian contemporaries. Indeed, it has sometimes been remarked that the rapid

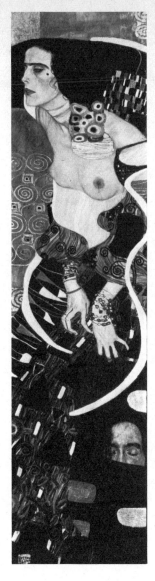

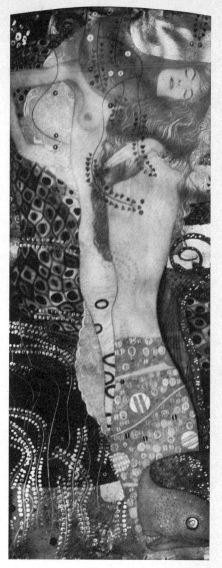

171 GUSTAV KLIMT
Salome 1909

172 GUSTAV KLIMT
Female Friends
1904–07

spread of Art Nouveau throughout Europe tended to coincide with a
distinct slackening of the Symbolist impetus in painting and sculpture.
There is, here, a distinct resemblance to the pattern of development
to be discerned in the Russian Constructivist Movement in the years
between 1913 and 1930.

195

173 GUSTAV KLIMT *Pallas Athene* 1898

Klimt's work is not only poised between naturalism and stylization; it is poised between the fine arts and the crafts. The most important of all his decorative commissions was that for the mosaics in the Palais Stoclet in Brussels, given to him when he was at the very height of his European reputation. In 1903, Klimt had seen the Byzantine mosaics in the churches of Ravenna, and these had made a great impact on his painting. It was only natural that mosaic should be the chosen medium at the Palais Stoclet. By encouraging him to render pattern in 'real' terms, rather than by simulating what was needed in paint, the Stoclet commission brought Klimt very close to the invention of collage, some years before its possibilities occurred to Braque and Picasso.

Yet one must not push Klimt's claims to pioneering originality too

174 GUSTAV KLIMT *Music* 1895

far. Even his use of ornament situates him within the Symbolist milieu, now irrevocably doomed by world events. The contemporary critic. Ludwig Hevesi spoke of Klimt's pattern as a metaphor for 'never-ending, infinitely mutating primal matter – spinning, whirling, coiling, winding and twisting – a fiery whirlwind which assumes all *172* shapes, flashing lightning and the darting tongues of serpents, clinging tendrils, enmeshed chains, dripping veils, stretched nets'. Yet this pattern is also the means whereby the artist creates his typical air of luxury, the very thing which makes him a man of the pre-1914 world, rather than of our own. One keynote of Klimt's work is passivity; the creative energy to be found in his work is a doomed, even a self-destructive force.

Unlike Munch, Klimt is by no means an isolated figure. In Vienna, he was surrounded by other artists, some of whom worked in an idiom which distinctly resembled his own. Perhaps the most talented was Kolo Moser; another was Oskar Laske, whose *Ship of Fools*, illustrated here, takes up a theme traditional in German art.

175, 176

Two younger men, both of them connected with the Vienna Secession, serve to pinpoint the difference between Klimt's enclosed, luxurious world, and the harsh reality which co-existed with it, and which was to overwhelm it in 1914. One was the short-lived Egon Schiele, whom Klimt admired and helped. Though their names are now often linked, they represent fundamentally different tendencies. Schiele abandoned ornament for expression, decoration for outcry. It is true that he comes close to Klimt in certain townscapes, but his treatment of the figure is very different: angular and awkward, where Klimt's is fluid and suave. It is, of course, true that we see almost the last flicker of the French Decadence of the mid 1880s in some of Schiele's themes – the well-known picture which shows a cardinal embracing a nun might have delighted Huysmans, but for its subject-matter rather than its style. In mood, it is related to Rops.

177

175 KOLO MOSER *The Dancer Loie Fuller*

176 OSKAR LASKE *Ship of Fools*

177 EGON SCHIELE *Cardinal and Nun* 1912

178 OSKAR KOKOSCHKA *The Bride of the Wind* 1914

The other young artist who should be mentioned in this context is Oskar Kokoschka, who was born in Lower Austria, and who entered the Vienna School of Applied Art in 1904, at the very height of Jugendstil influence. In 1908, the Vienna Workshops, which were closely connected with the Secession, put out a series of lithographs by Kokoschka entitled *The Dreaming Youths*. These show the influence of Klimt and Beardsley, and also that of Hodler (to whom Schiele owed something as well). The Symbolist influence was to persist in Kokoschka's work after 1910, when Herwarth Walden brought him from Vienna to Berlin. Walden was the centre of the Der Sturm group, and Der Sturm was a focus for Expressionism; Walden ran a magazine and an art gallery under the same title. But even in this changed artistic atmosphere, Kokoschka long retained his *178* leaning towards Symbolism. His *Bride of the Wind*, which dates from 1914, after the Berlin period, still holds Expressionist and Symbolist elements in balance with one another.

The Young Picasso

One important Symbolist artist remains to be discussed: the young Pablo Picasso. Picasso's commitment to Symbolist ideas, during the earlier part of his career, is something which has been obscured by his later fame as an innovator. Since Symbolism was for a long period out of fashion, it was considered to be somehow embarrassing that one of the central figures in the Modern Movement should have his roots in it. The pictures of Picasso's Blue and Rose Periods represent a further upsurge of Symbolist ideas at a time when these seemed to have exhausted their creative energy.

Picasso grew up in the artistic milieu of Barcelona. As the centre of Catalan culture, the city had a lively intellectual life. There was, in particular, a good deal of curiosity about artistic developments outside Spain, of which true Catalans did not consider themselves to be an integral part. This curiosity, in avant-garde circles, was directed towards everything northern. Frequent translations were made from contemporary German literature; articles on Schopenhauer and Nietzsche were published; and, from 1900 onwards, an Asociación Wagneriana existed to promote interest in the master's operas. These, especially *Siegfried* and *Tristan und Isolde*, were often performed at the Barcelona opera-house. In addition, there were performances of plays by Ibsen and Maeterlinck.

English art exercised a particular influence through the periodical *Juventut*. The first number, which appeared in 1900, contained a long illustrated biography of Aubrey Beardsley, whom it characterized as the 'Fra Angelico of Satanism'. Later issues had illustrations by Rossetti and Burne-Jones.

Picasso's family had established itself in Barcelona in 1896, when his father was appointed Professor at the Academy. In the following year the tavern Els Quatre Gats was founded by Pedro Romeu, and Picasso soon became a habitué. Els Quatre Gats was one of the most important centres of Bohemian and artistic life in the city; it stood, in particular, for a raucous defiance of bourgeois standards. By 1900, the young artist felt that he was ready to venture outside Spain, to

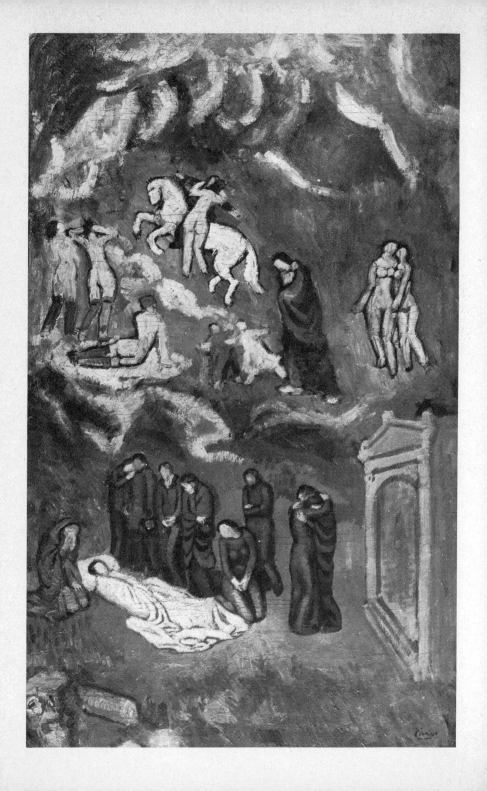

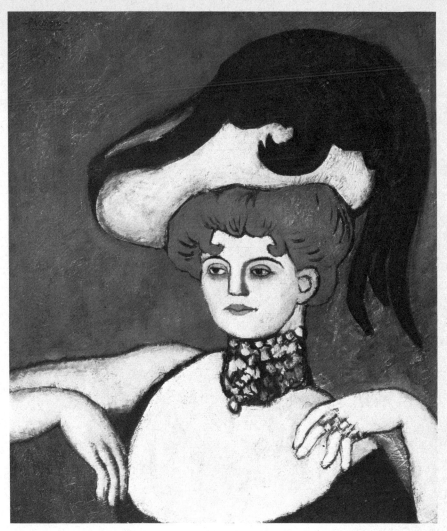

180 PABLO PICASSO *Courtesan with Jewelled Collar* 1901

see what was going on abroad for himself. He set out for Paris in the autumn of that year, and apparently meant to go on from France to England, a plan which was not fulfilled. Though this first trip to Paris was hardly a success, it was followed by others, until Picasso finally abandoned Barcelona for good in 1904.

179 PABLO PICASSO *Evocation* 1901

The early friendships which Picasso made in Paris, and the exhibitions which he saw there, had an important influence on his development as an artist. For example, he saw the Seurat retrospective, staged under the auspices of *La Revue blanche*, in 1900, a show of Redon pastels in the same year, and the Gauguin memorial exhibition in 1903.

Like any young artist, Picasso found it difficult to choose among the various possibilities which were open to him. About 1900, he admired Burne-Jones and Beardsley among others, but the strongest attraction was undoubtedly exercised by French urban Realists such as Steinlen and Toulouse-Lautrec. Gradually, however, he began to give his exercises after Lautrec an increasingly Symbolist flavour. The *Courtesan*
180 *with Jewelled Collar*, illustrated here, is one of Lautrec's demimondaines subtly transformed into a contemporary version of the *femme fatale*. Still more Symbolist is the important picture entitled
179 *Evocation*. This, which dates from 1901, is dedicated to Picasso's friend Casamegas, who accompanied him on his first trip to Paris, and who committed suicide there.

The Symbolist influence in Picasso's work at this time was reinforced by his contacts with the gifted Barcelona painter Isidore Nonell, who lent his studio to Picasso at some time just before 1900. This must have given him ample opportunity to study Nonell's compositions. These, with their closed angular silhouettes (characteristics ultimately derived from Puvis de Chavannes and Hodler), have a distinct resemblance to the paintings of Picasso's Blue Period, which began in 1903.

The Blue Period, and the Rose Period which followed it, were Picasso's personal contribution to the history of Symbolist art. In the works that he created at this time, there is an extensive recapitulation of favourite Symbolist themes. For example, the etching *Salome*
181 *Dancing before Herod* might almost be regarded as a parody of Gustave
182 Moreau; while the *Poor People Beside the Sea*, now in the National
65 Gallery in Washington, carries a distinct echo of Puvis's *The Poor*
183 *Fisherman*. The unfinished *Death of Harlequin*, which entranced the German Symbolist poet Rainer Maria Rilke, looks as if it owed a good deal to Beardsley's design for Ernest Dowson's *The Pierrot of the Minute*.

In fact, Picasso's artistic ambitions at this time were in themselves
184 close to those of the Symbolist artists who had preceded him. *Life*, which is one of the best known of all the paintings of the Blue Period, is an attempt to sum up the meaning of existence – something already

181 PABLO PICASSO *Salome Dancing before Herod* 1905

182 PABLO PICASSO *Poor People Beside the Sea (Tragedy)* 1903

familiar to us from the work of Edvard Munch. Symbolist art often possessed, as we have seen, a confessional element, and this is plainly the case with the pictures in which the figure of Harlequin appears. The melancholy jester who was also an eternal outsider clearly aroused in Picasso strong feelings of self-identification.

It seems particularly appropriate that the man who is now universally acknowledged as one of the founders of the Modern Movement in art should also have been the last of the important Symbolist painters. The poet André Salmon, one of Picasso's earliest friends in Paris, remarked of the painter and his group that 'they were to their Symbolist elders the ungrateful sons who had once been Symbolists'. This seems an admirable summary. A painting such as *The Mountebanks* of 1905 stands precisely at the parting of the ways. On the one hand it looks backward to Puvis de Chavannes, and past Puvis to the whole academic tradition which he had attempted to revivify. On the

185

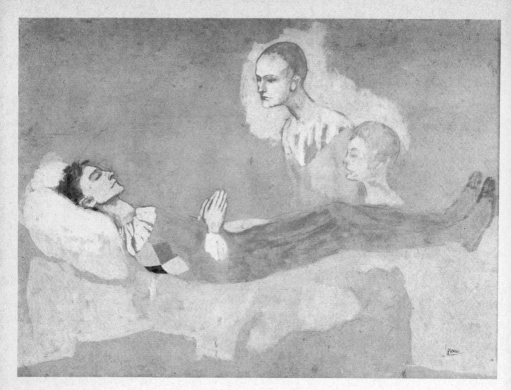

183 PABLO PICASSO *Death of Harlequin* 1905

other hand, through the mere fact of its authorship, it looks forward to *Les Demoiselles d'Avignon*.

Symbolism is the bridge between the Romanticism of the earlier part of the nineteenth century, and modern art as we now recognize it. At the same time it is the proof that the development away from Romanticism into Modernism was a continuous process. It is true that, in the years immediately preceding the First World War, there was a growing impatience with what was considered to be Symbolist preciosity and over-refinement. Artists began to long for a harsh Primitivism, just as some of their contemporaries longed for war itself. But even this taste for the Primitive had its roots in Symbolism – we need look no further than Gauguin for the proof.

It has long been recognized that literary Symbolism adumbrates many of the things which are now, nearly a hundred years later, considered typical of Modernism in literature. Mallarmé's late poem

184 PABLO PICASSO *Life* 1903

'Un Coup de dés' is as radical an experiment as anything that has been created since. It ought also to be recognized that the Modernist Movement in the visual arts was not a matter of a single explosion somewhere about 1905.

Symbolism is the thread which allows us to make sense of the way in which European art developed in the second half of the nineteenth century. The determination shown by many art historians to ignore it as a kind of feeble rival of Impressionism has been, to put it mildly, unfortunate. In this book I have endeavoured to put right a number of distortions which, if not really old in themselves, have become sanctified by much repetition. At the same time, I have attempted to show that painting and sculpture, in the nineteenth century, as in the twentieth, ought to be considered on a European rather than a national scale.

185 PABLO PICASSO *The Mountebanks* 1905

Angeli, Helen Rossetti, *Dante Gabriel Rossetti*, New York 1949, London 1969.

Aubrun, René Georges, *Péladan*, 2nd edn, Paris 1904.

Bacou, Roseline, *Odilon Redon*, Geneva 1956.

Baldick, Robert, *The Life of J. K. Huysmans*, Oxford and Fair Lawn, N.J., 1955.

Bell, Malcolm, *Edward Burne-Jones*, London and New York 1892.

Bénédite, Léonce, *Théodore Chassériau*, Paris 1931.

Benois, Alexandre, *Memoirs*, London 1960.

Blanche, Jacques-Emile, *Portraits of a Lifetime*, London 1937.

Blunt, Anthony, and Phoebe Pool, *Picasso, the Formative Years*, London and Greenwich, Conn., 1962.

Brombert, Victor, *The Novels of Flaubert*, Princeton 1966.

Burne-Jones, Georgiana, *Memorials of Edward Burne-Jones*, London and New York 1904.

Charteris, Evan, *John Sargent*, London 1927.

Chassé, Charles, *Le Mouvement symboliste*, Paris 1947.

Chassé, Charles, *The Nabis and their Period*, London and New York 1969.

Chesterton, G. K., *G. F. Watts*, London 1904.

Courthion, Pierre, *Rouault*, London 1962.

Daix, Pierre, and Georges Boudaille, *Picasso, 1900–1908*, Lausanne 1966.

Doughty, Oswald, *A Victorian Romantic (Dante Gabriel Rossetti)*, 2nd edn, Fair Lawn, N.J., 1960, London 1963.

Dumont-Wilden, L., *Fernand Khnopff*, Brussels 1907.

Geffroy, Gustave, *L'Œuvre de Carrière*, Paris 1901.

Gray, Camilla, *The Great Experiment in Russian Art*, London 1962. 2nd edn, *The Russian Experiment in Art 1863–1922*, London and New York 1970.

Haftmann, Werner, *Painting in the Twentieth Century*, rev. edn, New York and London 1965.

Hassaerts, Paul, *James Ensor*, Brussels 1957.

Hilton, Timothy, *The Pre-Raphaelites*, London and New York 1970.

Hodin, J. P., *Edvard Munch*, London and New York 1972.

Hoff, August, *Johan Thorn Prikker*, Recklinghausen 1958.

Huysmans, J. K., *L'Art moderne*, Paris 1883.

Huysmans, J. K., *Certains*, Paris 1889.

Jaworska, Wladyslawa, *Gauguin and the Pont-Aven School*, London and Greenwich, Conn., 1972.

Jean, René, *Puvis de Chavannes*, Paris 1914.

Jullian, Philippe, *Dreamers of Decadence*, London 1971, New York 1972.

Kandinsky, Vassily, *Concerning the Spiritual in Art*, New York 1955.

Knipping, J. B., *Jan Toorop*, Amsterdam 1947.

Laran, Jean, *Gustave Moreau*, Paris n.d.

La Sizeranne, Robert de, *La Peinture anglaise contemporaine, 1844–1894*, Paris 1922.

Laver, James, *The First Decadent (J. K. Huysmans)*, London 1954.

Lehman, A. G., *The Symbolist Aesthetic in France, 1885–1895*, 2nd edn, Oxford and New York 1968.

MacMillan, Hugh, *The Life Work of George Frederick Watts*, London 1903.

Michel, André, *Puvis de Chavannes*, Paris n.d. (1911).

Milner, John, *Symbolists and Decadents*, London and New York 1971.

Moen, Arve, *Edvard Munch: Age and Milieu*, Oslo 1956.

Moen, Arve, *Edvard Munch: Woman and Eros*, Oslo 1957.

Moen, Arve, *Edvard Munch: Nature and Animals*, Oslo 1958.

Moore, T. Sturge, *Charles Ricketts R. A.*, London 1933.

New York, Guggenheim Museum. 'Gustav Klimt and Egon Schiele', exhibition catalogue, New York 1965.

Novotny, Fritz, and Johannes Dubai, *Gustav Klimt*, London and New York 1968.

Ormond, Richard, *John Singer Sargent*, London and New York 1970.

Paladilhe, Jean and José Pierre, *Gustave Moreau*, London and New York 1972.

Paris, Musée Gustave Moreau, *Catalogue sommaire*, Paris 1904.

Péladan, Joséphin, *De la sensation d'art*, Paris 1907.

Péladan, Joséphin, *Introduction à l'esthétique*, Paris 1907.

Péladan, Joséphin, *L'Art idéalistique et mystique*, Paris 1909.

Perruchot, Henri, *Gauguin*, London and New York 1963

Polak, Bettina Spaanstra, *Het Fin-de-Siècle in de Nederlandse Schilderkunst*, The Hague 1955.

Polak, Bettina Spaanstra, *Symbolism*, Amsterdam 1967.

Praz, Mario, *The Romantic Agony*, 2nd edn, London 1951, Fair Lawn, N.J., 1970.

Reade, Brian E., *Aubrey Beardsley*, London and New York 1967.

Redon, Odilon, *A soi-même*, Paris 1922.

Ricketts, Charles, *Self Portraits: Letters and Journals*, ed. Cecil Lewis, London 1939.

Rose, Barbara, *American Art Since 1900*, London and New York 1967.

Rothenstein, John, *Artists of the Nineties*, London 1928.

Rothenstein, John, *The Life and Death of Conder*, London 1938.

Sandstrom, Sven, *Le Monde imaginaire d'Odilon Redon*, Lund and New York 1955.

Séailles, Gabriel, *Eugène Carrière*, Paris 1901.

Symons, Arthur, *From Toulouse-Lautrec to Rodin*, London 1929, Freeport, N.Y., 1930.

Taylor, John Russell, *The Art Nouveau Book in Britain*, London 1966, Cambridge, Mass., 1967.

Toronto, Art Gallery of Ontario. 'Sacred and Profane in Symbolist Art', exhibition catalogue, Toronto 1969.

Vachon, Maurice, *Puvis de Chavannes*, Paris 1895.

West, W. K., and Romualdo Pantini, *George Frederick Watts*, London 1904.

Wind, Edgar, *Pagan Mysteries of the Renaissance*, 2nd edn, London 1968.

Wind, Edgar, *Giorgione's 'Tempesta'*, Oxford and Fair Lawn, N.J., 1969.

List of Illustrations

Measurements are given in inches and centimetres, height before width

AMAN-JEAN, EDMOND (1860–1935)
91 *St Julian the Hospitaller*, 1882. Musée des Beaux-Arts, Carcassonne.

BAKST, LEON (1866–1924)
126 *Schéhérézade: The Grand Eunuch*, 1910. Watercolour. Musée des Beaux-Arts, Strasbourg.

BEARDSLEY, AUBREY VINCENT (1872–98)
48 *The Wagnerites (Tristan and Isolde)*, 1894. Published in the *Yellow Book,* vol. III, October 1894. From the original drawing in the Victoria and Albert Museum, London.
110 *Merlin and Nimue*, 1893–94. Full-page illustration to Malory's *Le Morte d'Arthur*, vol. I, London 1893–94. Victoria and Albert Museum, London.
112 *Salome, c.* 1894. Illustration to Oscar Wilde's play, published London 1894.
117 *The Rheingold (Third Tableau), c.* 1896. Pen and ink. Museum of Art, Rhode Island School of Design, Providence, R.I.

BENOIS, ALEXANDRE (1870–1960)
128 *Le Pavillon d'Armide*, 1907. Stage set, watercolour on paper. Russian Museum, Leningrad.

BERNARD, ÉMILE (1868–1941)
69 *Self-portrait*, 1888. 18¼ × 21⅝ (46 × 55). Collection V. W. van Gogh, Laren.
70 *Breton Women in a Green Pasture*, 1888. Canvas, 29⅛ × 36¼ (74 × 92). Denis Family Collection, Saint-Germain-en-Laye.

BLAKE, WILLIAM (1757–1827)
25 *The Ancient of Days*, 1794. Watercolour, black ink and gold paint, over a relief-etched outline painted in yellow, 9¼ × 6⅝ (23.5 × 17). Whitworth Art Gallery, University of Manchester.

BOCCIONI, UMBERTO (1882–1916)
149 *Those who Stay*, 1911. Oil on canvas, 27⅝ × 37⅜ (70 × 95). The Museum of Modern Art, New York.

BÖCKLIN, ARNOLD (1827–1901)
129 *Battle of the Centaurs*, 1873. Tempera, 41⅜ × 76¾ (105 × 195). Öffentliche Kunstsammlung, Basle.
130 *The Island of the Dead*, 1880. Oil

on canvas, 43¾ × 61 (111 × 155). Öffentliche Kunstsammlung, Basle.
131 *Calm Sea*, 1887. Wood, 40⅛ × 59 (102 × 150). Kunstmuseum, Berne.

BOLDINI, GIOVANNI (1845–1931)
42 *Count Robert de Montesquiou*, 1897. Oil on canvas, 78¾ × 39⅜ (200 × 100). Musée National d'Art Moderne, Paris.

BONNARD, PIERRE (1867–1947)
79 *La Revue blanche*, 1894. Lithograph, 30¾ × 23⅞ (78·1 × 60·6).

BORISSOV-MUSSATOV, VICTOR (1870–1905)
124 *The Sleep of the Gods*, 1903. Study for a fresco, tempera. Tretyakov Gallery, Moscow.

BOTTICELLI, SANDRO (*c.* 1445–1510)
5 *Primavera, c.* 1478. Tempera on panel, 79⅞ × 123⅝ (203 × 314). Uffizi, Florence.

BRANCUSI, CONSTANTIN (1876–1957)
150 *The Prayer*, 1907. Bronze, h. 40 (101·5). Muzeul de Artă R.S.R., Bucharest.

BRESDIN, RODOLPHE (1822–85)
56 *The Comedy of Death*, 1854. Lithograph, first state, 8½ × 5⅞ (21·7 × 15). Bibliothèque Nationale, Paris.

BURNE-JONES, SIR EDWARD COLEY (1833–98)
101 *Danaë: The Tower of Brass*, 1887–88. Oil on canvas, 91 × 44½ (231 × 113). City Museum and Art Gallery, Glasgow.
102 *The Annunciation*, 1879. Oil on canvas, 98½ × 41 (250 × 104). By courtesy of the Trustees of the Lady Lever Art Gallery, Port Sunlight.
103 *The Golden Stairs*, 1880. Oil on canvas, 109 × 46 (276 × 117). Tate Gallery, London.
104 *Love and the Pilgrim*, 1896–97. Oil on canvas, 62 × 120 (157 × 304). Tate Gallery, London.
105 *Pygmalion: The Godhead Fires*, 1878. Oil on canvas, 38¾ × 29½ (97·5 × 75). City Museum and Art Gallery, Birmingham.
107 *The Flower Book: Grave of the Sea*. Plate XVI ('A drowned man found by a mermaid'), published London 1905. 17 × 12 (43·5 × 30·5).
108 *The Sleeping Knights*, 1871. Oil on canvas, 23¼ × 32½ (59 × 82·5). Walker Art Gallery, Liverpool.
109 *Merlin and Nimue*, 1861. Water-

colour, 25¼ × 20½ (65 × 52). Victoria and Albert Museum, London.

CALVERT, EDWARD (1799–1883)
26 *A Primitive City, c.* 1822. Watercolour, 2¾ × 4⅛ (7 × 10·5). By courtesy of the Trustees of the British Museum, London.

CARRIÈRE, EUGÈNE (1849–1906)
46 *Paul Verlaine, c.* 1896. Oil on canvas. Palais du Luxembourg, Paris.
67 *Motherhood*. Oil on canvas. Musée Rodin, Paris.

CHASSÉRIAU, THÉODORE (1819–56)
24 *Mazeppa*, 1851. Oil on canvas, 22 × 14½ (55·5 × 37). Musée des Beaux-Arts, Strasbourg.

ČIURLIONIS, MIKALOJUS (1875–1911)
138 *Sonata of the Stars*, 1908. Tempera on paper, 28¾ × 24⅜ (73·5 × 62·5). Valstybinis M. K. Čiurlionis Dailés Muziejus, Kaunas.

CONDER, CHARLES (1868–1909)
116 *A Toccata of Galuppi's*, 1900. Watercolour on silk, 11 × 8¼ (28 × 21). The Fine Art Society Ltd, London.

COSSA, FRANCESCO DEL (1435/6–*c.* 1477)
2 *Triumph of Venus*, 1458–78. Fresco, whole room, 94½ × 42¼ (240 × 110). Palazzo Schifanoia, Ferrara.

CRANE, WALTER (1845–1915)
106 *The Laidly Worm*, 1881. Oil on canvas, 26⅜ × 65¾ (67 × 167). Galleria del Levante, Milan.

DADD, RICHARD (1817–87)
28 *The Rock and Castle of Seclusion*, 1861. Watercolour, 5⅞ × 5⅞ (14·3 × 14·9). By courtesy of the Trustees of the British Museum, London.
29 *The Fairy Feller's Masterstroke*, 1855–64. Oil on canvas, 21¼ × 15½ (54 × 39). Tate Gallery, London.

DAVIES, ARTHUR BOWER (1862–1928)
123 *Full-orbed Moon*. Oil on canvas, 20½ × 15½ (52 × 39). The Art Institute of Chicago, the Ryerson Collection.

DELACROIX, EUGÈNE (1798–1863)
22 *The Death of Sardanapalus*, 1827. Oil on canvas, 195 × 145 (495 × 395). Louvre, Paris.

DELVILLE, JEAN (1867–1951)
47 *Parsifal*, 1890. Charcoal, 27½ × 22 (70 × 56). Piccadilly Gallery, London.

94 *Orpheus*, 1893. Oil on canvas, 31 × 39 (79 × 99). Collection Mme Gilléon-Growet, Brussels.
95 *The End of a Reign*, 1893. Oil on canvas, 34 × 21 (86·5 × 53·5). Collection M. Olivier Delville, Brussels.

DENIS, MAURICE (1870–1943)
73 *Landscape with Hooded Man*, 1903. Oil on canvas, 24¾ × 21 (63 × 54). National Gallery of Canada, Ottawa.

DESBOUTIN, MARCELLIN (1823–1902)
88 *Sâr Péladan*, 1891. Oil on canvas. Musée des Beaux-Arts, Angers.

DORÉ, GUSTAVE (1832–83)
21 *Ship among Icebergs*, c. 1865. Illustration to Coleridge's *Rime of the Ancient Mariner*. Dark brown paper, with an indian ink wash, highlighted with white gouache, 23¼ × 18 (59 × 45·5). Musée des Beaux-Arts, Strasbourg.

DUCCIO, AGOSTINO DI (1418–81)
3 *Mercury*, after 1450. Marble bas-relief. Tempio Malatestiana, Rimini.

DÜRER, ALBRECHT (1471–1528)
7 *Melancholia*, 1514. Engraving, 9½ × 7½ (24·2 × 19·1). Victoria and Albert Museum, London.

ENSOR, JAMES (1860–1949)
156 *The Ray*, 1892. Oil on canvas, 31⅓ × 39¼ (80 × 100). Musées Royaux des Beaux-Arts de Belgique, Brussels.
157 *The Vengeance of Hop Frog*, c. 1910, backdated to 1898. Oil on canvas, 44¾ × 32 (114 × 81·5). Kröller-Müller Foundation, Otterlo.
158 *Self-portrait with Masks*, 1899. Oil on canvas, 46½ × 32½ (118 × 83). Collection Mme C. Jussiant, Antwerp.
159 *Old Woman with Masks*, 1889. Oil on canvas, 21¼ × 18½ (54 × 47). Musée des Beaux-Arts, Ghent.
160 *The Cathedral*, 1886. Etching, 9½ × 7½ (24·3 × 19·2). Bibliothèque Royale de Belgique, Brussels.
161 *The Entry of Christ into Brussels*, 1889. Oil on canvas, 98⅜ × 170⅞ (250 × 434). Musée Royal des Beaux-Arts, Antwerp.

FILIGER, CHARLES (1863–1928)
85 *Chromatic Notation No. 1 (Synthetic Notation)*, c. 1900. Watercolour, 9½ × 9¾ (24 × 24·5). The Museum of Modern Art, New York.

FRIEDRICH, CASPAR DAVID (1774–1840)
19 *The Wreck of the 'Hope'*, 1821. Oil on canvas, 38½ × 51⅛ (98 × 128). Kunsthalle, Hamburg.

20 *The Cross in the Mountains*, 1808. Paper, pen and sepia ink, 25¼ × 36⅝ (64 × 93·1). Staatliche Museen, Berlin.

FUSELI, HENRY (1741–1825)
17 *The Nightmare*, c. 1782. Oil on canvas, 30¼ × 25 (77 × 64). Goethe-Museum, Frankfurt.

GAUGUIN, PAUL (1848–1903)
45 *Stéphane Mallarmé*. Etching on copper. Art Institute of Chicago, the Albert M. Wolf Memorial Collection.
68 *Self-portrait*, 1889. Wood, 31¼ × 20¼ (79 × 51). National Gallery of Art, Washington, Chester Dale Collection 1962.
71 *Vision after the Sermon (Jacob and the Angel)*, 1888. Oil on canvas, 28¾ × 36¼ (73 × 92). National Gallery of Scotland, Edinburgh.
76 *Contes barbares*, 1902. Oil on canvas, 38⅝ × 26 (98 × 66). Folkwang Museum, Essen.

GHEYN, JACQUES II DE (1565–1629)
11 *Vanitas*. Collection Mrs Muensterberger, London.

GIORGIONE (GIORGIO DA CASTELFRANCO, c. 1477/8–1510)
8 *Tempesta*. Oil on canvas, 30 × 28½ (78 × 72). Accademia, Venice.

GOYA Y LUCIENTES, FRANCISCO DE (1746–1828)
16 *The Dream of Reason Produces Monsters*, 1797–99. No. 43 of *Los Caprichos* series. Etching, 7⅛ × 4¾ (18·1 × 12). Prado, Madrid.
18 *Panic (The Colossus)*, 1808–12. Oil on canvas, 45⅝ × 41⅛ (116 × 105). Prado, Madrid.

GREINER, OTTO (1896–1916)
136 *The Devil Showing Woman to the People*, 1897. Chalk on paper, 15½ × 11⅛ (39 × 29). Art Gallery of Ontario, Toronto.

HODLER, FERDINAND (1853–1918)
140 *The Night*, 1890. Oil on canvas, 45⅝ × 117¾ (116 × 299). Kunstmuseum, Berne.
141 *Adoration*, 1894. Oil on canvas, 31½ × 39¾ (80 × 101). Kunsthaus, Zürich, loan of Gottfried Keller Foundation.

HOLST, ROLAND (1868–1938)
152 *Un Beau sire grave*, Lithograph. Rijksmuseum, Amsterdam.

HUGO, VICTOR MARIE (1802–85)
23 *The Dream*. Drawing, indian ink,

10½ × 6½ (26·5 × 16·4). Maison de Victor Hugo, Paris.

HUNT, WILLIAM HOLMAN (1827–1910)
31 *The Scapegoat*, 1854. Oil on canvas, 33¾ × 54½ (85·6 × 138). By courtesy of the Trustees of the Lady Lever Art Gallery, Port Sunlight.

KANDINSKY, VASSILY (1866–1944)
139 *Couple Riding*, c. 1905. Oil on canvas, 21½ × 19½ (55·5 × 50). Staatliche Graphische Sammlung, Munich.

KHNOPFF, FERNAND (1858–1921)
1 *The Sleeping Muse*, 1896. Pencil and coloured chalks, 10½ × 4½ (26·7 × 11·4). Piccadilly Gallery, London.
96 *The Caresses of the Sphinx*, 1896. Oil on canvas, 19⅞ × 58½ (50 × 150). Musées Royaux des Beaux-Arts de Belgique, Brussels.
97 *I Lock the Door upon Myself*, 1891. Oil on canvas, 28¾ × 54¼ (72 × 140). Neue Pinakothek, Munich.
99 *The Offering*, 1891. Pastel, 12½ × 28½ (32 × 72). Private collection, USA.

KLIMT, GUSTAV (1862–1918)
170 *Friederike Maria Beer*, 1916. Oil on canvas, 66⅛ × 51⅛ (168 × 130). Friederike Beer-Monti Collection, Vienna, afterwards New York.
171 *Salome*, 1909. Oil on canvas, 70½ × 18⅛ (178 × 46). Galleria Internazionale d'Arte Moderna, Venice.
172 *Female Friends*, 1904–07. Mixed technique on parchment, 19⅝ × 7⅞ (50 × 20). Osterreichische Galerie, Vienna.
173 *Pallas Athene*, 1898. Oil on canvas, 37⅜ × 37⅜ (95 × 95). Collection Rudolf Zimpel, Vienna, on loan to Historisches Museum der Stadt Wien, Vienna.
174 *Music*, 1895. Oil on board, 14⅝ × 17½ (37 × 44·5). Bayerische Staatsgemäldesammlungen, Munich.

KLINGER, MAX (1857–1920)
132 *The Rape*, 1878–80. From *The Glove* series. Etching, 3½ × 8½ (9 × 21·8). Staatliche Graphische Sammlung, Munich.

KOKOSCHKA, OSCAR (b. 1886)
178 *The Bride of the Wind (The Tempest)*, 1914. Oil on panel, 71¼ × 87 (181 × 221). Öffentliche Kunstsammlung, Basle.

KUBIN, ALFRED (1877–1959)
133 *One-eyed Monster*, 1899. Pen, ink and wash on paper, 5⅞ × 7½ (15 × 19). Kunstkabinett Schottle, Munich.

KUPKA, FRANK (1871–1957)
148 *The Soul of the Lotus*, 1898. Watercolour, $13\frac{5}{8} \times 13\frac{5}{8}$ ($34 \cdot 5 \times 34 \cdot 5$). Narodní Galerie, Prague.

LACOMBE, GEORGES (1868–1916)
81 *St Mary Magdalen*, 1897. Wood sculpture, $41\frac{3}{8} \times 16\frac{1}{2}$ (105×42). Musée des Beaux-Arts, Lille.

LA ROCHEFOUCAULD, COUNT ANTOINE DE (1862–1900)
86 *St Lucy*, c. 1892. Oil on canvas, 34×262 (85×67). Collection Mlle H. Boutaric, Paris.

LASKE, OSKAR (1874–1951)
176 *Ship of Fools*. Tempera on canvas, $76\frac{3}{4} \times 94\frac{1}{2}$ (195×240). Österreichische Galerie, Vienna.

LORRAIN, CLAUDE (1600–82)
12 *Landscape with the Angel Appearing to Hagar*, c. 1670. Oil on canvas, $42\frac{1}{8} \times 55\frac{1}{8}$ (107×140). Alte Pinakothek, Munich.

MACDONALD, FRANCES MACNAIR (1874–1921)
115 *The Moonlit Garden*, c. 1895–97. Pencil with grey and white wash on brown tracing paper, $12\frac{1}{2} \times 20\frac{1}{2}$ ($31 \cdot 8 \times 52$). Glasgow University, Mackintosh Collection.

MACKINTOSH, MARGARET MACDONALD (1865–1933)
114 *Kysterion's Garden*, c. 1906. Pencil and watercolour on brown tracing paper, $11\frac{1}{2} \times 32\frac{1}{2}$ ($28 \cdot 8 \times 83 \cdot 5$). Glasgow University, Mackintosh Collection.

MANET, ÉDOUARD (1832–83)
43 *Stéphane Mallarmé*, 1876. Oil on canvas, $10\frac{3}{4} \times 14\frac{1}{4}$ ($27 \cdot 5 \times 36$). Louvre, Paris.

MANTEGNA, ANDREA (c. 1431–1506)
6 *Parnassus* (detail), c. 1490–97. Oil and tempera on canvas, $63 \times 75\frac{5}{8}$ (160×192). Louvre, Paris.

MARC, FRANZ (1880–1916)
142 *The Bewitched Mill*, 1913. Oil, $51\frac{3}{8} \times 35\frac{3}{4}$ ($130 \cdot 5 \times 91$). Art Institute of Chicago, Arthur Jerome Eddy Memorial Collection.

MAXENCE, EDGARD (1871–1954)
92 *The Soul of the Forest*, c. 1897. Musée des Beaux-Arts, Nantes.

MELLERY, XAVIER (1845–1921)
100 *Autumn*. Watercolour, pencil and chalk on paper laid on cardboard, $35\frac{5}{8} \times 22\frac{1}{2}$ ($90 \cdot 5 \times 57$). Musées Royaux

des Beaux-Arts de Belgique, Brussels.

MILLAIS, SIR JOHN EVERETT (1829–96)
30 *The Return of the Dove to the Ark*, 1851. Oil on canvas, $34\frac{1}{2} \times 21\frac{1}{2}$ (88×55). Ashmolean Museum, Oxford.
32 *Sir Isumbras at the Ford*, 1857. Oil on canvas, 49×67 (124×170). By courtesy of the Trustees of the Lady Lever Art Gallery, Port Sunlight.

MINNE, GEORGES (1866–1941)
98 *Fountain with Kneeling Youths*, 1898–1906. Marble, height of figures $30\frac{3}{4}$ (77). Folkwang-Museum, Essen.

MOREAU, GUSTAVE (1826–98)
49 *Mystic Flower*. Canvas, $91\frac{3}{4} \times 54\frac{3}{4}$ (233×138). Musée Gustave Moreau, Paris.
50 *Jupiter and Semele*, 1896. Canvas, $83\frac{7}{8} \times 46\frac{1}{2}$ (213×118). Musée Gustave Moreau, Paris.
51 *The Apparition*, 1876. $41\frac{3}{4} \times 28\frac{3}{8}$ (106×72). Louvre, Paris.
52 *Wayfaring Poet*. Canvas, $71\frac{1}{4} \times 56\frac{3}{4}$ (181×144). Musée Gustave Moreau, Paris.
53 *Fairy with Griffons*. Canvas, $83\frac{1}{2} \times 47\frac{1}{4}$ (212×120). Musée Gustave Moreau, Paris.
54 *The Suitors*, 1852. Canvas, 150×137 (381×348). Musée Gustave Moreau, Paris.

MOSER, KOLOMAN (1868–1918)
175 *The Dancer Loie Fuller*. Watercolour and chalk, $5\frac{7}{8} \times 8\frac{1}{2}$ ($15 \times 21 \cdot 7$). Albertina, Vienna.

MUNCH, EDVARD (1863–1944)
44 *Stéphane Mallarmé*, 1896. Lithograph, $16 \times 11\frac{1}{2}$ ($40 \cdot 5 \times 29$). Art Institute of Chicago, the Stanley Field Fund.
162 *The Cry*, 1895. Lithograph, $13\frac{3}{4} \times 9\frac{7}{8}$ ($35 \cdot 2 \times 25 \cdot 5$). Rosenwald Gallery of Art, Washington, Lessing Collection.
163 *The Sick Child*, 1896. Oil on canvas, $47\frac{5}{8} \times 46\frac{1}{2}$ (121×118). Nasjonalgaleriet, Oslo.
164 *The Voice*, 1893. Oil on canvas, $43\frac{1}{2} \times 35\frac{5}{8}$ (110×88). Museum of Fine Arts, Boston, Ellen Kelleran Gardner Fund.
165 *Vampire*, 1896–1902. Woodcut. Munch Museum (Oslo Kommunes Kunstsamlinger), Oslo.
166 *Madonna*, 1895–1902. Lithograph, $35\frac{5}{8} \times 17\frac{1}{2}$ ($60 \cdot 7 \times 44 \cdot 3$). Nasjonalgaleriet, Oslo.
167 *Dance of Life*, 1899–1900. Oil on canvas, $49\frac{1}{4} \times 75$ (125×190). Nasjonalgaleriet, Oslo.
168 *Three Stages of Woman*, 1894. Oil on canvas, $64\frac{5}{8} \times 98\frac{3}{8}$ (164×250). Collection Rasmus Meyer, Bergen.

169 *Self-portrait*, c. 1893. Oil on cardboard, $27\frac{1}{8} \times 17\frac{1}{8}$ ($69 \times 43 \cdot 5$). Munch Museum (Oslo Kommunes Kunstsamlinger), Oslo.

OSBERT, ALPHONSE (1857–1935)
87 *The Vision*, 1892. Oil on canvas, 110×71 ($279 \cdot 5 \times 180 \cdot 5$). Collection Mlle Yolande Osbert, Paris.

PALMER, SAMUEL (1805–81)
27 *The Magic Apple Tree*, c. 1830. Pen, indian ink and watercolour, $13\frac{3}{4} \times 10\frac{3}{4}$ ($34 \cdot 9 \times 27 \cdot 3$). Reproduced by permission of the Syndics of the Fitzwilliam Museum, Cambridge.

PICASSO, PABLO (b. 1881)
179 *Evocation*, 1901. Oil, $58\frac{3}{8} \times 35\frac{5}{8}$ ($148 \times 90 \cdot 3$). Musée National d'Art Moderne, Paris.
180 *Courtesan with Jewelled Collar*, 1901. Oil on canvas, 25×21 ($63 \cdot 5 \times 53 \cdot 3$). Los Angeles County Museum of Art, Mr and Mrs George Gard de Sylva Collection.
181 *Salome Dancing before Herod*, 1905. Drypoint, $15\frac{7}{8} \times 13\frac{3}{8}$ (39×34).
182 *Poor People beside the Sea* (*Tragedy*), 1903. Oil on wood, $41\frac{1}{2} \times 27\frac{1}{8}$ ($105 \cdot 4 \times 69$). National Gallery of Art, Washington, Chester Dale Collection.
183 *Death of Harlequin*, 1905. Gouache on board, $26 \times 36\frac{1}{2}$ (66×93). Mr and Mrs Paul Mellon Collection.
184 *Life*, 1903. Oil on canvas, $77\frac{5}{8} \times 50\frac{7}{8}$ (197×127). Cleveland Museum of Art, Gift of Hanna Fund.
185 *The Mountebanks*, 1905. Canvas, $83\frac{3}{4} \times 90\frac{3}{8}$ ($212 \cdot 8 \times 229 \cdot 6$). National Gallery of Art, Washington, Chester Dale Collection.

PIRANESI, GIOVANNI BATTISTA (c. 1720–80)
14 *Prison with Colossal Wheel*, 1745. From *Carceri* series. Etching. By courtesy of the Trustees of the British Museum, London.

POINT, ARMAND (1860–1932)
89 *The Siren*, 1897. Oil on board, $35\frac{1}{2} \times 27\frac{3}{4}$ (90×70). Piccadilly Gallery, London.

PRENDERGAST, MAURICE (1859–1924)
122 *The Picnic*, 1915. Oil on canvas, 37×57 ($94 \times 144 \cdot 5$). National Gallery of Canada, Ottawa.

PREVIATI, GAETANO (1852–1920)
145 *The Sun King*, 1890–93. Watercolour, $13\frac{3}{4} \times 19\frac{7}{8}$ (35×50). Galleria d'Arte Moderna, Milan.

PRIKKER, JOHAN THORN (1868–1932)
151 *The Bride*, 1892–93. Oil on canvas, 57¼ × 33⅞ (146 × 88). Kröller-Müller Foundation, Otterlo.

PUVIS DE CHAVANNES, PIERRE (1824–98)
62 *Meditation*, 1869. 21¼ × 14⅝ (54 × 37). Kröller-Müller Foundation, Otterlo.
63 *Decollation of St John the Baptist*, 1869. 49 × 65⅜ (124 × 166). Barber Institute of Fine Arts, University of Birmingham.
64 *The Prodigal Son*, c. 1879. Canvas, 41⅞ × 57¼ (106 × 146). National Gallery of Art, Washington, Chester Dale Collection.
65 *The Poor Fisherman*, 1881. Oil on canvas, 75¾ × 61 (192 × 155). Louvre, Paris.
66 *The Dream*, 1883. Oil on canvas, 31½ × 39⅜ (80 × 100). Louvre, Paris.

RACKHAM, ARTHUR (1867–1939)
118 *The Rhinemaidens Teasing Alberich*, 1910. Watercolour.

RANSON, PAUL (1864–1900)
74 *Christ and Buddha*, c. 1890. Oil, 26¼ × 20¼ (67 × 51). Collection Mr and Mrs Arthur G. Altschul, New York.

REDON, ODILON (1840–1916)
55 *Orpheus*, c. 1913–16. Pastel, 27½ × 22¼ (70 × 57). Cleveland Museum of Art, Gift from J. H. Wade.
57 *Homage to Goya* (first plate), 1885. Lithograph, 11⅜ × 9 (29·1 × 23·8). Bibliothèque Nationale, Paris.
58 *The Grinning Spider*, 1881. Charcoal, 19½ × 15¾ (49·5 × 39). Louvre, Paris.
59 *Head of a Martyr*, 1877. Charcoal, 14⅝ × 14⅛ (37 × 36). Kröller-Müller Foundation, Otterlo.
60 *The Sun Chariot of Apollo with Four Horses*, c. 1905. Oil on canvas, 26 × 32 (66 × 81). Metropolitan Museum of Art, New York.
61 *The Green Death*, c. 1905–16. Oil on cardboard, 22⅜ × 18¾ (57 × 47). The Museum of Modern Art, New York. Collection Mrs Bertram Smith.

RICKETTS, CHARLES (1866–1931)
111 *In the Thebaid*, 1894. Illustration to Oscar Wilde's poem *The Sphynx*.

ROERICH, NIKOLAY (1874–1947)
127 *Set for 'Prince Igor'*, 1909. Tempera and gouache on paper, 20 × 30 (50 × 76). Victoria and Albert Museum, London.

ROMANI, ROMOLO (1884–1916)
147 *Lust*, 1904–05. Pencil, 18½ × 24¼ (47 × 61·5). Musei Civici, Brescia.

ROPS, FÉLICIEN (1833–98)
155 *The Monsters (Genesis)*. From *Les Sataniques* series. Etching, 10 × 7½ (25·6 × 18·9). Bibliothèque Royale, Brussels.

ROSSETTI, DANTE GABRIEL (1828–82)
33 *Ecce Ancilla Domini (The Annunciation)*, 1850. Canvas mounted on wood, 28½ × 16½ (72 × 42). Tate Gallery, London.
34 *The Wedding of St George and Princess Sabra*, 1857. Watercolour, 13½ × 13½ (34 × 34). Tate Gallery, London.
35 *Bocca Baciata*, 1859. Oil on panel, 13¼ × 12 (34 × 31). Collection Mrs Suzette M. Zurcher, Chicago.
36 *Dantis Amor*, 1859. Oil on panel, 29½ × 32 (75 × 81). Tate Gallery, London.
37 *Astarte Syriaca*, 1877. Oil on canvas, 72 × 42 (183 × 107). City Art Galleries, Manchester.

ROUSSEL, KER-XAVIER (1867–1944)
77 *L'Après-midi d'un faune*, 1919. The Museum of Modern Art, New York.

RUBENS, PETER PAUL (1577–1640)
10 *Henry IV Receiving the Portrait of Marie de Médicis*, 1622–25. Oil on canvas, 155 × 116 (394 × 295). Louvre, Paris.

SARGENT, JOHN SINGER (1856–1952)
120 *Astarte*, c. 1892. Approx 84 × 108 (213·5 × 274·5). By courtesy of the Trustees of the Boston (Mass.) Public Library.

SCHIELE, EGON (1890–1918)
177 *Cardinal and Nun*, 1912. 27⅝ × 31½ (70 × 80). Private collection, Vienna.

SCHUFFENECKER, CLAUDE-ÉMILE (1851–1934)
82 *Le Lotus bleu*. Project for a magazine cover. Crayon, 24 × 18 (61 × 46). Galerie des Deux-Iles, Paris.

SCHWABE, CARLOS (1866–1926)
84 *Poster: Salon de la Rose + Croix*, 1892. 73 × 32 (185·5 × 81·5). Piccadilly Gallery, London.
93 *The Virgin with Lilacs*, 1897. Watercolour, 19½ × 39½ (49·5 × 100). Collection Robert Walker, Paris.

SEGANTINI, GIOVANNI (1858–99)
143 *The Punishment of Lust*, 1897. Oil on cardboard, 15¾ × 28¾ (40 × 73). Kunsthaus, Zürich.

SÉGUIN, ARMAND (1868–1903)
83 *Les Fleurs du mal*, 1892–94. Oil on canvas, 20⅞ × 13¾ (53 × 35). Josefowitz Collection, Switzerland.

SÉON, ALEXANDRE (1857–1917)
90 *The Chimaera's Despair*, c. 1892. Collection Pierre Elie Flamand, Paris.

SÉRUSIER, PAUL (1865–1927)
72 *Landscape: the Bois d'Amour (The Talisman)*, 1888. Oil on panel, 10⅝ × 8⅝ (27 × 22). Denis Family Collection, Saint-Germain-en-Laye.
75 *Paul Ranson in Nabi Costume*, 1890. Oil on wood, 23⅝ × 17¾ (60 × 45). Collection Mme Paul Ranson, Paris.

STUCK, FRANZ VON (1863–1928)
134 *Fighting Fauns*, 1889. Oil on panel, 33½ × 58⅝ (86·2 × 149). Neue Pinakothek, Munich.
135 *The Kiss of the Sphinx*, c. 1895. Oil on canvas. Museum of Fine Arts, Budapest.

STURGE MOORE, THOMAS (1870–?)
113 *Vision of James I of Scotland*. Published in *The Dial* No. 5, 1897. Woodcut.

TIEPOLO, GIOVANNI BATTISTA (1692–1770)
15 *Two Magicians and a Boy*, 1755–65. No. 22 of *Scherzi di fantasia* series. Engraving, 5½ × 7⅛ (14 × 18). By courtesy of the Trustees of the British Museum, London.

TITIAN (TIZIANO VECELLIO, c. 1487/90–1576)
4 *Allegory of Prudence*, late work. Oil on canvas, 29½ × 26½ (75 × 67). National Gallery, London.
9 *Sacred and Profane Love*, c. 1515–16. Oil on canvas, 110 × 46¾ (275 × 119). Galleria Borghese, Rome.

TOOROP, JAN (1858–1928)
153 *Faith in Decline*, 1894. Charcoal sketch. Rijksmuseum, Amsterdam.
154 *The Three Brides*, 1893. Coloured drawing, 30¾ × 38⅝ (78 × 98). Kröller-Müller Foundation, Otterlo.

VALLOTTON, FÉLIX (1865–1925)
41 *J. K. Huysmans*, drawing in indian ink, 5 × 4 (12·8 × 10·2). Musée des Beaux-Arts, Lausanne.
78 *Indolence*, 1896. Engraving. Musée des Beaux-Arts, Lausanne.

VEDDER, ELIHU (1836–1923)
121 *The Cumaean Sibyl*, 1876. The Detroit Institute of Arts.

VRUBEL, MIKHAIL (1856–1910)
125 *The Dance of Tamara*, 1890. Watercolour on paper. Russian Museum, Leningrad.

VUILLARD, ÉDOUARD (1876–1953)
80 *Misia Sert and Félix Vallotton*, 1899. Oil on wood, 26¾ × 20¼ (68 × 51). Musée National d'Art Moderne, Paris.

WATTEAU, JEAN-ANTOINE (1684–1721)
13 *The Departure from the Island of Cythera (Embarkation for the Island of Cythera)*, 1716–17. Oil on canvas, 50 × 75½ (127 × 191). Louvre, Paris.

WATTS, GEORGE FREDERICK (1817–1904)
38 *The Dweller in the Innermost*, 1885–86. Oil on canvas, 41¾ × 27½ (106 × 70). Tate Gallery, London.
39 *Love and Death*, 1887. Oil on canvas, 97½ × 46 (247 × 117). Tate Gallery, London.
40 *The Minotaur*, c. 1877–86. Oil on canvas, 46 × 36¾ (117 × 93). Tate Gallery, London.

WELTI, ALBERT (1862–1912)
137 *The King's Daughters*, 1901. Tempera on wood, 12¾ × 17½ (32·5 × 44·5). Kunsthaus, Zürich. Loan of the Gottfried Keller Foundation.

WHISTLER, JAMES ABBOTT MCNEILL (1834–1903)
119 *The Little White Girl: Symphony in White No. 2*, 1864. Oil on canvas, 21 × 29¾ (53 × 75). Tate Gallery, London.

WILDT, ADOLFO (1868–1931)
146 *A Rosary*, 1915. Marble, 15¾ × 19⅝ × 9⅞ (40 × 50 × 25). Vanni Scheiwiller Collection, Milan.

ZECCHIN, VITTORIO (1878–1947)
144 *Salome Triptych*, 1909–12. Tempera on cardboard, 9½ × 4¾, 9½ × 2¾, 9½ × 2¾ (24 × 12·5, 24 × 7·5, 24 × 7·5). Galleria Martano, Turin.

Photographic Acknowledgments

ACL, Brussels: 156. Archives Photographiques: 51. Bayerische Staatsgemäldesammlungen; 12, 97, 174. Bulloz: 22, 23, 24, 46, 49, 50, 52, 53, 54, 58, 66, 179. A. C. Cooper: 35. Courtauld Institute of Arts: 16, 107, 111, 113, 118. M. Olivier Delville, Brussels: 94, 95.

John Freeman: 14. Galerie Durand-Ruel, Paris: 69. Giraudon: 6, 10, 42, 43, 65, 70, 72, 79, 80, 126. Solomon R. Guggenheim Museum, New York: 170. Historisches Museum der Stadt Wien: 173. Mas, Barcelona: 18. Mansell Collection: 2. Mansell-Alinari: 5.

Mansell-Anderson: 9. Meyer, Vienna: 172, 176. Museum of Modern Art, New York: 61. Musées Nationaux: 13. National Gallery of Art, Washington: 183. Piccadilly Gallery, London: 82, 85, 86, 93, 133. Royal Academy of Arts, London: 159.

Index *Figures in italic are illustration numbers.*